This book is dedicated to
Sabine Annabel Concepcion

Your incredible mind, strong will, and kind heart
make you the beautiful eight-year-old girl you *are*.

Your empathy for others and will to want to help
will make you the amazing woman I *know* you'll be.

Though it'd take a million books,
to share the love I have for you.

I'll do my best to sum it up,
and share my heart
with just this one.
Your life gives *me* life.

ACKNOWLEDGEMENTS

FIRST AND FOREMOST, I'd love to thank my mother, Cristela Concepcion. My mom continues to be an inspiration to me. She shows me daily how hard work and respect are important things to live by. La quiero mucho mama.

To my wife, Jennifer Concepcion: I would shout to the world that if ever someone needs to see the definition of an amazing mother, they should look no further than you. Thank you for being a rock and guiding light for me and our Sabine. I am thankful for your love, and I am so incredibly proud of you. You are the most incredible fifth grade teacher, and it makes me so proud to walk through your school with some swagger, bragging that I know you.

To my brothers, Victor, Everardo, David, Jesus, Carlos, and Tito: While time and distance keeps our conversations short, I cannot help but laugh out loud at all of the foolishness I see in our text threads. That has been such a gift. To Danielle and Jim Bontempi, your support as in-laws is only overshadowed by your love of me as one of your own. I am grateful to have you in my life.

To my best friend, Al Fudger: For over 22 years you have been a vital part of my life. I am very thankful for every chance we get to connect.

To Bonnie Scharf and Matt Davis: I love you two very much and am grateful that there isn't much that would ever get in the way of us helping one another out—not even a trip into the Bronx!

I always want to be better, both as a teacher and as a photographer, because of three people. Jay Maisel and Gregory Heisler: You are icons for whom I have a great admiration,

and I am blessed to call you my friends. And to the inimitable Joe McNally: Your friendship, counsel, mentorship, and advice has been one of the greatest things that being in this business has given me. You, Annie, Cali, John, and Lynn are just wonderful.

To Alan Shapiro: You are an amazing photographer and incredible force in the photo space. Your support and trust have been unwavering, and I am incredibly grateful for your belief in me. I'm so thankful to call you a friend.

Special thanks to Denise Patti, Linwood Henry, Donna Green, Katrin Eismann, Jim Booth, Rich Reamer, Steve Peer, Zack Arias, April Love, Jesica Bruzzi, Meredith Payne Stotzner, Jeff Tranberry, Dan Steinhardt, Mark Suban, Nancy Davis, Nikki McDonald, Jennifer Bortel, Sara Jane Todd, and Mike Corrado. Chrysta Rae—my secret weapon—I am so thankful for our connection through the years! To Bill Fortney: Thank you for your guidance and support. When it happens, it will be because of you. Brian Wells: Thank you for being such a positive and genuine voice in photography for me. I can't wait to work closer together. John Nack: It's been a pleasure to stay connected—from Photoshop to Photos—and there isn't a time we've spoken that I have not left with some nugget of inspiration for "my next thing."

Kevin Agren: Thank you for wanting to come along for the ride of building a new school. I'm grateful to have you on the little ship that could. We're going to go to some cool places.

Mia McCormick: You have been both a great friend to me and a source of inspiration for reinvention. I can honestly say that I am changed and am better because of what I've learned from you. Thank you for your candor and your patience; it has meant the world.

To the Waldron family, Roz, Carl, Thalia, and Connor: It's such a gift to have friends like you just a few doors down. Our lives are so much better knowing you guys are nearby, just a sleepover away!

To my new family at Rocky Nook: Jocelyn Howell, Lisa Brazieal, and Mercedes Murray, thank you for keeping up with me and being so patient! To Ted Waitt and Scott Cowlin: I'm grateful to be connected with you at this new spot. Let's see what we can do here!

Dubai has become such a special place for me to go to get away from it all. That part of the world has given me people who I miss terribly and am so happy to see: Hala Sahli, Mohamed Somji, Saadia Mahmud, Imraan, Tarek Sakka, Raad Sabounchi, and the head of Lightning Hand Tomato, Katie Kuuskler.

Sara Lando: I'd learn Italian just to find another way to tell you amazing you are, and how much I love to see you. I need to get out to Grappa to visit you and Alessandro.

THIS PAST YEAR has been one of those years where you really take stock of what is truly important in your life. To that, I am humbled beyond words to know that I am surrounded by a net of family and friends who really make me appreciate all of the blessings I have.

Kim Patti: You have not only singlehandedly built the ship on which we are sailing, but you have given me a new lease on life. I never would have thought I'd find a man I could say I love almost like a father.

Latanya Henry: You are my partner in crime, a trusted confidant, an incredible sounding board, and such a great cheerleader for what I want to do. You believe in me more than I am able to believe in myself at times. We switch from teacher to student so much, and that's what has made my friendship with you so special. Thank you.

Jay Abramson and Susan Henry: To say you are like family to us would be completely understating how important you guys are to Sabine, Jenn, and I. We love you very much.

Martin Stephens: As soon as I leave your company, I immediately start planning how to get halfway around the world to see you again. Here's to our next adventure, buddy!

To Daniel Gregory: Your friendship has brought an incredible love in my heart, a passion for becoming a better photographer, and incredible clarity in such a clouded mind. You are one in a million.

Finally, to the most important person of all, to you, dear reader: It is because of you that I get to do what I do. I don't ever want to forget that. Thank you for your time, investment, and attention. I hope this book gives you what you need, and I stand willing to help should you need anything else.

THE ENTHUSIAST'S GUIDE TO LIGHTROOM

55 Photographic Principles You Need to Know

RAFAEL "RC" CONCEPCION

THE ENTHUSIAST'S GUIDE TO LIGHTROOM:
55 PHOTOGRAPHIC PRINCIPLES YOU NEED TO KNOW

Rafael "RC" Concepcion

Project editor: Jocelyn Howell
Project manager: Lisa Brazieal
Marketing coordinator: Mercedes Murray
Layout and type: WolfsonDesign
Design system and front cover design: Area of Practice
Front cover image: Rafael Concepcion

ISBN: 978-1-68198-270-0
1st Edition (1st printing, August 2017)
© 2017 Rafael Concepcion
All images © Rafael Concepcion unless otherwise noted

Rocky Nook Inc.
1010 B Street, Suite 350
San Rafael, CA 94901
USA

www.rockynook.com

Distributed in the U.S. by Ingram Publisher Services
Distributed in the UK and Europe by Publishers Group UK

Library of Congress Control Number: 2016962838

This book is printed on acid-free paper.
Printed in China

CONTENTS

CONTENTS

1

GET ORGANIZED

CHAPTER 1

You have to hand it to Adobe; with Photoshop Lightroom, they've created a program that is incredibly easy to use to develop the pictures you take. You can move a few sliders up and down and get some great results.

Oftentimes, however, people ignore overall organization in Lightroom. I can't tell you how many times I see people fire up the software, import a card of images, and just start dragging sliders left and right willy-nilly. Though they're happy with the process of making the pictures, they'll come back a couple of months later and have no idea where the pictures are. They don't know why they're getting missing file messages and they aren't able to find a shoot they processed months ago.

The truth of the matter is that Lightroom is an organizational program first. Because you are going to be shooting a lot, you need to have a good strategy for organizing all of your images in your computer. Once that's done, you need to be able to organize individual shoots to get the best out of each one and ignore all of the garbage that invariably comes with making pictures with a DSLR (I do it all the time). You can then set up a strategy for targeting specific pictures to edit in Lightroom or to move into Photoshop. The process is not hard, but it does require you to think about it before you actually begin.

1. WHAT IS THE LIGHTROOM CATALOG?

THIS MIGHT SOUND a little counterintuitive, but you are going to spend a lot more time as a photographer organizing your pictures than actually developing them. You'll take hundreds of pictures during one shoot, only to come back and develop just a few select images for your portfolio or to give to a client. You'll go through this process over and over, developing only a fraction of the pictures you take to their full potential. This could put any photographer—no matter what level of experience they have—in a sticky situation. How do you organize the massive number of shoots that you do into some form of cohesive structure that enables you to find the pictures you want and develop them as quickly as possible?

This is one of the main reasons Lightroom was built in the first place—to give users a program that allows them to organize their shoots and makes it easy for them to quickly find the pictures they need, develop them, and share them with their clients and followers. To do this you need a strong organizational structure—this is the Lightroom catalog (**Figure 1.1**).

Imagine that someone knocks on your door and presents you with a box of pictures. They ask you to store these pictures for safekeeping, so you place them on top of your desk in the living room. In order to remember where you placed these pictures, you pull out a notebook and write down that the pictures are sitting on the desk in the living room.

There's another knock at the door and another box of pictures appears. You place these pictures in one of the drawers in your bedroom. You want to remember where they are, too, so you write it down in your notebook.

More boxes of pictures appear and you continue placing them in different spots in your house, writing down the location of each box of pictures in your notebook. This notebook becomes a central location outlining where each box of pictures is stored in your home.

Now imagine you're bored one day and you start to organize the pictures that are on the desk in your living room into some special order. You want to make sure you remember that you've made changes to this box of pictures, so you write down in your notebook that the pictures on top of the desk in the living room have been organized in a specific fashion.

The notebook you've been using serves as the master record of the locations of the pictures that sit inside your home, as well as a record of all of the changes that you've made to each set of pictures. This is exactly what the Lightroom catalog is—a record of where your pictures are stored and what changes have been made to them. When you first start Lightroom, it creates a catalog in the "Pictures" folder on a Mac or in the "My Pictures" folder on a PC (**Figure 1.2**).

As you start importing pictures into the catalog, it keeps track of the locations of those pictures on your computer, as well as any changes that you make to them (rank, sort, pick, flag, or develop changes). It serves as a hall monitor, making changes to your pictures and monitoring their locations as you move them around inside your collections. While it is not the sexiest of Lightroom's features, the ability to keep track of your photographic life is what makes it the most powerful program you can use.

It's always a good idea to make sure that all of your photographic life exists inside of one catalog. Lightroom does let you create multiple catalogs, but if you do so, it can become a bit of a hassle to find individual pictures. Lightroom does not have the ability to search across different catalogs, so you would have to remember which catalog your pictures are stored in, and then open that catalog to perform any searches. I suggest you make things easier for yourself by keeping just one catalog and making sure that all of your pictures exist only in that catalog.

As you work with Lightroom, the program will occasionally want to do backups of your catalog. Keep in mind that when you back up the catalog, you are backing up your "digital notebook," or the record of the locations of your pictures and the changes you have made to them. This backup does not back up any of the image files themselves. For that you need to use some form of computer backup to keep copies of your images safe.

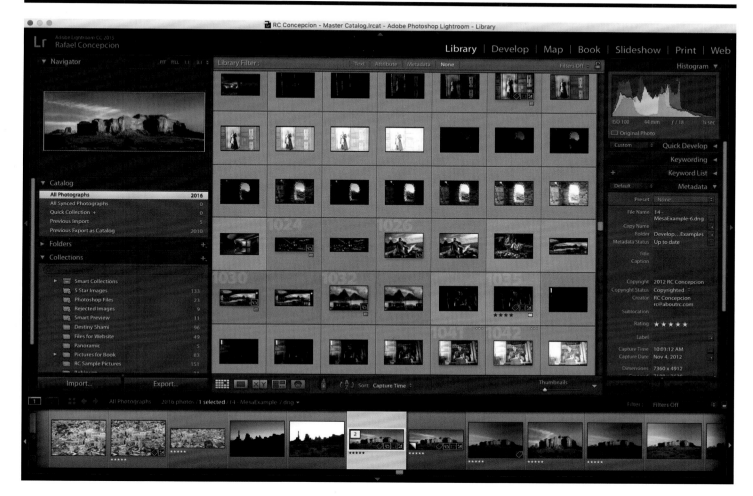

Figure 1.1 The Lightroom catalog

Figure 1.2 This is what your Lightroom catalog looks like on your computer.

2. THE DIFFERENCE BETWEEN LIGHTROOM AND LIGHTROOM MOBILE

WHILE LIGHTROOM HAS largely been considered a desktop program to manage all of your photography shoots, Adobe has made some great inroads for people who use mobile devices with Lightroom Mobile. This program works on tablets as well as Android and iOS devices, giving users a great amount of control over the images they take with their phones, as well as access to images stored in their desktop collections. Let's walk through a few things that I think will make you excited to download and try this program on your mobile device.

The Camera for Lightroom Mobile Rocks

One of the things that's severely limiting for mobile iOS and Android users is the built-in camera. Inside Lightroom Mobile, you can use its camera app to take pictures to be stored in its internal camera roll (**Figure 2.1**). When the Lightroom camera is set to Auto, it functions exactly the same as your device's standard camera app. When you click on the drop-down menu, you'll see an option to use the professional (PRO) level of the camera. You can now control several key elements of your device's camera, so it's similar to using a DSLR:

- **Exp:** Exposure control allows you to under-expose or overexpose your images by several stops, giving you great creative control. For example, you can get more saturated colors by underexposing a shot, or create high-key images that are brighter than the actual scene.

- **Sec:** This setting allows you to regulate the shutter speed of the camera, so you can use slower shutter speeds to capture things like light trails, or faster shutter speeds to freeze fast-moving subjects. You'll need to mount your device on a tripod if you're using slow shutter speeds; otherwise, you're pictures will be out of focus.

- **ISO:** This setting allows you to control how sensitive the camera's sensor is to light. When you are photographing in low light, increase the ISO setting to make the sensor more sensitive to the available light. Be aware that this may increase noise in the image.

- **WB:** The white balance setting allows you to control how the camera tints the picture so you can achieve proper colors in an image, or even add an intentional colorcast.

- **[+] (metering mode):** This allows you to control what area of a scene the camera uses to measure the light, and sets the exposure based on that area.

The camera even allows you to see filters for your pictures in real time. If you click on the two circles in the lower-left corner of the camera app, a slide out of filters will appear to the right of the camera controls. These thumbnails will show the filters you can use for your picture in real time.

Composition and Crop Options for Better Shots

Lightroom Mobile's camera also lets you change the overall crop of a picture. By default, the built-in camera on your mobile phone shoots pictures with an aspect ratio of 4:3. This is different from the 3:2 ratio that you may be used to on a DSLR. With one push of a button in the Lightroom camera app, you can change that ratio, and make compositional changes to your pictures while working with a ratio that you are more familiar with. I'm a big fan of using the 16:9 aspect ratio—I think it gives pictures more of a cinematic feel that's different from what everyone else is shooting out there.

Once you've changed the aspect ratio, click on the Grid and Level button for your guides (**Figure 2.2**). While some photographers look at these visual aids as a bit of a nuisance, I think they really do help with composing pictures at the time of capture, giving you better results. For example, let's look at the rule of thirds. Imagine your screen has a tic-tac-toe overlay. Any subject that is placed at the intersection points of those lines will immediately draw more visual interest. So by having the grid on your screen as a constant reminder, you can frame better shots—and who wouldn't want that?!

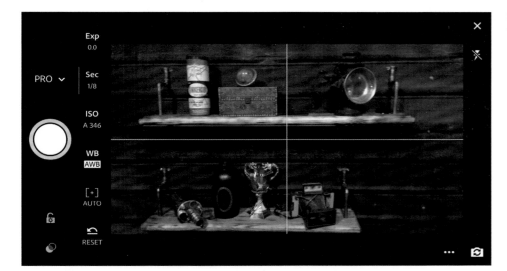

Figure 2.1 The camera in Lightroom Mobile

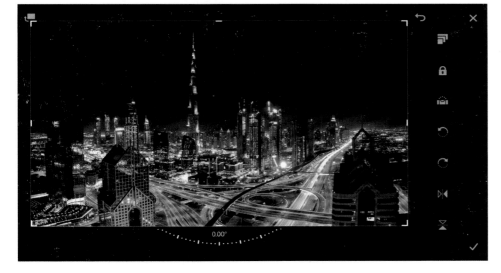

Figure 2.2 Using the crop tool in Lightroom Mobile

Share Collections from Your Desktop to Your Mobile Device

While I think Lightroom Mobile is a great tool to use for mobile shots, I also see it as a great way to continue any work that I am doing on the desktop side of things while I'm on the go.

Let's say that you want to be able to work on a series of images while you're away from your computer. Simply create a collection for these pictures (we'll talk about collections later) and place the pictures inside of it. You immediately have the option to sync this collection with Lightroom Mobile (**Figure 2.3**).

Once the images appear on your mobile device, you can rank, sort, pick, and keyword them, as well as make many of the changes that you would make to them on your computer. As soon as you get back to your computer and start up the desktop version of Lightroom, these corrections will sync to the desktop.

Save Your Camera Phone Shots to Your Desktop

One of the biggest things I've noticed with photographers when it comes to organizing their images is that there is a huge line of separation between the images they are making on DSLRs and the images they are making with their phones. On the DSLR side, Lightroom fits the bill pretty perfectly. Ask them what they are doing to streamline the pictures on their phone, and you'll usually get a blank stare.

This has always troubled me because I think the pictures that you take with your phone are oftentimes some of the most valuable ones. These pictures are usually the ones that capture family moments or document your personal life. So how can you make sure these pictures get the same amount of organizational support? Use Lightroom Mobile, of course!

Figure 2.3 It's incredibly easy to share your collections—just click on the sync icon (thunderbolt) that appears to the left of a collection when it is selected.

1 Create a collection in Lightroom Mobile called "My Mobile Uploads" (**Figure 2.4**).
2 Once that's complete, click on the three dots to the right of the collection name and select Enable Auto Add from the list (**Figure 2.5**).
3 Make sure you have the Auto Add Photos option turned on in the Lightroom Mobile menu (**Figure 2.6**). This ensures that all of the pictures you take in Lightroom Mobile will be automatically added to the My Mobile Uploads collection. The great part about this is that when you open your desktop version of Lightroom, your phone images will automatically be synced with your computer, bringing your mobile photography life and your DSLR life closer together.

You can get Lightroom Mobile in both the Android and Apple app stores, but I would recommend you sign up for Adobe's Creative Cloud Photography plan before you do. This should give you access to the syncing capability you'll need to make all of this happen.

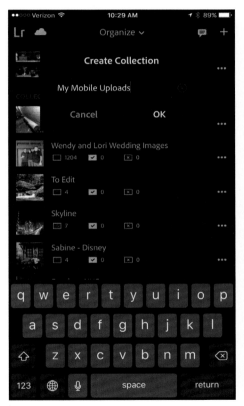

Figure 2.4

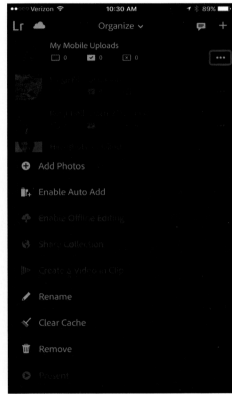

Figure 2.5

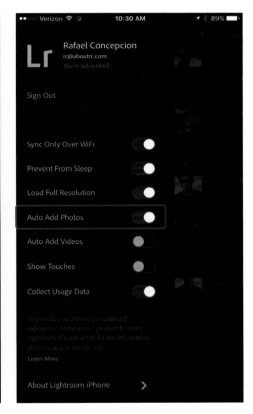

Figure 2.6

3. IMPORTING PICTURES FROM AN SD CARD

ONE OF THE first screens you will run into when working in Lightroom is the Import screen. While it may seem like there is a lot of stuff to look at here, it's really not all that complex. The important thing is to know how each field in the Import screen can help you later on as you're searching for and editing images. Let me walk you through a few sections in the Import dialog that you don't want to miss.

As soon as you insert a memory card into your computer, you'll see Lightroom's Import screen appear (if you don't, you can always select *File > Import* from the menu). The screen is broken down into three columns (**Figure 3.1**). The Source column on the left side of the screen deals with where the images are coming from. You'll see different sources listed in this column, including the card directory and other sections of your computer.

The middle column shows the contents of whatever source you selected in the left column. Frequently, I come back from a shoot and know that I don't intend on keeping a good portion of the images from the beginning of the shoot. Instead of taking the extra time to import these images and wasting space on my computer, I can limit

the pictures I import to only the ones I want.

In the bottom-right corner of the center column there is a slider that allows you to increase or decrease the size of the image thumbnails, so you can review the images quickly and make judgments as to what gets imported into Lightroom. I tend to make the thumbnails a little larger so it's easier to see the differences among the pictures.

You can also look at individual pictures in the center column; just double-click on any thumbnail, and you will be taken to the Loupe View (keyboard shortcut E). You can go back to the Grid View by clicking on the Grid View icon in the bottom-left corner of the center column (keyboard shortcut G).

After you set your view, you can import the entire photo shoot or select individual pictures. To select individual pictures, start by clicking on the Uncheck All option, and then Shift-click to select a series of contiguous pictures, or Command-click (Mac) or Ctrl-click (PC) to select a set of non-contiguous images. Once the pictures are selected, you can click on the checkbox in the upper-left corner of any selected image to flag the entire set for import (**Figure 3.2**).

The right-hand column is the most important column because it's where you select what

information will be added to the pictures that you are about to import into Lightroom. Let's walk through each of the sections in this column.

Import Location

First up is the location of the pictures. At the top-right corner of the Import screen you are asked to name a location where the pictures will go. By default, Lightroom attempts to place the pictures in your "My Pictures" (PC) or "Pictures" (Mac) folder.

It's good to use a central location that you know has a lot of space for your collection of images to grow. Many photographers choose to keep their pictures in this directory, but after many shoots, they find the computer is running out of space. When this happens, they opt to keep a USB drive connected to their computer and load the pictures onto that.

Since you're just starting out, I would leave this at its default ("My Pictures" or "Pictures"). Later on, when you have some Lightroom experience under your belt, I'll share a workflow I use for my shoots that gives me a great amount of room to grow.

Figure 3.1 The Lightroom Import window with images of my buddy Lisa.

Figure 3.2 Shift-click to select a series of contiguous images, or use the Command (Mac) or Ctrl (PC) key to select noncontiguous images.

File Handling

When you are importing pictures into Lightroom, you will notice a drop-down menu called Build Previews at the top-right corner of the screen (**Figure 3.3**), which contains three options for creating thumbnails of your pictures. (There are actually four options, but one of them is generally not used.) These thumbnail options will help you speed up your workflow when you're making edits or changes to your pictures, and will affect how much space you use on your computer. It's a good idea to know what each thumbnail option means and how it will impact your work.

The Minimal Preview

When you select the Minimal preview, you allow Lightroom to use the embedded JPG in the raw file as the preview for the image. This preview is used in the grid mode when Lightroom has not yet rendered a preview that's suitable for viewing. This is the fastest way to get all of your images into the Catalog.

Once the images are loaded into the Catalog, Lightroom will go ahead and generate Standard previews for these images. Using the Minimal preview is best when you want to quickly import your images into the catalog.

The Standard Preview

Importing images with the Standard preview will create larger thumbnails for your images in Lightroom. These larger previews are the ones Lightroom uses when you use the Develop module. If you're going to do a lot of developing immediately, this is a better option for you to use, but it will take a little more time to import your images into the catalog.

The 1:1 Preview

When you want to zoom into an image to see it at 100 percent, Lightroom will automatically create a 1:1 preview of the image. This is the largest of the three thumbnails that will be created for your Lightroom library.

If you find that you are going to want to zoom into each picture in your photo shoot immediately, it's often best to create a 1:1 preview during the import, even though it will take a little bit longer. Let's take a look at a real-world scenario where the selection of this preview type will benefit you.

Imagine you're shooting a portrait and you need to find out which of the images you have are focused correctly. If you select the Minimal preview during the catalog import, your import will take a lot less time. However, each time you zoom into a picture to check focus, you will notice a significant lag while Lightroom develops the 1:1 preview, and you'll have to wait several seconds each time to see whether or not the picture is actually in focus. Going through this for each picture adds up to a lot of wait time.

In an instance like this, it's probably better for you to select the 1:1 preview option and let Lightroom take a little bit longer during the import. You can walk away from the machine and let it finish doing the import, and when you come back, you'll notice that moving from picture to picture will take a little bit less time, which will speed up your overall workflow.

If you are more concerned with adding the pictures to the catalog so that you can create collections in collection sets, it's better to select the Minimal preview because it will get the images into the catalog a lot faster. (We'll be talking about collections and collection sets in lessons 9 and 10. For now, we'll leave this set to Minimal.)

Once the images are in the catalog, you can select *Library > Previews > Build 1:1 Previews* to make the previews on the fly in the grid mode (**Figure 3.4**). All of the previews you make for your images are loaded into the Lightroom previews file, which is stored next to the catalog file on your computer (**Figure 3.5**). The more images you add to the catalog, the larger that file will become.

Because 1:1 previews can take up a lot more space, Lightroom provides an option to regulate how long 1:1 previews are stored on your machine. Go to *Lightroom > Catalog Settings*, and under the File Handling tab, you will see a menu where you can select how frequently Lightroom will Automatically Discard 1:1 Previews (**Figure 3.6**). To keep file sizes small, I recommend you keep 1:1 previews for about a week.

Should you need to recover space from your previews, you can always select images inside the Library module and discard the 1:1 previews.

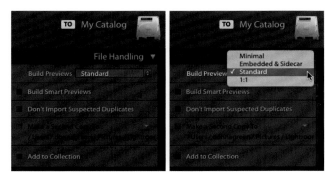

Figure 3.3 The thumbnail preview options in the Lightroom Import window.

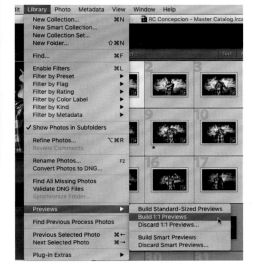

Figure 3.4 Generating previews in the Lightroom catalog.

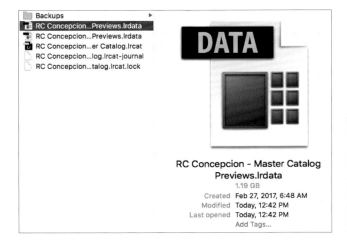

Figure 3.5 The Lightroom previews file is located next to the catalog file on your computer.

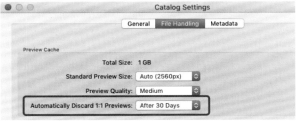

Figure 3.6 Choose how frequently you want to discard your 1:1 previews based on your specific workflow.

File Renaming

Lightroom gives you the option to rename files during the import process, and I suggest you take this opportunity. I've seen shoots come into a Lightroom catalog with a similar name as a previous shoot, which can cause a lot of confusion. This usually occurs when you leave the image filenames at whatever defaults the camera has selected. If you're someone who uses only one camera on a shoot, you may not run into this problem.

Check the Rename Files box (**Figure 3.7**), and then click on the Template drop-down menu, and you'll see a series of file-naming templates that you can use (**Figure 3.8**). The good part about these is that they tend to include very specific information about the shoot, such as the date and sequence in which the images were shot. My favorite out of this list is Custom Name – Sequence. This lets me enter some custom text that makes sense to me in the empty field, and then it adds a number (-1 , -2, -3, etc.) to the end of each filename (**Figure 3.9**).

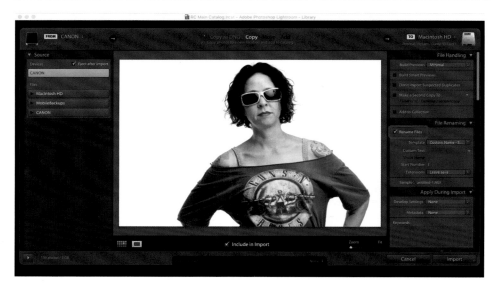

Figure 3.7 The options in the File Renaming panel allow you to rename your image files during the import process.

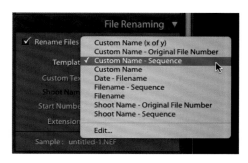

Figure 3.8

Figure 3.9

My Custom Naming Standard

I have a standard naming convention I like to use for my filenames that may seem a little anal, but it can totally help me later on:

`date_description_d1_c1`

From a formatting standpoint, everything is in lowercase and I always use an underscore for any spaces. The first part includes the date of the shoot. From there, I always add some descriptive text about the shoot (again, if it spans a couple of words, I'll use the underscore). After the description, I use d1 and c1, which means day 1 and card 1. I may shoot multiple days on location, and there are plenty of times when I use multiple cards on a shoot, so this lets me tag which card I used right in the filename.

For example, imagine you were photographing in Italy for three days in February of 2017 and had three cards with you. Your file-naming convention could look like this:

`feb2017_italy_d1_c1` (day 1 card 1)

`feb2017_italy_d1_c2` (day 1 card 2)

`feb2017_italy_d1_c3` (day 1 card 3)

`feb2017_italy_d2_c1` (day 2 card 1)

Some will argue, "Isn't this information that could be read from inside the EXIF data of the file?" Yes, it could be. However, I am planning on the off chance that there is no program out there available to read any of this information. Should something like this happen (and I know chances are slim), the couple of seconds I took to make this preparation would allow me to easily find a file with Windows Explorer or Finder on a Mac by typing in something that I remember about the trip. And it only took me a little bit of planning to make that possible.

Including information about which memory card each file came from can also save you when a card starts to fail. Memory cards are not invincible. Over time you may experience corruption of a single file on a card and wonder which card the file was saved on. Sometimes you get a pink bar on one of the images, or a bunch of blue noise. This is an early warning sign that the card the image was saved on is about to go bad. If the name of the card (e.g., c1, c2, and so forth) is included in the image filename, you can immediately determine which of your cards is beginning to go bad and pull it from the pile.

What do you do with it? Give it to a friend. Kidding!!

Metadata, Keywords, and Destination Folder

Once you've set up your file renaming conventions, you'll need to specify where you want your images to be stored, as well as what kinds of information you want to add to them. I always recommend that all of the images from a shoot be stored in a single folder that has a name format similar to the one you used for the individual filenames (just get rid of the _d1_c1 portion of it). In the Destination panel, the Organize drop-down menu will let you specify that all files should be placed into one folder—just select the "Into one folder" option (**Figure 3.10**).

In the Apply During Import section, you can input keywords to attach to the images, as well as add metadata information to your files. Let's talk about keywords first.

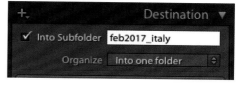

Figure 3.10 Organizing your images in one folder will cut down on the folder clutter that multiple subfolders can create.

When you're adding keywords at this point, I would suggest using the most generic keywords you can to describe the shoot. Going back to the Italy example, if you're importing images from when you were hanging out in Venice and the card has 30 pictures of you eating gelato on it, just use keywords like "Venice," "Italy," and "Vacation," and skip adding "Gelato." By using the keywords section to give broad brushstrokes to the files, you can do a portion of the heavy lifting during the import stage.

You can always go back and add "Gelato" to the individual pictures later.

Now it's time to work on the metadata. Each file contains information related to the picture—from the camera model, to the lens, to the shutter speed used to take the picture—all of which is read from inside the camera. You can, however, add information to the file that can be read by external sites and programs, should you wish to publish it. This information is known as metadata, and can be added to images en masse using a Metadata preset.

Click on the Metadata drop-down menu and select New from the list (**Figure 3.11**). You'll be presented with a dialog box where you can input information as it pertains to you. Not every field will be something you need to address. I suggest concentrating on the information in the IPTC Copyright and IPTC Creator fields.

In the IPTC Creator fields, you can add your contact details, but I advise you never include your phone number. When your picture is uploaded to a website like 500px or Flickr, the information you added will be readily available to viewers who want to contact you about the picture you took. Who knows, you may be able to sell a shot. Does this happen all of the time? Maybe not often enough to cover your rent payment, but what if it happened enough to let you feed your photography habit? I do know that it won't happen at all if you don't let yourself be found. So go ahead and add it!

Now that all of the information has been filled out, click on Import, and all of the images you've selected will be placed in the location you specified with the details you want. Not bad!

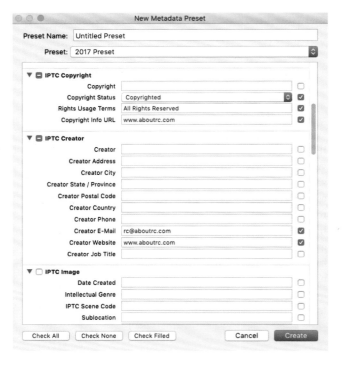

Figure 3.11 Make sure people can find you—just don't put your phone number in here!

4. IMPORTING A FOLDER OF IMAGES INTO LIGHTROOM

IF YOU BEGIN using Lightroom the moment you start getting into photography, it'd be safe to say you'll primarily be importing images from memory cards. However, most photographers who are getting into Lightroom have already processed quite a few pictures and are focusing on getting those pictures into the Lightroom catalog. Lightroom makes it easy for you to add already existing folders into the catalog, and gives you access to the Metadata and Keywording tools to make what

would normally be a laborious process pretty simple. This is also very helpful for people who have folders of images on a removable drive and want to add those pictures to the Lightroom catalog quickly.

There are two ways to import pictures from your hard drive or a removeable drive into Lightroom. You can drag a folder of images into the Library module of Lightroom, or you can select *File > Import Photos and Video* from the menu bar. Once you do, you'll

see Add as the option in the center column area (**Figure 4.1**). This allows you to register the images in this folder with the Lightroom Catalog. If you need to move a folder from one location to another, you can do so by selecting Move at the top of the screen. I think it's often better to add the images to the catalog than to perform a move. (We'll address consolidating hard drives and finding folders later in this book.)

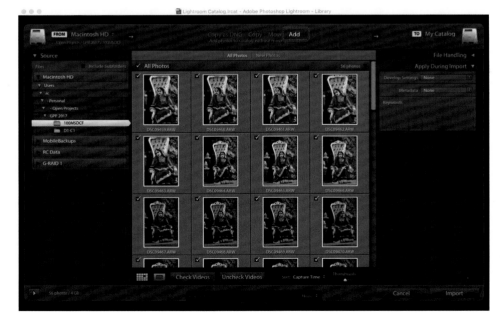

Figure 4.1 Importing an existing folder into Lightroom will bring up the Add window.

The benefit of adding folders to the Catalog here is that you can add keywords and metadata to your images if you have not already done so (**Figure 4.2**).

If you are adding an existing folder that contains subfolders, you can show the contents of the subfolders by clicking on the Include Subfolders button in the center of the screen (**Figure 4.3**). If there are individual image files in the main folder (in addition to the subfolders), you will see the image files in the center of the screen, but you will not see the subfolders. To see the contents of the subfolders in this case, you need to check the Include Subfolders box in the top-left corner of the screen. While this could certainly speed up the import of multiple folders when you are adding them to the catalog, I still prefer to add the folders one by one. This gives me more time to think about keywording and metadata.

Whether you are importing images from a memory card or adding a folder of existing images to the Library, you'll notice a small arrow in the bottom-left corner of the Import window. Clicking on this will make the window smaller, showing you only the most essential options for the current import (**Figure 4.4**). Click on it again, and all of the options will appear.

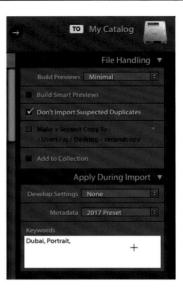

Figure 4.2 Remember that when you add keywords here, you want to use general ones. You can always add more specific keywords later.

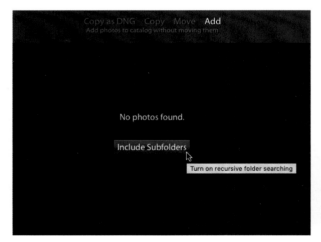

Figure 4.3

Figure 4.4

5. RAW OR DNG—IT'S YOUR CHOICE

AS YOU ARE importing pictures into Lightroom, you will notice that you have two options at the very top of the Import window: Copy as DNG and Copy (**Figure 5.1**).

The DNG file format is an archival format that was designed by Adobe to combat the large number of different RAW camera formats that are out there. Every manufacturer has a different proprietary RAW format, so it requires a bunch of different types of software to read each file type. Adobe's idea was to create one standard format so that all of these files can be read. Camera companies are a little slow to adopt the DNG format, but there is a lot of benefits to it when you use it.

The first benefit that you will immediately see is that the DNG file size is usually smaller than its RAW counterpart. This has a lot to do with the fact that the compression method Adobe uses to convert the RAW file to the DNG format is a little bit better than what you would see with the proprietary format.

Another benefit to the DNG format is that proprietary RAW files usually have an XMP file attached, which means there are two files to worry about. The RAW file is the raw data and the XMP sidecar file is a text file that goes along with the RAW file to monitor the changes you've made to it. By converting to a DNG format, all of that information is stored in a single file.

DNG files also have the ability to use "fast-load data," which is supposed to increase the speed at which you can preview the files, and they support "image tiling," which speeds up the reading of the file. Let me give you an oversimplified version of how this works.

Your computer has a processor and inside that processor are cores—four core processors, five core processors, eight core processors. These cores are almost like worker bees that are attacking a specific problem; each core is a bee.

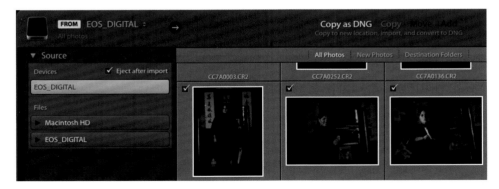

Figure 5.1 You can create a DNG file right from the Import window.

Now, imagine if a RAW file is presented to these cores. A proprietary RAW file will be read by only one core of your computer. So the worker bee attacks the core, while the other worker bees sit and watch. It's a very inefficient way for your computer to attack the information.

If you convert to a DNG format, multiple cores will attack the same file and accomplish the task in a smaller amount of time. So, with the DNG format, you have a smaller file that can be read faster and it's one file instead of two. You can't go wrong with that.

However, the decision is up to you and you don't have to convert to the DNG format during the import process. You can copy your images into Lightroom automatically without converting to a DNG format. Once the images are in the Lightroom Catalog, you can go to the Library module and select *Library > Convert Photos to DNG* from the menu bar (**Figure 5.2**).

Here you can specify what you want to convert, how big you want the preview to be, and whether or not you want to use the fast load data (**Figure 5.3**).

My advice to you would be to convert a couple of files to the DNG format and see if you're okay with the process. If you like what you see and you love the performance and smaller file size of the DNG files (**Figure 5.4**), then chances are the DNG format is in your future.

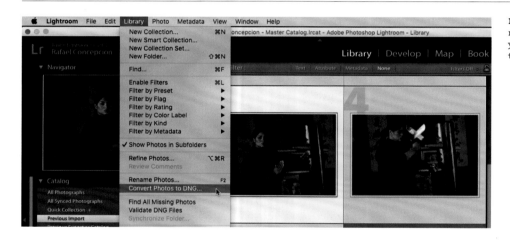

Figure 5.2 In the Library module, you can covert your RAW files to DNG after they've been imported.

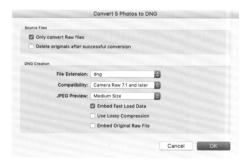

Figure 5.3 Converting RAW files to DNG in the Lightroom Catalog.

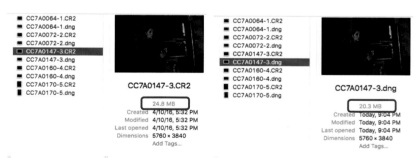

Figure 5.4 A side-by-side comparison showing just how much space you save by using the DNG format. The DNG file is 4.5MB (18%) smaller than the original RAW file.

6. PICK, RANK, AND SORT IMAGES

ONCE YOUR IMAGES are stored in the catalog, there are three different ways for you to classify them. These options make it easier to sort good images from bad ones, let you mark which images you want to work with further, and give you greater options for filtering out unnecessary images. How you use these ranking systems will largely be up to you, but it's good to know how to employ them and how they behave in Lightroom.

There are three options for flagging images in Lightroom: Pick, Reject, and Unflag. You can access these flags by going to *Photo > Set Flag*, as well as with keyboard shortcuts (which I think is a better option). Select one of the images in the Grid mode and press the keyboard shortcut P. This will mark the image you've selected with a Pick flag (**Figure 6.1**). You can see the flag for the image in the upper-left corner of the image thumbnail. If you would like Lightroom to automatically advance to the next image in the series, select *Photo > Auto Advance* to enable this feature.

Figure 6.1 The Pick flag is located in the upper-left corner of the image thumbnail.

To mark an image as Rejected, select *Photo > Set Flag > Rejected*, or press the X key. This will place a black flag with an X on it in the upper-left corner of the image thumbnail.

The last of the flag options—Unflagged—isn't really an option. Press the U key on the keyboard or select *Photo > Set Flag > Unflagged* to make sure there is no flag applied to the image or to remove an existing flag from the image.

Rating Images

Rating your images is pretty simple. Pressing the numbers 1–5 will add one to five stars to any images you have selected (**Figure 6.2**). Should you want to remove any of the star ratings, you can always select the image and press the number 0.

Setting Color Flags

If you move past 1–5 for star ratings, the numbers 6, 7, 8, and 9 on the keyboard will label the selected images with the colors Red, Yellow, Green, and Blue, respectively. There is one color left—purple—that can only be accessed through the *Photo > Set Color* menu (**Figure 6.3**). To remove the color from a picture, just select the picture and press the number for the associated color again.

Putting it All Together

Now that you know how to pick, rate, and label your pictures with colors, let's talk about how to best use these features.

Flagging pictures as rejected or picked is a great option for you to use when you want to sort out bad images from good ones in a shoot. I'll usually spend some time going through the images I have imported and mark any pictures with poor focus, poor composition, or bad exposure as Rejected. Any images that do not suffer from any of these problems will automatically get a Pick flag assigned to them.

Once the Pick flag has been assigned, I can use a number system to separate images from one another. While it may be your first impulse to go through all of your images and give each one a star rating, I don't think that is a good way to sort your stuff.

Let's step back from our photographic work to analyze this. We take pictures to show the very best of what we do, correct?

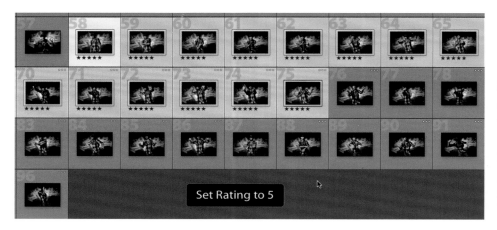

Figure 6.2 Marking a set of images with a five-star rating.

Figure 6.3 I find it so much easier to see images that are labeled with a color. Since there is no keyboard shortcut for Purple, it is the only color I cannot accidentally select by hitting a number key, which makes it a perfect choice for images that are final.

So, theoretically, we would only want to show people our five-star work. If that's the case, can you think of a situation where you would want to show someone your four-star work? Would you ever make a slideshow called "Pictures that were almost good enough to be in my portfolio?"

Think of a three-star shoot. Have you ever found yourself saying, "let's go ahead and showcase all of the images that I think are average." What about two-star shots?

By putting yourself in a position where you need to rank pictures with stars, you needlessly spend time assigning qualities to pictures that you really wouldn't share in the first place—so why do it? Instead, I argue that the star system is useful for flagging images for specific tasks. Five-star shots could be portfolio shots, while four-star shots are images that go into a slideshow. Three-star shots could be images of the groom, while two-star shots are images of the brides family. Assigning stars to specific functions will give you a greater ability to sort your work, and will mean you focus less on an "is this image a two or a three?" type of workflow.

I like to use colors to label files that I am going to work with in Photoshop, files that are ready for printing, and final edits of files. Any Red images in my catalog are images that need to be sent to Photoshop for some work. Green images are ready for printing, and Purple images are final copies that need no additional editing. I like using Purple for final images because it's the only color I cannot accidentally select with a number key. The colors make it very easy to spot images that I want to work on in Grid mode.

Once you have assigned flags, stars, and colors to your images, you can easily sort out which images you would like to see in the Library module with the Library Filter at the top of the window. When you click on the Attribute tab, you can select any of the individual categories to see only the images you need and eliminate those you don't (**Figure 6.4**).

Figure 6.4 You can filter your images based on pick, ratings, or colors in the Attribute tab of the Library Filter bar.

7. ITERATIVE CULLING IN LIGHTROOM

THE SINGLE MOST tedious task when you're importing pictures in Lightroom is separating bad pictures from good ones so that you can come up with a plan for editing them. This process is known as "culling," and it will probably take you the longest out of everything you do in Lightroom. I spend a lot of time talking to people around the world about their use of Lightroom, and this part of the process seems to be the part people struggle with the most. To that end, I want to share with you a technique I use that I borrowed from my days as a teacher. I call it "the iterative edit."

Think back to when you were a student in school taking a test. If the test was timed and consisted of multiple choice questions, the best strategy for completing it was to go through the questions as fast as you could, answering all the questions that you knew were correct. If at any point in time you got to a question that you did not know the answer to, the strategy was to skip the question. In doing so, you could focus your attention on all of the answers that you did know and get those completed first. You could then double back through the test and have more time to work on all of the questions that you didn't answer on the first pass.

Skipping the unknown questions also gives you a better chance at getting them right because you can pick up any context clues for answers from the other questions in the test.

Let's apply this strategy to our photography. If you have a shoot that contains 200 pictures, there is a good probability that a portion of those pictures are either really good or really bad. By bad, I mean things like the image is out of focus, a subject's eyes are closed in a portrait, or you cropped the photo and cut off a head. These are things you immediately know are problems and you would never spend any time working on this image. Conversely, when we're looking for good pictures at this point, we're not trying to pick the very best picture out of the very best series here. We're looking for pictures that are okay—the image is exposed, composed, and includes the whole subject. How you rank those pictures will be something you decide later on.

Go to the beginning of the shoot and double-click on the first picture in the Grid View. I don't want anything to interrupt me from this part of the process, so I turn off all of the panels immediately surrounding the picture (**Figure 7.1**). You can do this by clicking on the arrow in the corner of each panel, or by using the keyboard shortcut Shift-Tab.

Another great way to minimize distractions is to dim the Lightroom interface so that it is not visible. Press the letter L on the keyboard, and you'll see that the Lightroom interface dims by about 80 percent (**Figure 7.2**). Press the letter L again, and the interface darkens completely. This is known as the Lights Out display mode. Don't worry, pressing the letter L again will bring the interface back, and pressing Shift-Tab again will bring back all of the panels for you. The key here is to get rid of all of those distractions so you can focus on flagging images that you know you will never use and marking images that you want to rank later.

Take a look at the first picture in the series and give yourself about half of a second to decide: am I throwing this away or am I keeping it for later? If you're throwing it away, press the letter X to mark it as Rejected (**Figure 7.3**), and you will automatically advance to the next picture. If you're keeping it, press the letter P to mark it as a Pick, and you will move along to the next picture. If Lightroom does not advance you to the next picture, go to the Photo menu and select Auto Advance (**Figure 7.4**).

Invariably, you're going to get to a spot where it's difficult to make a quick decision as to whether or not you need to keep a specific picture. If you hesitate for more than just one second, I would suggest you skip the picture by pressing the letter U or moving to the right with your right arrow. These are the test questions that we do not know the answer to, so move on.

Figure 7.1 Press Shift-Tab to get rid of the panels in Lightroom.

Figure 7.2 Turn down the lights with the Lights Out display mode in Lightroom (keyboard shortcut L).

Figure 7.3 Press the X on your keyboard to mark an image as Rejected and advance to the next image in the shoot.

Figure 7.4 Turning on Auto Advance in Lightroom.

Continue to work through the series of pictures until you get to the end of the shoot. At the end of this process, you will have three sets of pictures: pictures you know you need to delete immediately, pictures you need to rate, and pictures you need to go back to (**Figure 7.5**).

In Grid View mode, you can use the Library Filter at the top of the window to filter out the picked and rejected images, so that you see only the unflagged pictures (**Figure 7.6**).

Now you can start the process again, using X, P, U, or the arrows to run through this second series of pictures. You'll find that you get through these pictures a lot faster than the original take because you will have the benefit of having seen all of the pictures that come before and after these questionable shots. Whereas during the first pass, you may have been unsure about whether you wanted to keep a picture or delete it, you can now make a more confident decision because you know whether there is another picture that is better. This can make you more willing to delete a picture.

In order for this to work, I cannot emphasize enough the importance of not doing anything else. If you stop to see whether or not a picture would look a little bit better with some exposure, you've broken the workflow. It does require a certain level of discipline to get through this part of the process. But I can guarantee you that if you stick with this, it will make things a lot easier for you later on.

Once you've filtered out all of the pictures you don't want to work on, you can then go back to the picked images and create some sort of order by which you would want to edit your shots. You can use star ratings to flag the best images of the series. In my case, I tag all of the pictures that I'm going to submit to a client with five stars (**Figure 7.7**).

After I've gone through all of the picked images and given them star ratings, I use the Library Filter to display only the five-star shots, and then I decide which of those pictures needs some editing in Photoshop. Those pictures usually get a red flag (**Figure 7.8**).

At the end of this process, I have a clear idea of which pictures I'm going to keep, which ones I'm going to edit in Lightroom, which ones I'm going to need to bring into Photoshop, and a good consolidated series of pictures that don't have any garbage attached to them.

We can definitely work a lot clearer like this.

Figure 7.5 This is what your folder will look like in Grid View after you've completed your first pass culling the pictures.

Figure 7.6 The Library Filter allows you to filter out specific pictures. I've filtered out the picked and rejected images, so only the unflagged images are visible. Above the filmstrip you can see how many images there are in each category (45 out of 197 images are unflagged).

Figure 7.7 Once the take has been pared down further, I'll add star ratings and colors based on my workflow.

Figure 7.8 Filtering the images by five-star shots that are also labeled with a red flag.

8. VIEWING AND COMPARING IMAGES

COMPARING IMAGES IS another thing that I think trips people up when they're trying to select the best picture. You have a filmstrip of images in front of you and you want to compare two of them. You select one picture and stare at it, then hit the right arrow to look at the second picture, stare at that, and then hit the left arrow to go back to the original picture and stare at that again.

You basically treated yourself to an eye exam using your own photography. This is probably good for one picture, but you don't want to do this as you sort through hundreds of pictures. It's just going to get a little frustrating, so it's a good idea for you to learn how to view and compare multiple pictures to make the best selection.

If you you're trying to decide between two pictures, single-click on the first picture and then Command-click (Mac) or Ctrl-click (PC) on the second picture to select them both. Once the two pictures are selected, press the letter C on your keyboard to enter the Compare View (**Figure 8.1**). You can also click on the XY icon in the toolbar at the bottom of the screen, or select *View > Compare*.

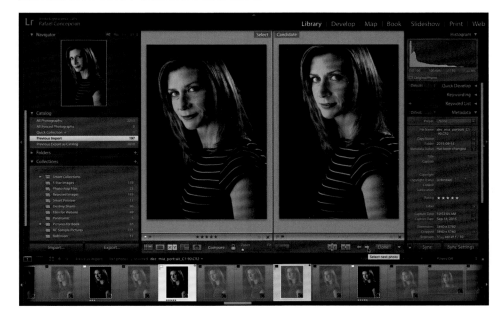

Figure 8.1 In this shoot of my friend Mia, I want to compare other images in the take with the one I think is the winning shot of the series.

On the left you will see the selected picture (marked Select) and on the right you will see the Candidate—the one you're trying to compare to the selected picture. You can zoom in and out of the pictures and make some critical judgments (**Figure 8.2**). The key here is to find a way to compare a picture you know you want to keep against all of the other photographs in your shoot. You're basically looking for another shot that will "dethrone" the selected image.

If you find a picture that is better than the picture you originally selected, press the letter P, and you will promote that picture so that it becomes the main picture for comparison. Additionally, you have the option of swapping the selected picture and the candidate by clicking on the Swap icon (XY icon with two arrows pointing opposite directions) in the toolbar at the bottom of the window.

You can use your left and right arrow keys, as well as the arrows in the toolbar at the bottom of the compare window, to move the previous or next image in the series into the Candidate position and continue the compare process (**Figure 8.3**). You even have options at the bottom of each individual image to set flags and star ratings, getting you closer to paring this shoot down even further. Once you're done, you can get back to the winning picture by pressing the letter C key.

One last thing to keep in mind is that Lightroom presumes you are trying to make a comparison between two pictures. If you do not have a second picture loaded, the picture that is selected in Lightroom will become the Selected picture. At that point, you'll need to select another image in the series that will automatically be set as the Candidate for the compare process.

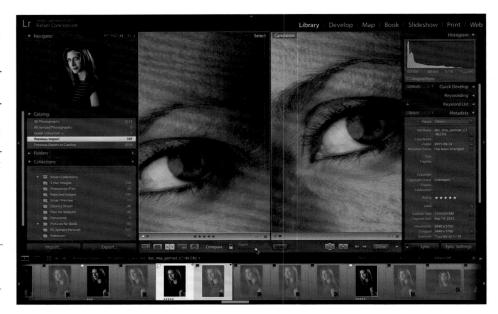

Figure 8.2 Getting in close to check the sharpness of the two pictures.

Figure 8.3 Checking other images in the series to see if there are any better ones.

9. MAKING COLLECTIONS IN LIGHTROOM

AS YOUR LIGHTROOM library gets bigger and bigger, you're going to need to organize key images in your catalog in one spot so you can access them quickly and easily. Without Lightroom, photographers who want to share a group of images—let's say a portfolio of specific work—often rely on placing copies of those pictures into a folder to share. As different needs arise, the photographer creates other folders with copies of those pictures in them. Each folder has a specific purpose—portfolio shots, images of a vacation, the best vacation pictures across multiple years—and each folder contains copies of pictures that live in other folders as well.

Using folders to group images for specific purposes causes two problems. First, you could end up with copies of the same image saved in multiple folders, filling up hard drive space with redundant work (**Figure 9.1**). Second, if you want to make a change to one of the images, you would have to remember that you have copies of that image in other folders, remember where the image is stored, and make the change to each copy of the image. Folders are a great way to store information, but they're not so great when you want to see all of your images in one spot.

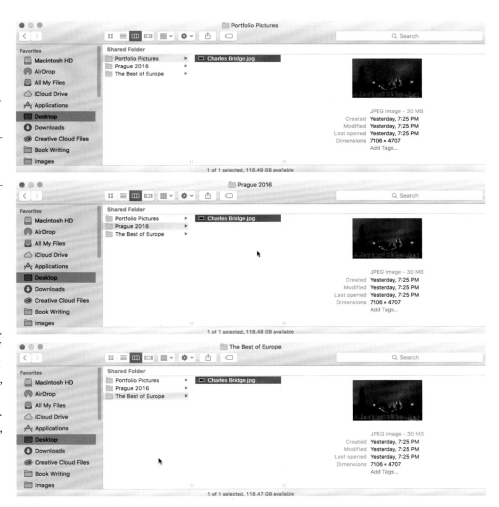

Figure 9.1 Three different folders, all of which contain the exact same file. That's over twice as many pictures as you need!

This is where Lightroom collections can be a great solution. In the Library module, you have a panel called Collections. Clicking on the plus sign in this area lets you create a collection and give it a specific name (**Figure 9.2**). From there, you can add images from your entire catalog, no matter what folder they live in. You can create as many collections as you need to organize your images, and simply add the images from the existing catalog to the list by dragging them in. If you are familiar with buying online music in places like iTunes, think of collections as Playlists for your pictures. You have one picture saved on your computer, but that picture can be referenced in a variety of different collections.

There's a couple of immediate benefits to doing this. For example, imagine I have a library of images that contains three vacation shoots—one in Italy, one in France, and one in Prague. I could create a collection in Lightroom called "Prague Pictures" and store only the selected pictures from the folder I imported with the Prague shots (**Figure 9.3**). I am not forced to bring in every picture—good and bad—from the trip. This way, I have a better curated album of images to go through and I don't have to deal with the clutter of rejected images.

When I create collections called "France Pictures" and "Germany Pictures," I can further curate my experience by not including pictures from other countries. This makes it easier to get to the shots I want quickly.

Finally, let's say I create three additional collections: "Sunsets of Europe," "Great Moments in Vacations," and "Cool Buildings Overseas" (**Figure 9.4**). The pictures in each collection are not specific to any trip per se, but I can drag images from all three trips and place them in one spot—a virtual scrapbook, so to speak.

Now, I could conceivably have a picture in three (or more) different collections at the same time. For example, I could have a picture of Prague in "Prague Pictures," "Sunsets of Europe," and "Great Moments in Vacations" (**Figure 9.5**). Because collections contain virtual references to single image files, it doesn't really matter how many collections I have created with this file; the references will all be linked to just one image file, saving a ton of space on my computer. And what's even more valuable is that if I go into one of the collections and make a change to an image, all of the references in the other collections will get that change automatically.

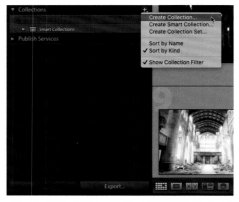

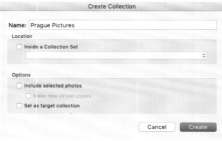

Figure 9.2 Creating a collection in the Collections panel and giving it a name.

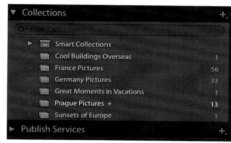

Figure 9.3 No one wants to sit through 1,000 pictures, no matter how cool they are.

Figure 9.4 Six different collections that contain images from three vacation shoots.

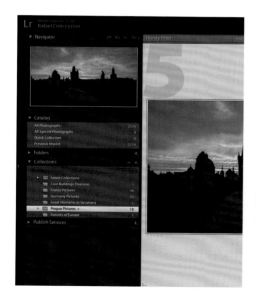

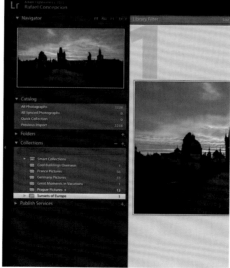

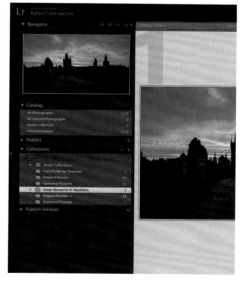

Figure 9.5 This image appears in three collections, but the references are all linked to one file. When I make a change in one collection, all of the other collections change as well. Sweet!

10. MAKING COLLECTION SETS IN LIGHTROOM

THE USE OF collections will certainly speed up the process of finding the best picture inside Lightroom, but as you start creating more and more collections, you're going to start running into problems with finding the collection you need.

The more collections you create, the longer the list in the Collections panel will grow, and you'll spend more and more time scrolling up and down trying to find the collection you want.

You can take this organization one step further by giving it more of a hierarchical look, so that you can isolate specific collections you want to work with at any given point in time. You can do this through the use of the collection set. This will make more sense if we put it into a practical example.

In **Figure 10.1**, notice that I have a series of collections of my daughter, Sabine. I also have a series of collections of my wife, Jennifer. You can imagine that I'm going to make pictures of both of them repeatedly, so every time I create a collection with the word "Sabine" or the word "Jenn," it's just going to aggregate into this list, making the list really long so that I have to scroll up and down to find the specific collection I want to work with.

However, when you take a look at the collections with the word "Sabine" in them, all of them happen to have something in common—my daughter, Sabine. So, I could create a collection set called "Sabine Images." This collection set would serve as an organizational block into which I can throw all of the Sabine collections.

To create a new collection set, click on the plus sign in the Collections panel and select Create Collection Set (**Figure 10.2**). Enter a name for your collection set and click Create. Now you can shift-click on collections and drag them into the new collection set (**Figure 10.3**).

Now if I want to see some of the Sabine collections, I can twirl down the Sabine collection set, and all of the associated collections are inside of it.

Moving forward with my example, I can do the same thing with all of the collections that have the word "Jenn" in them. I can create a collection set called "Jenn Images," and place all of the Jenn collections inside of the Jenn collection set (**Figure 10.4**). This cleans up my collections area drastically.

However, I can take this organization even further. The collection set offers a hierarchical organization of not only collections, but collection sets as well. Consider the example of Sabine and Jenn. What do these two things have in common? They both happen to be my family. So, I can create a collection set called "Family Pictures" and place the Sabine collection set and the Jenn collection set into the family collection set (**Figure 10.5**).

I can create a separate collection set for work images, and then place collections for any work-related projects inside of them. Now my collections in Lightroom are managed a lot better. If I want to see anything that's work-related, I can twirl down the work collection set and see the associated collections there. If I need to see something that's family-related, I can twirl down the family collection set and see all of the collections that are related to me on a personal level.

You can get very specific with how you use these collection sets in your workflow, but this is a good start to help you set up some basic organization for your images.

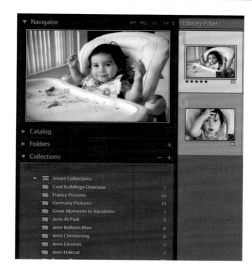

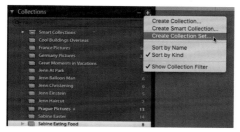

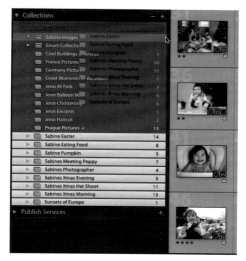

Figure 10.1 As my daughter, Sabine, grows, all of these collections could really get out of hand.

Figure 10.2 Creating the Sabine Collection Set.

Figure 10.3 Shift-click the collections and drag them into the appropriate collection set.

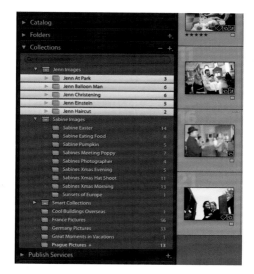

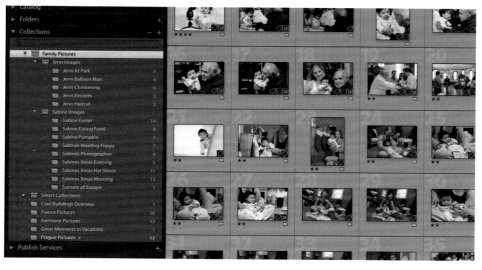

Figure 10.4 The Sabine and Jenn collections all organized into collection sets.

Figure 10.5 All of my family pictures are organized in a Family Pictures collection set.

11. CASCADING EDITS AND VIRTUAL COPIES

ONE OF THE most powerful features of Lightroom is its ability to create multiple references to one single image file. You can use this to your benefit by storing the same image in multiple collections, as well as by creating different versions of pictures to use.

There are times when you are going to want to change a picture once and have that change reflected in all of the references to that image, and there are times when you are going to want to create multiple variations of one file. Knowing when to create the differences and how to create the differences will help you greatly.

When you import an image into a catalog, Lightroom makes a reference to the original file that is stored on your computer. As you create collections, you are placing references to the original image files in each collection. It doesn't matter how many collections or references you have, each reference points back to that one individual file. If you go back and make a change to an image inside of a collection, all of the collections that contain a reference to that image will automatically be changed.

But what if you want to create a different version of an individual file, or a give it a different color treatment in one of your collections, but not in the others? This is where a virtual copy can be very helpful.

Let's take a step back and talk about how Lightroom makes changes to images. Lightroom treats the raw image and the changes that are made to the raw image as completely separate. After you import an image, all of the changes that you make to the image are stored in the database and are never really applied to the raw file itself. Because of that, it's a lot faster to process images, and you also have the ability to create multiple references for one individual file. Because all of the changes are text space, you can just add other variations as changes to those text files.

This is actually very powerful because it doesn't commit any of the development changes until you print or export the images. What's even better is that you can create a virtual copy of an image and apply a different set of corrections to that copy, and both the image inside of a collection and its virtual copy still reference one original image.

Go into any one of your collections and select one image. Right-click on the image thumbnail and select Create Virtual Copy from the list (**Figure 11.1**). You'll see a new image that looks exactly the same as the original image appear right next to it. The only difference is that the new image will have an icon in the lower-left corner of the thumbnail that looks like the corner of the image has

been folded up, letting you know that this is a virtual copy (**Figure 11.2**).

When you create development changes, the virtual copy contains its own development changes, and the original image in the collection contains a separate amount of exposure controls (**Figure 11.3**). This is a godsend in post-production because you can quickly create virtual copies and try out different development techniques without increasing the overall size of the image inside your library.

If you don't want to keep a virtual copy, single-click on it and hit the delete key on your keyboard, and it will be removed from the Lightroom catalog.

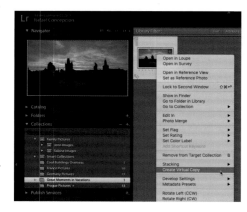

Figure 11.1 Creating a virtual copy in Lightroom.

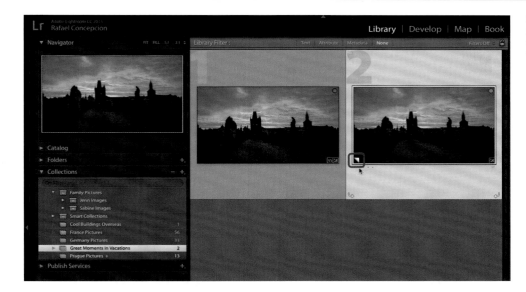

Figure 11.2 Virtual copies can be identified by the folded-corner icon in the lower-left corner of the image thumbnail.

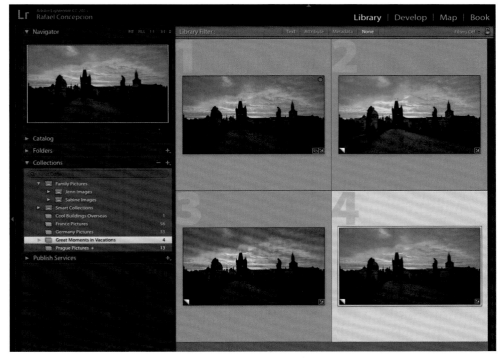

Figure 11.3 Virtual copies give you a great amount of creative options for your pictures.

12. ADDING KEYWORDS TO YOUR IMAGES

ADDING KEYWORDS TO your images is one of the most tedious parts of the organizational process in Lightroom. More often than not, photographers refuse to add keywords during the start of the process, and then the job becomes exponentially harder as you try to create some sort of order later on.

The truth is, adding keywords to images is a fairly easy process as long as you incorporate generic keyword usage during the import stage, and then go back in and selectively add keywords to the images once they are inside the library. You can use tools like the Painter tool and keyword sets to make the process of adding keywords to your images a little bit more tolerable.

During the import process, you'll see that you have a Keywording panel in the right-hand column. In this area, I suggest adding keywords that generically explain the shoot. Don't get too caught up in the individual details of the pictures; the point here is to add some keywords that describe the overall shoot at the point of import. This way, if you forget to add keywords later on in the process, you at least have some keywords already attached to the pictures.

Once you've imported your images, the keywords you added during import will appear in the Keywording panel in the Library module (**Figure 12.1**). Single-click on one of the images, and you will see the keywords appear in the text field. At this point, you can single-click on an image, or shift-click a series of images, and go into the keyword field and add any additional keywords you want to use.

Lightroom keeps a list of frequently used keywords directly under the text field, and

Figure 12.1 Add some generic keywords to your images during the import process, just in case you don't do it later. You can always get more specific later on.

you can add them to the selected images by simply clicking on them (**Figure 12.2**). This takes some of the sting out of adding keywords.

As you start working with different genres of photography, you'll notice that various photography topics have keywords in common. This is a great way for you to use keyword sets in Lightroom. By default, Lightroom has a series of preset keyword sets that you can select from. Select an option from the Keyword Set drop-down menu in the Keywording panel, and you will see all of the related keywords for that set (**Figure 12.3**). For example, selecting a keyword set for weddings will give you keywords like "Bride," "Wedding Party," "Pre-Ceremony," and "Groom." You can add these keywords by selecting an image or multiple images and single-clicking on the keywords you want to use.

If you want to create your own keyword set, you can click on the Keyword Set drop-down menu and select Edit Set from the list (**Figure 12.4**). This will allow you to add a series of up to nine keywords to an individual set (**Figure 12.5**). Once you've input the keywords, click on the Preset drop-down menu at the top of the dialog, select Save Current Settings as New Preset, and give the new preset a name (**Figure 12.6**). This new preset will now be available in the Keyword Set drop-down menu.

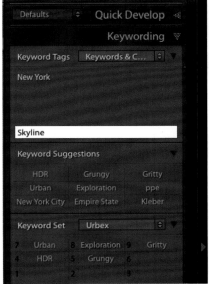

Figure 12.2 This list of keywords will be different depending on what keywords you enter in the text field.

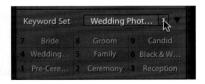

Figure 12.3 Select a preset from the Keyword Set drop-down menu to see keywords related to that topic.

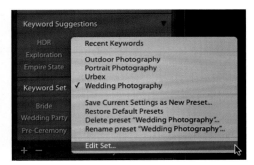

Figure 12.4 Select Edit Set to create your own keyword set.

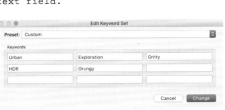

Figure 12.5 You can add up to nine keywords to a keyword set.

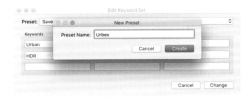

Figure 12.6 Give your new keyword set a name so you can find it again later.

There is an even easier way for you to apply keywords. In the toolbar at the bottom of the Library module, you'll see a little spray can (**Figure 12.7**). This is the Lightroom Painter tool, and it allows you to "paint" different types of data onto individual pictures. You can use it to apply keywords, labels, flags, ratings, develop settings, and more, but in this instance, we want to focus on keywords.

Click on the Painter tool, and you'll see that your cursor turns into a spray can. To the right of the Painter tool icon, select Keywords from the Paint drop-down menu. To the right of the menu, you will see a field where you can type in a series of keywords that you can paint onto your pictures.

If you hover your cursor over the eye-dropper and press the Shift key, you'll notice that you can access keyword sets from this window (**Figure 12.8**). When you select a keyword set from the drop-down menu, you will see all of the associated keywords for that keyword set in the list below it. You can then select individual keywords that you want to add to the Painter tool.

Once you've added all the keywords you want to use to the field next to the Painter tool, you can scroll through your images and apply the keywords by clicking on a picture, or clicking and dragging across a series of pictures in the list. If you've done this correctly, when you click on an image, you should see a message that says Assigned Keywords, followed by the keywords you added to the Painter tool (**Figure 12.9**).

If you want to remove the keywords from an image, Option-click (Mac) or Alt-click (PC) on the picture with the Painter tool, and the keywords that you've applied to the image will be removed.

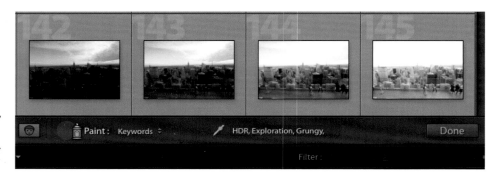

Figure 12.7 The Painter tool is a great tool to use for keywording.

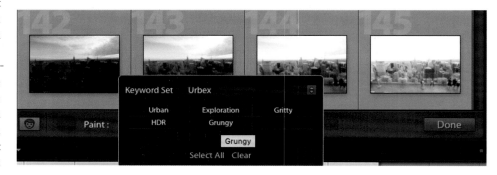

Figure 12.8 Hold down this Shift key as you hover your cursor over the eye-dropper, and you'll have access to keyword sets.

Figure 12.9 Assigning keywords in the Library module with the Painter tool.

13. ADDING TITLES AND CAPTIONS TO YOUR IMAGES

NOW THAT YOU have your images organized, let's spend some time making sure that you have titles and captions for the images you're going to publish online.

Take a look at the Metadata panel in the Library module. In this panel, you will see two fields that I think are pretty important: Title and Caption (**Figure 13.1**). Instead of putting the title for your picture in the filename, I recommend that you add a title to the picture in the metadata. It is also a good idea for you to add a short description of the picture.

Figure 13.1 Adding a title and caption to the metadata for an image in the Library module could not be easier.

There are two obvious benefits to this. The first is that the information you place in these two fields will automatically be attached to the image file. When you export this picture and publish it online, most services will read the EXIF data or metadata information attached to the picture. This will automatically prefill the informational fields on websites like Flickr with the image's title, caption, and keyword information (**Figure 13.2**).

Is this information easy to fill in manually on a website? Sure. But do you want to do this every single time you upload a picture to a site; or would you rather just enter this information once and have that information be read every time you export it? Taking care of it in the beginning is always a better option.

The other part that I think is essential here is that this information is something you can add to things you create in Lightroom later on, like slideshows and books. If you are creating a book, you want to pull that information into the creation of the book, rather than having to do it on a page-by-page basis. If it's already entered from the start, all you have to do is set a field to read the title and caption information and you're good to go. We'll talk a little bit more about this when we create a book and a slideshow of pictures.

The key here is to get it done early, and you won't have to do it again.

Figure 13.2 This is what your caption looks like when you upload a picture online.

14. SYNCING YOUR COLLECTION ONLINE

AS YOU START adding images to your photographic catalog, you're going to want to share those pictures online with other people, as well as have those pictures ready for you to look at or edit while you're on the go. Thankfully, Lightroom has created Lightroom Mobile to give you access to the information you have on your desktop anywhere you go.

During the creation of a collection, you'll notice a checkbox at the very bottom of the dialog box that says Sync with Lightroom mobile (**Figure 14.1**). If you click on this, the contents of the collection will be placed online.

Don't worry, if you have not done this for every collection you've made, you can always click on the thunderbolt icon to the left of a collection name to get it to sync online.

At the very top of the Grid View, you'll notice there is a URL that is created for the contents of the collection (**Figure 14.2**). This URL can be public or private, depending on what you choose.

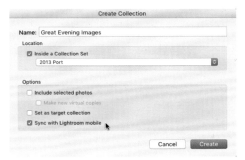

Figure 14.1 Clicking on this little checkbox is the only thing you need to do to get your images online.

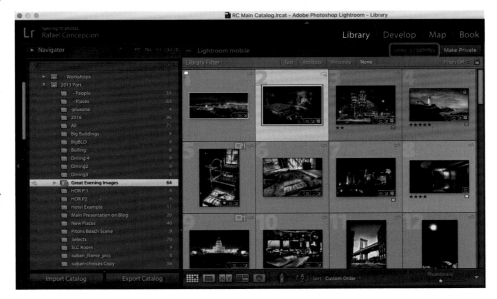

Figure 14.2 The URL that Adobe gives you is a short URL—perfect for using on social media.

When you send this URL to people, you have the option to collect feedback from them on the images in the collection. That feedback will automatically come back into the Lightroom collection, and you can see it as likes or additional comments in the Comments panel on the right side of the screen (**Figure 14.3**).

But let's take this a step further. If you have Lightroom Mobile for your mobile device or tablet, the collections you've synced online will automatically be available to you on those devices. You will have the option to flag, rank, sort, pick, and perform any kind of develop changes to copies of these images right on your mobile device. The moment you come back to your desktop version of Lightroom and sync it with your mobile device, all of the changes you made on your mobile device will transfer to the desktop version. So you can edit on the go without a problem.

I'll give you an extra tip that I think is even cooler: if you go to lightroom.adobe.com and sign in with your Creative Cloud ID, you will have access to these collections right from a browser. This is just another way that Adobe is marching toward getting you access to all of the images you need wherever you go.

You can make any organizational or development changes, and again, when you connect with your mobile device or desktop program, all of those changes will be automatically synced to all of your devices.

Adobe has created a really cool ecosystem with Creative Cloud. You must have a Creative Cloud ID and be part of a subscription plan in order for all of this to work.

This is one of the reasons I'm really excited about telling people about the Creative Cloud Photography Plan. You can get all of these things, plus Photoshop, for something like $10 a month, which I think is an incredible bargain considering the amount of features that allow you to take your images wherever you go.

With this feature, you can quickly create a portfolio of your images and share it online without any other third-party software; Lightroom has you covered (**Figure 14.4**).

Figure 14.3 You can see feedback from people with whom you shared your collection in the Comments panel.

Figure 14.4 Your portfolio is now online in no time, thanks to synced collections.

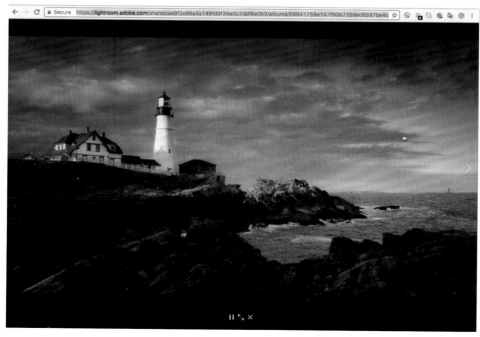

2

DEVELOPING
YOUR IMAGE

CHAPTER 2

If I had to give you one piece of advice in regard to your photography, it's this: processing is as important as the capture of the image itself. You can shoot a wonderfully composed image with good detail, but it's your job to process the image to get the most detail out of it.

Lightroom's Develop module is deceptively simple. With just a few sliders, you can create some amazing work, provided you understand how each slider works. I want to give you a top-down strategy for how to use the individual sliders in as simple of terms as possible. You can definitely dive deeper if you want, but having an uncomplicated, proven strategy right out of the gate will enable you to make some amazing pictures quickly.

Lightroom's Develop module will work on both RAW and JPG images, but you will definitely see better gains when you use a RAW file. With a JPG, most of the contrast, color, and sharpness has already been prebaked into the file, so any kind of overexposure or underexposure that you apply will be limited.

This does not mean a JPG file is inferior to a RAW file, though. If you're happy with the quality of the contrast, tone, and sharpness that you're getting out of the camera, then congratulations, a lot of your work is done. However, it's still a good idea to go back and do a little clean up on those images. Let's get started.

15. ADJUSTING WHITE BALANCE

WHEN YOU SHOOT RAW images, the camera collects all of the information about the picture and lets you make changes to the picture later on in post-processing. One of the first things you'll do is adjust the white balance. White balance is the combination of temperature and tint in a picture.

Temperature can be measured in a range from low (cooler, or blue) to high (more of a yellowish tone). The tint allows you to change the color of the picture, from green to a magenta color. Your DSLR has a set of white balance options that automatically set the temperature intent for the scene you are shooting. While it is always advantageous for you to make this white balance decision in-camera, shooting in a RAW format allows you to make changes to the white balance at a later date in Lightroom.

Select one of the images you want to work with and head to the Develop module by clicking on the Develop tab at the top of the panel, or by pressing the keyboard shortcut D. You'll see the white balance (WB) in the Basic panel at the top right of the module. You can click on the WB drop-down menu to select from a series of white balance presets that will change the temperature and tint of the image automatically for you (**Figure 15.1**).

If you selected an incorrect white balance in-camera, simply select the preset for the white balance that you intended to use, and the image will be automatically adjusted. You can also select Auto, and Lightroom will take care of the temperature and tint for you.

It's important to note that you don't have to use the white balance preset options in the drop-down list. More often than not, your selection of temperature and tint is the first place where you can exercise some creative control in making a picture. For example, in many of my blue-hour cityscape shots, I tend to ride the temperature slider a little cooler (to the left) and add a little bit more magenta to create a surreal look (**Figure 15.2**). Automatic settings are great, but it's your individual touch that's going to make your picture stand out.

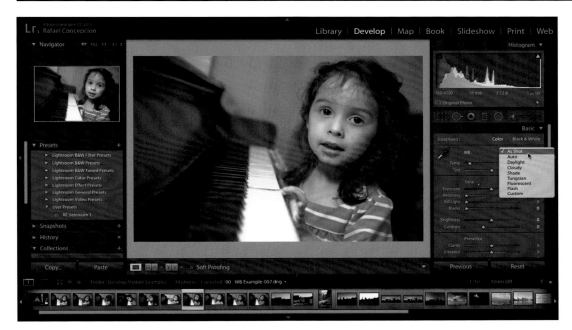

Figure 15.1 Try as it might, sometimes the DSLR does not make the best white balance choices.

Figure 15.2 A picture of the Burj Khalifa at sunset. The only settings I changed for this shot were the Temperature and Tint.

To the left of the WB drop-down menu, you'll see an eyedropper. This eyedropper allows you to select an area of the picture to use as the basis for a white balance adjustment. If you're not sure of the correct white balance for your picture, scan the image and see if you can find an area of gray. Clicking on the gray portion of the image with the eyedropper will yield a great white balance result.

Oftentimes if I want to make sure I have the right white balance for a picture, I will photograph a gray card at the start of my shoot to make sure I have an image with a neutral gray color (**Figure 15.3**). Then I can use the eyedropper in Lightroom to click right on the target and I'm good to go.

There will be plenty of times when you're not carrying around a gray card. In these instances, you'll be left scrounging around the image looking for a gray portion you can use. If you can't find one, try using the eyedropper to select an area that you believe may have a neutral tone (**Figure 15.4**). This will at least get the Temperature and Tint settings

in the right ballpark, and you can finish the adjustments yourself.

Using Lightroom's Camera Profiles

The Develop module in Lightroom allows you to work in a "top-down" format that usually makes sense. However, there is one area that I like to check before I make any initial adjustments to the picture—the Camera Calibration panel.

Have you ever taken a shot with your DSLR, looked at the picture on the camera screen, and thought it looked great? Have you then looked at it later on your computer, only to see that the great picture that was in your camera has all but disappeared, leaving you with a picture that looks extremely plain?

When you make a picture in a JPG format, your camera applies color, contrast, and sharpening adjustments to the image based on the settings you choose. When you shoot in a RAW format, the camera presumes that you'll make these changes later on in post-processing. However, if you look at pictures on the back of your camera when you

take them, you're staring at an image that will look quite different from the RAW file you'll work on later.

The reason you see this discrepancy has to do with the fact that the camera exposes a picture using its built-in JPG settings, and shows you that JPG on its screen. This JPG is also embedded in the RAW file as a thumbnail for import into Lightroom. When Lightroom imports the image and starts building its own previews, it takes the JPG the camera created and replaces it with a JPG that *it* creates, often with very "blah" results.

The good news is that you don't have to accept these results, and this is where the Camera Calibration panel can be quite useful. In this panel there are two drop-down menus: Process and Profile (**Figure 15.5**). If you click on the Profile drop-down, you'll see a series of camera profiles that are similar to the ones you would have selected in your DSLR. Cycle through the previews to find a color and contrast treatment that brings the thumbnail closer to what you saw on the back of your camera, and you're done!

Figure 15.3 Sometimes a simple collapsible gray card can take care of a lot of the white balance problems you have on a shoot.

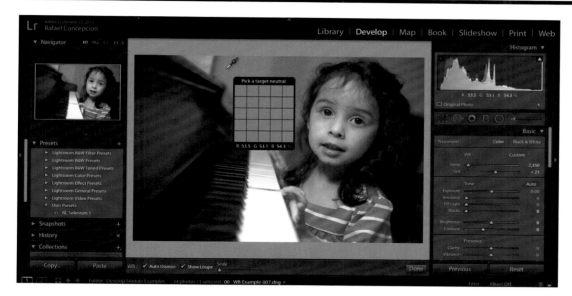

Figure 15.4 I believe the back wall in this picture was whitish. Clicking on it with the eyedropper got me pretty close to the white balance I was looking for.

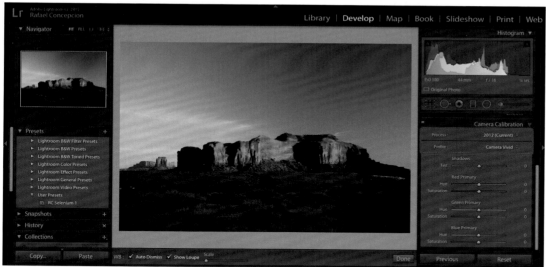

Figure 15.5 The Camera Profile settings are specific to the camera you used. If the image was shot with a Canon, you will only see Canon Profiles; if it was shot with a Nikon, you will only see Nikon Profiles; and so on.

THE FIRST FOUR sliders in the Tone section of the Basic panel can take care of an extremely large amount of processing in your pictures. If I look back at the last 50 shoots I've done, I can saypretty confidently that I've been able to edit my pictures completely with these four sliders about 80 percent of the time. And the even better news is that they're pretty straightforward to understand and easy to use.

Exposure and Contrast— The Bottle of Water

When you make a picture, you are, in essence, making a recording of the scene in front of you. Your camera registers your scene in a file that contains a range of pixels from extremely dark all the way to extremely bright. When you bring the image into Lightroom, the program tries to give you an accurate readout of what you captured. To do this, it creates a histogram.

In extremely simplified terms, a histogram is a glorified bar chart. The chart records information from the darkest of tones to the brightest of tones. The only problem here is that there are so many tones (about 255 of them) in such a small space that the bars are literally rubbing up against one another. The histogram shows the entire tonal range of your picture.

I like to picture the histogram like a half-full bottle of water. For the most part, you want to try to make sure some water is touching the entire bottom of the bottle. One of the ways you can do that is by tipping the bottle one way or another—that's exposure.

The Exposure slider in Lightroom controls how bright an image is (**Figures 16.2** and **16.3**). Dragging it to the right makes the image brighter, and dragging it to the left makes it darker. Tilt the bottle to one side, and the water slides in one direction. Tilt it to the other side, and the water goes in the other direction. Adjusting the exposure is your first option.

Contrast, by contrast (I know, very punny), works by increasing the distance between the shadow and highlight areas in a picture. So by making the shadows darker and the highlights brighter, you increase the contrast of the image (**Figures 16.4** and **16.5**). It's the equivalent of going into the center of the bottle of water and parting it a little. It's a split.

Figure 16.1 An imaginary Excel file showing the tonal data of a picture. It would be completely accurate if cameras had Microsoft Excel installed, which they don't.

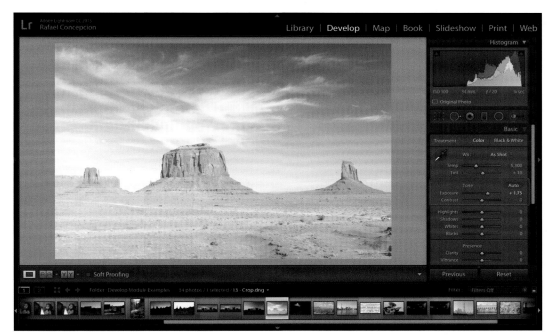

Figures 16.2–16.3 Exposure makes things brighter and darker, but that is just part of the picture. #PunsRule

Figures 16.4–16.5 Before and after, with contrast parting the water. I'll forgo the abundantly plain religious reference I could have made here and just go with "split the water, just like Moana." #SpoilerAlert

Rather than overburdening myself on the technical side of things, I like looking at the pictures I want to work with in this manner—tip or split (**Figure 16.6**). When I first start making a change to a picture, I'm just trying to get enough of the tonal data in the correct range and make sure that no parts of the water bottle are completely empty. Simplifying this process helps because sometimes you stare at a picture and you're not quite sure *what's* wrong with it. You know that it doesn't look good, but you don't really know where to begin. Now you have a basic question you can ask yourself when you look at the histogram: tip or split?

Shadows and Highlights

There are times when the picture you're working on has a problem in just one specific region. For example, you've taken a picture of a sunset and you notice that some ground elements are too dark to see. Or you'll attempt to take a picture and some of the elements in the picture are too bright, showing up as flashing highlights in your DSLR.

These kinds of problems are usually caused by the limitations of your DSLR's sensor compared to what you can see. The human eye is capable of seeing both the sunset and the ground in perfect exposure; it has a higher dynamic range of sensitivity. Camera sensors have not been able to reproduce this to date, but they are slowly catching up.

Thankfully, the Shadows and Highlights sliders in Lightroom can help us get some of this detail back. If an image is too dark in the shadow area, drag the Shadows slider to the right to make the image brighter (**Figures 16.7** and **16.8**). If the image suffers from a blown out highlight, drag the Highlights slider over to the left to make the highlight area darker.

The question here is, just how far do you drag the sliders? At the very top of the Histogram you'll see two arrows. The arrow on the left side is for the shadow clipping. If

you click on this to turn it on (or hover over it for a temporary look), the areas of the image that are too dark to show information will have a blue overlay (**Figure 16.9**). If you click on (or hover over) the arrow on the right, you'll see the highlight clipped areas with a red overlay (**Figure 16.10**). In these areas that are too dark and too bright, there is no data to show any visual information. This is a bad thing. Your goal is to adjust the Highlights and Shadows sliders so that these warnings go away. Once they do, you can play around with them to taste.

There are two things to keep in mind here:
- If you drag the sliders to their extreme limits, you'll produce a very unnatural effect. Be sparing with how you use them.
- If regions of your picture have been extremely underexposed, brightening the shadow areas will introduce a bit of noise to the picture. You may need to dial in more noise reduction later on.

Figure 16.6 If you were staring at this picture and its histogram, would you choose to tip or split?

Figures 16.7-16.8 The most powerful part about the Shadows slider isn't what it does to the shadows; it's how it leaves the rest of the image alone.

Figure 16.9 The shadow clipping overlay in Lightroom is blue.

Figure 16.10 The highlight clipping overlay is red. You definitely want to avoid seeing the shadow or highlight clipping overlays.

17. MANAGING BLACKS AND WHITES IN AN IMAGE

NOW THAT YOU'VE adjusted exposure, contrast, highlights, and shadows, let's move into the whites and blacks. This is somewhat controversial because a lot of individuals like to set their whites and blacks first. But, with how well the four sliders at the very top work, I find that I use the Whites and Blacks sliders less and less. More often than not, I like using these sliders when I see that I have enough water across the bottle in the tonal range, but just need to do some slight tweaking to the file.

In **Figure 17.1**, you'll notice that there's a pretty good amount of range, but if you look at the histogram (**Figure 17.2**), you can see that the image could use a little bit more information on the blacks and whites sides. By dragging the sliders over, we can solve that problem pretty quickly.

Think of the whites and blacks as the brightest and darkest portions of the picture. You want to find the point that's completely white and the point that's completely black, but it's really hard to see this in the picture. To achieve this, I recommend you hold down the Option (Mac) or Alt (PC) key and drag the white slider to the right. At first, the image will turn completely dark, and then as you drag the Whites slider to the right, you'll see some areas of the picture change. You're looking for the first area that turns white, which is the portion of the picture that could clip (**Figure 17.3**). This is the brightest level that's there; it is about as bright as you can make the white appear. You may see other colors in this process, but what you're looking for is white.

Next, hold down the Option or Alt key and drag the Blacks slider to the left. As you do this, you may see other colors appear, but what you're looking for is the first spots of black (**Figure 17.4**). This will tell you how

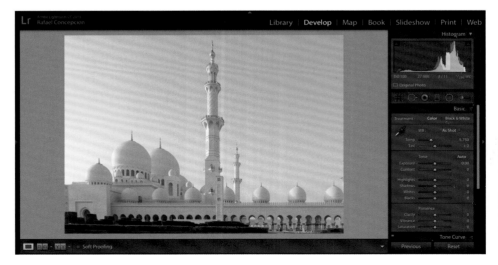

Figure 17.1

Figure 17.2

Figure 17.3 The brightest part of the image is in the sky, just above the structure on the far left.

Figure 17.4 The darkest part of the image is in the hedges at the bottom.

far you can technically move the Blacks slider. Once the white and black points are set, you can use the Shadows and Highlights sliders to bring back as much information as you can in the file.

This is technically a good way to set your white and black points, but again, I can't stress enough how rarely I use these sliders. I only use them when I need to do some final cleanup work.

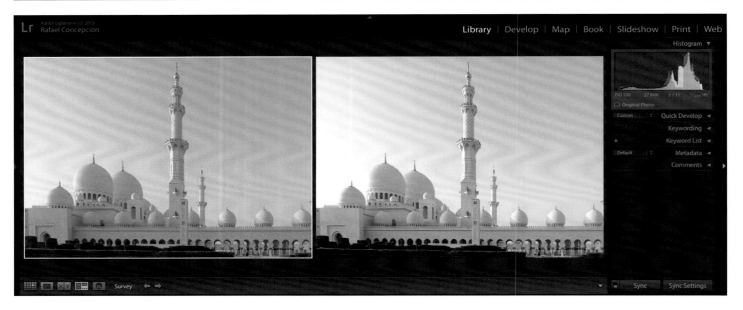

Figure 17.5

Figure 17.6 The final image

18. CLARITY, VIBRANCE, AND SATURATION

ONCE YOU'VE DIALED in the tonality of your picture, you can move on to making some of the final adjustments. The Clarity, Vibrance, and Saturation sliders can be used to round out the basic editing of a picture.

Clarity

The general exposure of a picture adds contrast in the shadows and highlights, and treats the whites and blacks of the image. The one part that doesn't get a lot of attention is the midtone portion of the image. There are times when adding a little punch to the midtone area could be very helpful. The Clarity slider controls the midtone contrast.

Midtone contrast is great for adding a bit of grit to your pictures (**Figures 18.1** and 18.2). Metals, textures, brick walls, and hair are all things that could benefit from a little bit of a clarity boost. The only thing to keep in mind when you're using the Clarity slider is that, in general, out of focus areas will not look good with Clarity applied to them.

Saturation and Vibrance

The Saturation and Vibrance sliders deal with the application of color in the picture, but they work a little differently. Dragging the Saturation slider to the right will increase all of the colors in the image (**Figure 18.4**). The only problem with this slider is that it doesn't take into account whether or not a color is already overused in a picture. That's where Vibrance comes in.

As you increase the Vibrance slider, you'll notice that any underrepresented colors will be increased a lot more (**Figure 18.5**). Any colors that are overrepresented will not be adjusted as much. If there are any skin tones in the picture, Vibrance will not affect them as much either.

I tend to add a more generous Vibrance boost to a picture and see how it does before I try making any adjustments with the Saturation slider. That said, if there is an individual color you wish to adjust, I wouldn't focus on it by trying to increase Vibrance or Saturation here. You can either adjust that color individually in the HSL panel, or paint in a color change later with an adjustment brush.

Figures 18.1-18.2
A before and after comparison showing the effects of the Clarity slider. Notice how it improves the look of the background elements in the second picture. However, I'd prefer it to have a little less of an effect on the subject.

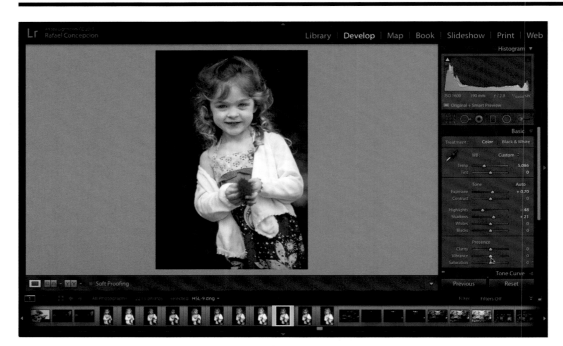

Figure 18.3 This is the image before I adjusted the Saturation or Vibrance sliders.

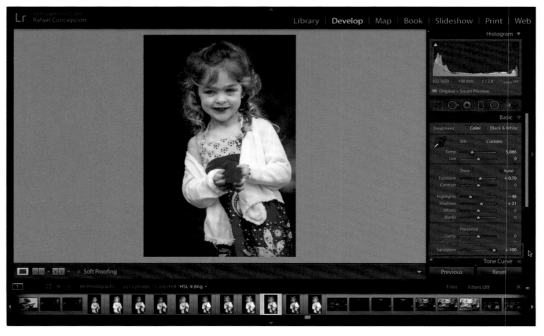

Figure 18.4 I used the Saturation slider to adjust the image, and you can see that the skin tones and reds in the image are overdone.

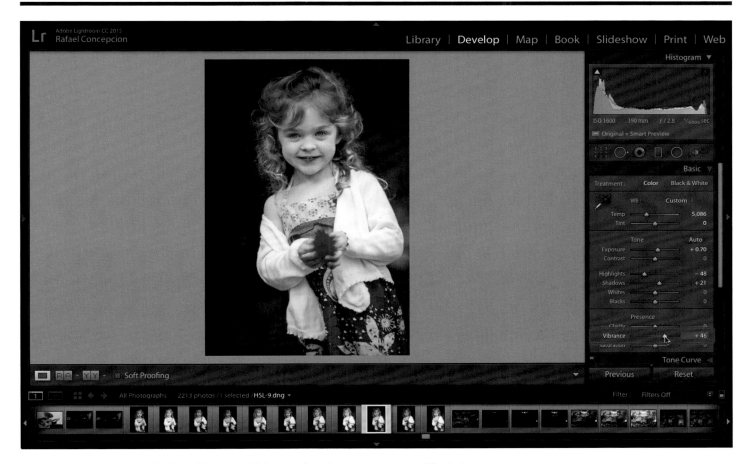

Figure 18.5 When I used the Vibrance slider, only the greens were affected.

19. MANAGING HUE, SATURATION, AND BRIGHTNESS

ONCE YOU'VE FINISHED adjusting the exposure and tonality of your image, you can focus on making changes to individual colors. Lightroom makes it pretty easy to do this with the Hue, Saturation, and Luminance (HSL) sliders in the Develop module.

The HSL panel separates colors and lets you change them with a series of sliders. When you first expand the panel, you'll note that the Hue option is selected (**Figure 19.1**), so sliding each of the color sliders will adjust the hues in the image first. The color bar directly under each slider marker shows you what the color change will be when you adjust that slider. Switching from Hue to Saturation or Luminance will change the effect those sliders have on the individual colors you see.

While these sliders are very powerful, I find that a lot of people don't know which color they want to adjust when they are looking at an image. I mean, if I asked you to change the magenta values in a picture, I would guess that a good portion of people wouldn't really know what they're changing—I barely do.

This is why I think the Targeted Adjustment Tool is pretty brilliant (**Figure 19.2**). Rather than having to figure out what color you need, you can click on the tool to select it, and then click and drag on the area you want to change in the image. Clicking on the area and dragging to the left and right will adjust the associated color sliders in the HSL panel (**Figure 19.3**). If you want to change the Luminance or Saturation, just switch to the appropriate mode and select the Targeted Adjustment Tool again.

If you want to reset a slider, simply double-click on the slider marker and it will jump back to its default middle position (**Figure 19.4**). To reset all of the sliders in one pass, double-click on the word Hue, and all of the markers will return to their original positions.

It's important to note that the changes you make to each slider will affect that specific color throughout the entire image. If you want to have greater control over how a specific color looks in a particular area of a picture, you are better off moving the image into Photoshop and doing a selective color adjustment with the HSL Adjustment Layer and a Layer Mask.

Figure 19.1 The HSL Sliders in Lightroom

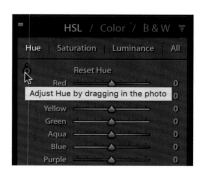

Figure 19.2 The Targeted Adjustment Tool

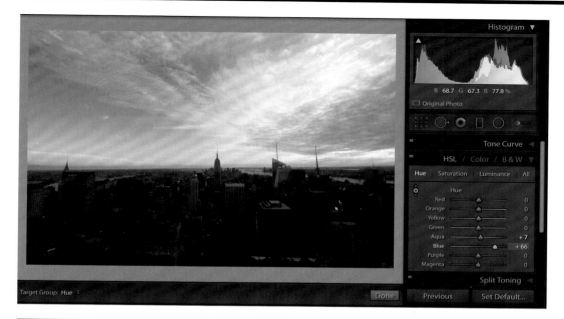

Figure 19.3 Adjusting the hue in an image with the Targeted Adjustment Tool.

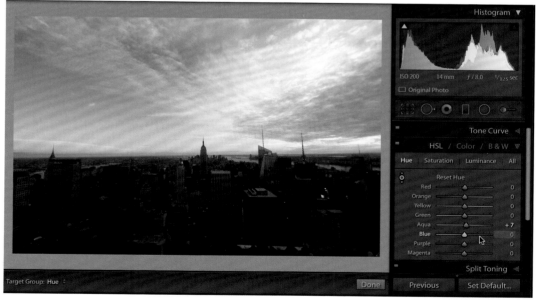

Figure 19.4 Resetting the Blue Hue slider.

20. MAKING A BLACK-AND-WHITE IMAGE

IN MY OPINION, you can make a very powerful photographic expression by working in black and white. It's been said that working in black and white lets you see the "bones of the image," and I could not agree more.

Working with black-and-white images involves a lot more than just removing the color. There are plenty of ways you can make the process of creating a black-and-white image uniquely your own.

Select B&W from the HSL / Color / B&W panel in the Develop module, and your image will immediately turn into a black-and-white image. Under the B&W header you'll see a series of color sliders that allow you to change the overall look of the black-and-white image. Dragging one of the color sliders to the right will take all of that color in the image and make it brighter. Dragging it to the left will make the color darker.

You can also adjust the brightness of each color by using the Targeted Adjustment Tool (**Figure 20.2**). Activate the tool by clicking on it in the B&W panel, and then click on one of the colors in the picture and drag to the right to make brighter, or drag to the left to make darker.

Directly controlling which colors you make brighter and darker is a great way to make your own black-and-white image, but many people skip over the fact that you can develop this image further by going back to the Basic panel.

The change to black and white often reduces exposure and contrast in an image, or decreases clarity. Once your conversion to black and white is complete, make sure you go back to the Basic panel and reprocess your image to offset any of the changes lost in the conversion. You can then finalize the black-and-white image by adding a little extra sharpness and grain to the image (**Figure 20.3**).

Share Your Best Black-and-White Image!

Once you've captured your best black-and-white image, share it with the Enthusiast's Guide community! Follow *@EnthusiastsGuides* and post your image to Instagram with the hashtag *#EGBlackandWhite.* Don't forget that you can also search that same hashtag to view all the posts and be inspired by what others are shooting.

Figure 20.1 This shot I took of the sunset in NYC from the Top of the Rock is nice in color, but I'm looking for a more timeless look. This would be a perfect candidate for black and white.

Figure 20.2 I like toning black-and-white images with the Targeted Adjustment Tool. Rather than having to think about what colors the sliders control, it's a "what you see is what you get" approach.

Figure 20.3 The final black-and-white image with some added sharpness and grain. Because of their timelessness, you'd be surprised by how much sharpness and grain you can get away with.

21. CREATING DUOTONES AND TINTED IMAGES

ANOTHER WAY YOU can give your images a classic look is by tinting them. This process is very straightforward and opens the door to a lot of creative interpretations of your work. Let's take a quick tour of how tinting works, and then go over a couple of things you should consider when you are making your own custom looks.

The Split Toning panel allows you to change the tint of your image. It contains two settings: Highlights and Shadows (**Figure 21.2**). These two settings are responsible for the coloring of the highlight and shadow tones in the picture. When you click on the Highlights swatch you are presented with a color bar where you can use an eyedropper tool to select the color you wish to use (**Figure 21.3**). You can also enter a Hue setting manually by clicking on the number next

to the H below the color bar and inputting a number, or by scrolling on the number. You can change the Saturation with the S slider.

Now click on the Shadows swatch and you'll see the exact same settings. The only change here is that there's a dot on the color bar to show you what setting you picked for the Highlights color, which is a nice touch (**Figure 21.4**). The arrows next to the Highlights and Shadows swatches open Hue and Saturation sliders that you can adjust without seeing the color bar, but I think it's much better to visually select the colors you want to use by clicking on the color bar.

When you're tinting an image in Lightroom, remember that you are tinting only the shadows and highlights of the image. If you are working with a color image, there will be a little bit of a color bleed in the midtones. If

you'd like to eliminate this, I recommend that you make a good black-and-white image before you do any tinting (**Figure 21.5**).

Want to try a quick sepia-inspired tinting? Set your Highlights to 60,40 and your Shadows to 30,24, and you're done (**Figure 21.6**)!

While it's tempting to use this tool to create a sepia-toned image (everyone tries the sepia look at least once), I like to use the tinting to create a little bit of a different black-and-white image. Once you've converted your image to black and white, set your Highlights to 237,24 and your Shadows to 48,7, and the black-and-white image will have a little bit of a blue tint that gives it a different feel than just a desaturation of color (**Figure 21.7**).

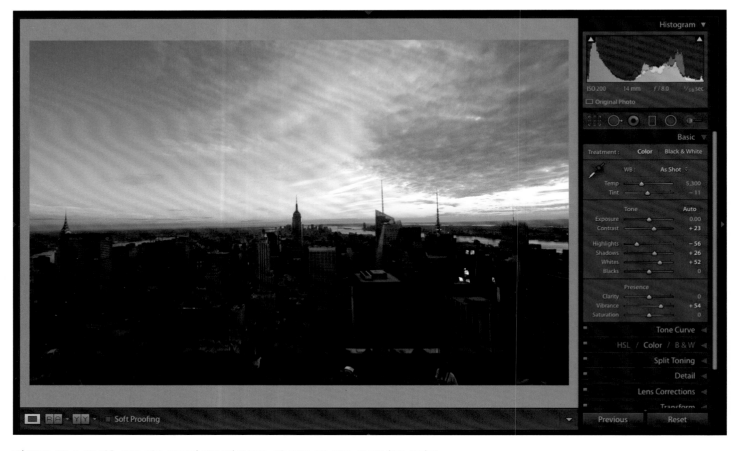

Figure 21.1 We'll use the previous picture of NYC as our starting point.

Figure 21.2 The Split Toning panel allows you to adjust the tint of an image.

Figures 21.3-21.4 Changing the Highlights and Shadows creates a cool tint look. Notice that the Shadows color bar has a dot to mark the color that was picked for the Highlights.

Share Your Best Tinted Image!

Once you've created your best tinted image, share it with the Enthusiast's Guide community! Follow *@EnthusiastsGuides* and post your image to Instagram with the hashtag *#EGTint.* Don't forget that you can also search that same hashtag to view all the posts and be inspired by what others are shooting.

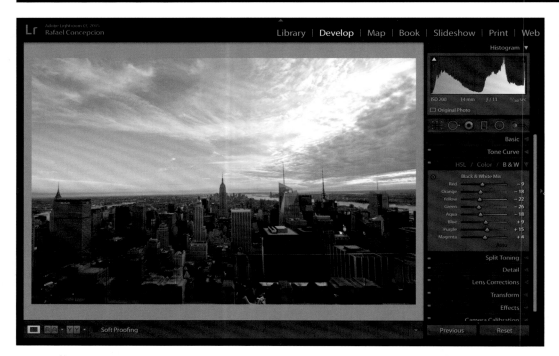

Figure 21.5 Tinted images look much better when you start with a black-and-white image.

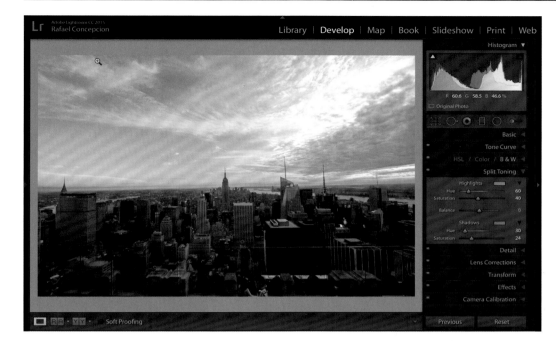

Figure 21.6 A sepia-toned image.

Figure 21.7 Adding a slight blue tint to a black-and-white image gives it a different look.

22. THE LOWDOWN ON DETAIL AND NOISE REDUCTION

IN THE DETAIL panel you will see that the Sharpening section has four sliders: Amount, Radius, Detail, and Masking. Above the Sharpening area there is a box that shows you a 100 percent view of everything in the picture. I don't like using this because it's not really a good way to see how much sharpness is being applied to the picture.

Instead, I like to click on the main picture in the center workspace to zoom in to 100 percent (**Figure 22.1**). You can then click and hold on the picture and move it around to see how sharpness is going to be applied to a specific area. Okay, now that we've covered that, we can turn back to the sliders.

The Amount slider is pretty straightforward—it dictates how much sharpness is applied to the picture. The Radius slider offers you the opportunity to set how far from the center of the pixel the sharpness

is applied. It's really hard to see this when you adjust the Radius slider, so I recommend that you hold down the Option (Mac) or Alt (PC) key while you drag the slider. When you drag it all the way to the left, the image will turn gray, and as you drag it over to the right, you will start seeing more edge information (**Figure 22.2**). The edge information indicates the area that is going to be sharpened; anything that's gray will be sharpened. This allows you to apply the sharpness that you need.

Once you have that set, move down to the Detail slider. The Detail slider increases the frequency in an image, and by doing so, it brings out more texture or more detail (**Figure 22.3**).

I recommend you use the Radius and Detail sliders first to define the areas you want to see in the picture. Once you have those set, then

go back and adjust your Sharpening Amount.

Another thing to keep in mind is that if the Detail slider is moved all the way to the right (or almost all the way to the right), it will start to introduce a little bit of noise. So you want to be careful with that.

If you want to limit where the sharpening is applied, you can use the Masking slider. This slider creates a black-and-white overlay, where black shows the areas that are not going to be sharpened and white shows the areas that will be sharpened (**Figure 22.4**).

Again, press down the Option (Mac) or Alt (PC) key and drag the Masking slider to the right to dictate where you want sharpening to be applied. Once that is set, let go of the Masking slider, and now you have a much sharper picture.

Figure 22.1 Using the main picture instead of the preview in the Detail panel to examine sharpening gives you a lot more to look at.

Figure 22.2 Adjusting the Radius for sharpening in Lightroom.

Figure 22.3 Adjusting the Detail for sharpening in Lightroom.

Figure 22.4 Adjusting the Masking for sharpening in Lightroom.

If you want to see the before and after versions of your image, you can use the little power switch to the left of the word Detail to toggle back and forth between the two versions (**Figure 22.5**). When you turn it off, it removes all of the sharpening that you've done. Click on it again to turn it back on. This allows you to make a better judgment as to whether you've added enough sharpening to the picture.

Now let's go ahead and tackle noise. Noise in a picture is the result of two different things. First, it can be caused by the use of a really high ISO setting. I shot the image shown in **Figure 22.6** at 12800 ISO, which is pretty high, so there was some noise in the image.

The Noise Reduction section of the Detail panel has a few different settings, the first of which is Luminance. When you drag the Luminance slider to the right, the noise in the image will start to disappear. This is the slider that you'll use for 90 percent of the noise reduction you do.

Noise reduction works by blurring the image slightly, so as you reduce the noise, you will also lose some detail. If you want to add some detail back into the picture, you can grab the Detail slider under Luminance and drag it to the right. If you want to increase the contrast in the picture, you would drag the Contrast slider over to the right. However, it's important to understand that increasing the detail and contrast in the image is going to reduce some of the effects of the Luminous slider, so they tend to work more as counterbalances to one another.

Again, you can use the Detail power switch to turn these adjustments off and on and see how well you've done with the noise reduction (**Figure 22.7**).

The sliders for Color Detail and Smoothness deal with the fact that some camera sensors will display noise as colored pixels, rather than just as little black, white, or gray dots. If you want to mitigate this, you can use the Color slider to remove some of that color noise from the picture. And then you can add a little bit more detail and smoothness back in with the Detail and Smoothness sliders.

This section dealt largely with how to reduce noise that resulted from the use of a high ISO. But it's important to note that this is something you also have to do if you excessively sharpen a picture. The more you sharpen a picture, the more noise is going to be introduced, especially if you are using the Detail slider. So every time you increase the sharpening, go back into Noise Reduction and add a little bit more there as well. You'll be surprised by the quality of the results you get.

Figure 22.5 Hit the power switch to quickly turn adjustments off and on in Lightroom.

Figure 22.6 I used the Luminance slider to remove noise in this high-ISO image. Happy Birthday, Haley!

Figure 22.7 I used the power switch to turn off the Detail adjustments so I could compare my adjusted image to the original.

23. CROPPING YOUR IMAGE

WHEN IT COMES to conversations that will cause a little bit of controversy, you can always count cropping to be pretty high among the list of topics. On one side, there are individuals who believe that it is your job as a photographer to try to frame the picture in the camera exactly as you want it to look in the final image, and that cropping is "cheating." The second camp believes that if there is something in the image that takes away from what you are trying to convey, you should crop to your heart's delight.

I consider myself to be firmly in the "crop to your heart's delight" camp, but I totally respect your point of view if you are on the "no cropping" side of things. Feel free to skip this chapter entirely.

But before you do, I'd like to give you something to consider:

When I started developing an interest in photography, the picture that did it for me was one of the pianist Igor Stravinsky by Arnold Newman. It is a beautiful black-and-white image. The open lid of a grand piano fills the majority of the frame and is a stark contrast to the white wall behind it. Stravinsky sits in the lower-left corner of the frame, staring straight out at the viewer with his elbow propped up on the piano and his head resting in his hand. He is only visible from the shoulders up, and occupies a very small portion of the image.

I remember staring at that picture in awe: how masterful it was to use the piano in that manner; the use of negative space; the subject being the smallest part of the frame. I thought it was brilliant.

A couple of years into my practice, having adopted the whole "thou shalt never crop a picture" mindset, I stumbled upon a picture that would quickly change my mind. It was a picture of the original negative, clearly showing that there was more to the picture, with lines where Newman had specified it should be cropped. Later, I found additional pictures that showed how Newman had posed Stravinsky in different places before deciding that the picture that's universally famous would be "The One."

While many of us hold onto the idea that cropping is something that just wasn't done, shouldn't be done, or is a form of cheating, this picture illustrates that the practice has been going on for much longer than many people may think. At the end of the day, you serve the image that was in your mind when you took the picture, and if making a different crop of it gets your message out further, you owe it to yourself to try.

Pressing the R key on the keyboard will bring up the Crop Tool Overlay. You'll notice that there are some transformation handles on the corners of the picture. Drag them in to crop the picture tighter (**Figure 23.1**).

If you place your cursor on the outside portion of the crop, you can adjust the overall rotation of the picture. You can also straighten the picture with the ruler tool inside of the crop area. Simply select the ruler next to Angle in the tool panel, click on the picture, and drag a line on whatever area you believe should be straight.

The Crop Overlay serves as a compositional guide. You can change the overlay by pressing the keyboard shortcut O (**Figure 23.2**). There are several different options, so keep pressing O to cycle through them. If you want to change the orientation of the overlay, press Shift + O.

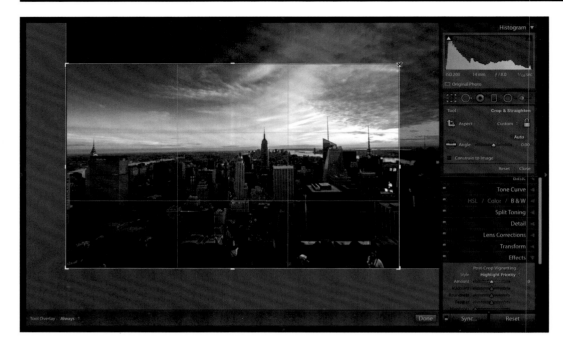

Figure 23.1 Adjusting the Crop in Lightroom.

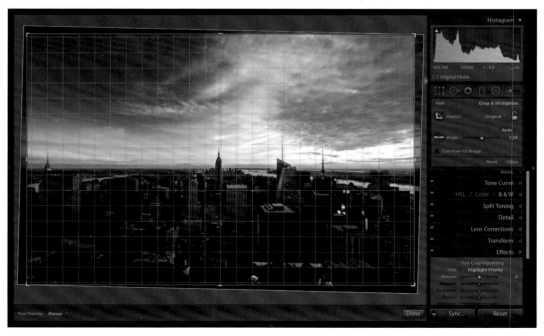

Figure 23.2 Changing the Crop Overlay with keyboard shortcut O.

If you want to keep the aspect ratio of the picture locked, you can click on the lock button (**Figure 23.3**). Clicking on the button to unlock it lets you freely move the crop around. There are times, however, when you want to use a very specific aspect ratio.

That's where the drop-down menu comes in pretty handy.

The Aspect drop-down menu includes some commonly used aspect ratios, and gives you an option to make your own (**Figure 23.4**). For example, let's say that you want to crop a picture to use as a header on your Facebook page. Click on the Aspect drop-down menu, select Enter Custom, and type in 8.51 by 3.15. Now when you use the Crop Tool, the crop will be restricted to that aspect ratio.

Figure 23.3 Click on the lock button to restrict the crop to a specific aspect ratio.

Figure 23.4 The Aspect drop-down menu contains commonly used aspect ratios as well as an option to create custom ratios.

Get Rid of Distractions When You Crop

Whenever I am cropping an image, I like to remove all of the distractions, much like we did during the iterative edit process. Press Shift + Tab to eliminate the panels, and press the L key twice to go into Lights Out mode. With all of the distractions removed, I think you can be better focused on making a good crop.

Figure 23.5 The final cropped image

24. LOCAL ADJUSTMENTS TO MAKE GREAT IMAGES BETTER

SO FAR, EVERY adjustment you have made has been to the picture as a whole. Every slider has affected every component of the picture. But the reality is that when you make adjustments to pictures, you want to do it in pieces. There's not just one global adjustment that you make for everything. So, in Lightroom you want to have the ability to make some global changes, but at the same time, go back and start working with individual elements in the picture.

In this respect, the Adjustment Brush is a fantastic tool for you to get used to. We've spent time working through all of the details in the Basic panel, so you have a good idea of how those work. Twirl all the way back up to the top of the panel, and directly under the histogram you will see a row of tool icons. The Adjustment Brush is all the way to the right (**Figure 24.1**). You can also access it with the keyboard shortcut K.

When you select the Adjustment Brush, a new panel will appear right above the Basic panel with a whole host of things you can apply with the brush (**Figure 24.2**).

The first section contains all of the sliders that are found in the Basic panel: Temperature, Tint, Exposure, and all the way down to Saturation. Directly under that, you have another section that deals with detail: Sharpness, Noise, Moiré, and Defringe. And following that, you have an area that allows you to control the size of the brush and how soft the feathering is, as well as the rate at which the effect is applied (**Figure 24.3**).

All you have to do now is load the Adjustment Brush with the specific change you want to make. I wanted to apply a little bit of an exposure change to the example picture in this lesson, so I moved the Exposure slider to the right and made sure the brush was large enough to paint on the adjustment. At the bottom of the panel there is a selection called Auto Mask. This is a good feature because it automatically detects an edge area and tries to limit the effect of your adjustment to that one mask area.

Once you have adjusted the appropriate sliders, you can go ahead and paint the effect across the image. When you let go

of the brush, a small pin will appear in the image. If you hover over that pin, a red overlay will appear in the areas where the effect was applied (**Figure 24.4**).

Generally, when I work with this tool, I like to increase my effect pretty drastically so that I can see exactly where I'm painting it. Then once I'm done, I bring the effect down.

Figure 24.1 The Adjustment Brush Tool

Figure 24.2 The Adjustment Brush panel

Figure 24.3 The Adjustment Brush characteristics

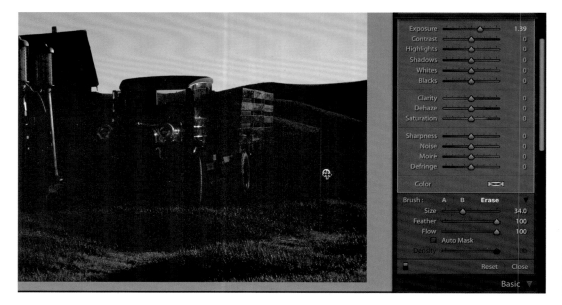

Figure 24.4 The red overlay shows where I applied an exposure adjustment with the Adjustment Brush.

If you want add a second brush, you can click on New at the very top of the panel, and that will give you a new set of controls that you can adjust for the brush (**Figure 24.5**).

In my example image, I dropped the exposure, increased the contrast, and increased the saturation in the sky (**Figure 24.6**). I was able to paint with a large brush while pretty confident that the Auto Mask was going to keep me within the confines of the sky (**Figure 24.7**).

Notice that when you hover over the secondary pin, you can see the red area that reflects the changes you made with the second brush. At any point in time, you can click on an individual pin to go back to that brush and make more adjustments to the image. If you decide you don't like the changes you made with one of the brushes, you can single-click on the pin and hit the delete key on the keyboard to take away the brush (**Figure 24.8**).

Figure 24.5 Click on New at the top of the Adjustment Brush panel to add a second brush with a new set of adjustments.

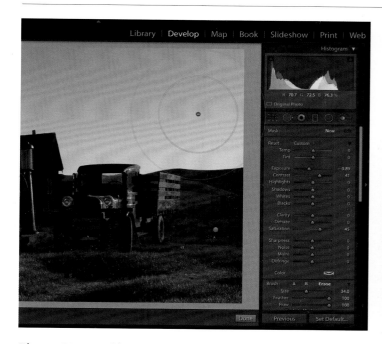

Figure 24.6 I adjusted the exposure, contrast, and saturation in my image.

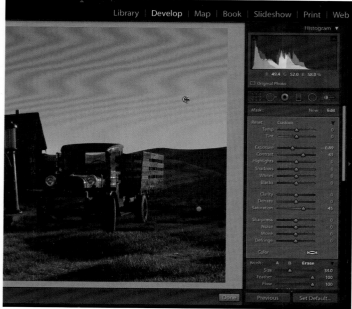

Figure 24.7 Hovering over the secondary pin reveals the changes you made with the second brush (red area).

There are times when you're working with a brush and you want to remove some of the effect that you've applied with it. If you are actively using one of the brushes, you can switch to the eraser by selecting Erase from the Brush section at the bottom of the Adjustment Brush panel (**Figure 24.9**). However, I find that to be somewhat cumbersome because I have to scroll down to that part of the panel every single time. Instead, as you're brushing, you can hold down the Option (Mac) or Alt (PC) key to temporarily turn the brush into the eraser.

You can decrease and increase the size of both the brush and the eraser with the left and right bracket keys on your keyboard. If you're trying to adjust the size of the eraser, make sure that you hold down the Option/Alt key while you press the bracket keys so that you are actually changing the size of the eraser and not the brush. Once you have it set, you can remove the effect by simply painting on the picture.

If you want to see a really cool before and after, just hit the backslash on the keyboard and it will bring you to your original picture (**Figure 24.10**). Hitting the backslash again will show you all of the changes that you've made to the shot (**Figure 24.11**).

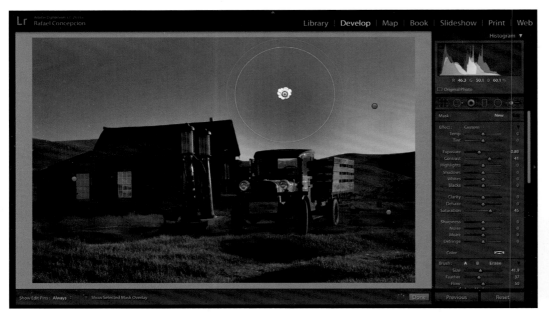

Figure 24.8 Single-click on a pin and hit the delete key to remove the effects of the associated brush. You'll see a little cloud to indicate that the brush is being deleted.

Figure 24.9 The Erase option in the Brush section.

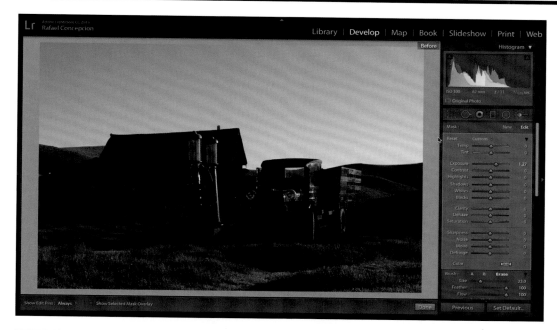

Figures 24.10-24.11
A before-and-after look at the picture with local adjustments applied.

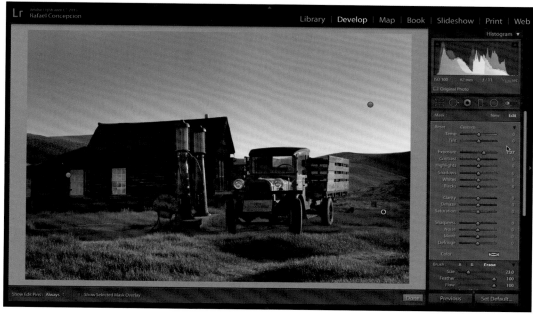

It's also important to note that this does not preclude you from going back into the Develop module and making additional changes after these local adjustments have been made.

This is a great way for you to add sharpness and noise reduction to portions of a picture. In this instance, I would want to sharpen the ground, the building, and the car, but I would want a little bit of noise reduction in the sky. I can accomplish this by making two separate brushes—one that allows me to paint some sharpness onto the building, car, and grass; and one with just a noise removal adjustment that I can paint into the sky.

Let me leave you with one last quick tip: if you find yourself in a spot where you've made a lot of different adjustments to an adjustment brush and you want to reset them, you can double-click on an individual slider to reset it back to its normal position, or you can double-click on the word Effect to move all of the sliders back to their original spots (**Figures 24.12** and **24.13**).

Figures 24.12-24.13 Double-click on the word Effect to reset all of the adjustment brush sliders.

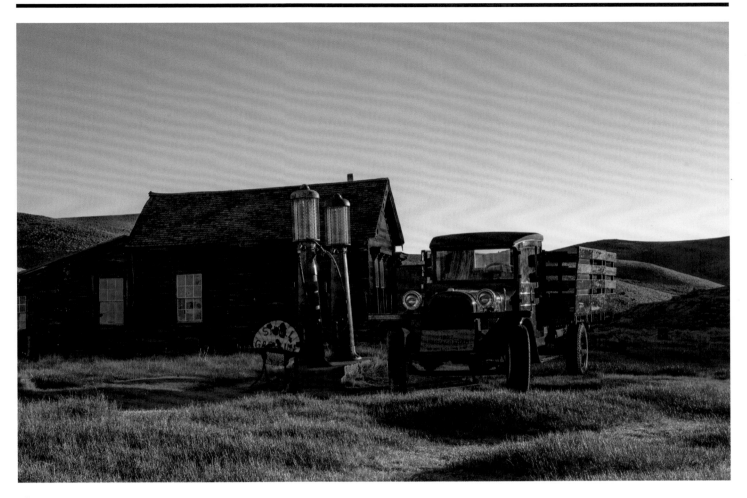

Figure 24.14

3

NEXT-LEVEL EDITING IN LIGHTROOM

CHAPTER 3

Once you have the basics in the Develop module down pat, there are a couple of other things Lightroom can do for you that were not available in previous versions of the software. You no longer have to go to Photoshop to make blemish corrections; you have built-in HDR support in the Develop module; and you can make beautiful, seamless panoramas that do not waste space. Photoshop used to be the program you would use to straighten crooked image elements, but you'll be shocked to see how easy it is to straighten something right inside Lightroom.

These techniques are slightly beyond the sliders we've worked with so far, but they are by no means difficult. All you need to know is where the tools are and how to use them effectively. As you work on this next level of editing, you're going to want to have the ability to save the changes you've made so you can repeat them over and over again as quickly as possible. Lightroom allows you to do exactly that, and you can even share the styles you create with others.

25. SPOT AND BLEMISH REMOVAL

NOW THAT YOU'VE finished making some of the major edits to your picture, let's go ahead and do a little bit of cleanup. No matter how hard you try to keep your camera clean, you're always going to get something on your sensor that will translate to spots on a picture. The last thing you want is to send a picture to print, only to get it back with spots that stand out like a sore thumb.

Fortunately, Lightroom gives you the ability to perform spot correction right inside the Develop module, and provides a couple of tools that make the process a lot easier. Select the Spot Removal Tool by pressing the letter Q on your keyboard, or by selecting the icon that sits to the right of the Crop Tool. When you select the tool, your cursor will turn into a circle, which you will use to cover the entire spot on your image.

In the image shown in **Figure 25.1**, it's kind of hard to see where the spots are. In this type of situation, I recommend using the Visualize Spots option. When you put a check in the Visualize Spots checkbox below the main image, you will get a black-and-white overlay on the picture (**Figure 25.2**). The slider next to the Visualize Spots option allows you to adjust how much of the image turns black and white.

Drag the image slider to the left and right until you see the spots appear in your picture. From there, all you have to do is adjust the size of the brush so that it covers the spot you want to remove, and then click on the spot and release. Lightroom will sample the surrounding area and find the best area from which to pull information to replace that spot. Don't worry, if you don't like the area that Lightroom chooses, you can always change it by selecting the area and dragging it to a new location.

You can also change the size of the spot after the fact. Hover over the edge of the spot, and you'll see a diagonal arrow appear (**Figure 25.3**). Click and drag it out to make the sample area bigger.

Figure 25.1 The Spot Removal Tool in Lightroom.

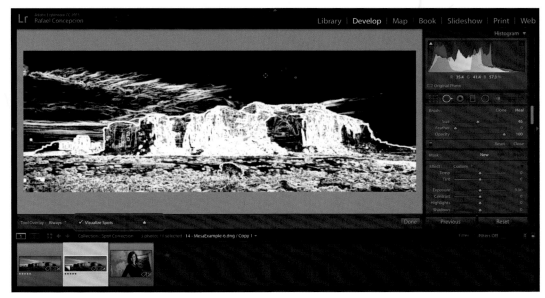

Figure 25.2 The Visualize Spots option can make spotting sensor dust problems much easier.

Previously, Lightroom only worked with circular spots. But recent changes to the software have made it possible to use brushstrokes as well, which I think is great. Notice that there are a couple of cars in the bottom-left corner of my picture. They're not spots per se, but I can use the Spot Removal Tool to cleanly remove them from the image.

For this removal, I'll use a really large brush and I'll drag it across the two cars (**Figures 25.4** and **25.5**). You can see that this creates a brushstroke option and samples from a surrounding area. Again, I can always change that area by single-clicking on the sample and dragging it to a new spot. Once I find the area that I think is a better match, I can click the Done button.

You will see all of the different brushes and sample spots as white circles on your image. Don't worry, these won't print, but they give you a good idea of the type of work you've done so far (**Figure 25.6**).

The Spot Removal Tool is also great for portrait retouching (**Figures 25.7–25.9**). Individual blemishes or marks can be quickly removed right in Lightroom. This is something you would have had to do in Photoshop before, but now it's quick and easy to do it in Lightroom without having to leave the program at all.

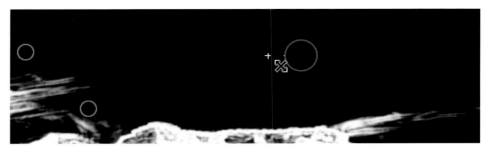

Figure 25.3 Adjusting the size of the Spot Removal brush in Lightroom.

Figure 25.4 I selected a large brush size to remove the cars from my image.

Figure 25.5 I dragged my brush over the cars to create a long brushstroke, and Lightroom replaced the area with a sample from a nearby area in the image.

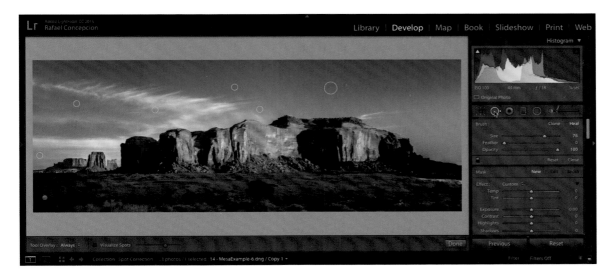

Figure 25.6 The final product with spots removed.

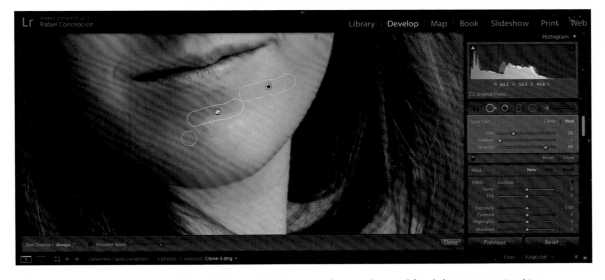

Figure 25.7 The Spot Removal Tool is great for removing marks or blemishes on portraits.

Figure 25.8 Before Spot Removal.

Figure 25.9 After Spot Removal.

26. CREATING HDR IMAGES

AS WONDERFUL AS our cameras are, there are times when the camera will not be able to capture the entire range of light values in a scene with one single shot. If you try to expose for a beautiful background in a scene, chances are you're going to underexpose the shot to get all of the saturated colors. When you do that, you'll notice that the foreground elements, or anything that happens to be behind the light source, turn out really dark. If you try to expose for the foreground elements, you're likely going to overexpose the sky, and you'll lose all of the color you're intending to capture in the picture.

In situations like this, the solution is to take a series of pictures at different exposures, and then merge the images together to create a single image with a higher dynamic range. Up until very recently, Lightroom did not have the capacity to do this, but now it has a built-in HDR feature that works extremely well for producing really natural-looking HDR images.

When Adobe released this update, they said that one of the benefits of working with HDR in Lightroom is that you need fewer images to create the resulting HDR file. After some experimentation with the HDR feature in Lightroom, I can safely say that they are correct. You can get away with using about three images of varying exposures to create the final HDR file.

Locate the three images you wish to use in the filmstrip below the main workspace or in the Grid View mode, and Command-click each image to select it. Right-click on one of the images and select *Photo Merge > HDR* from the menu (**Figure 26.1**).

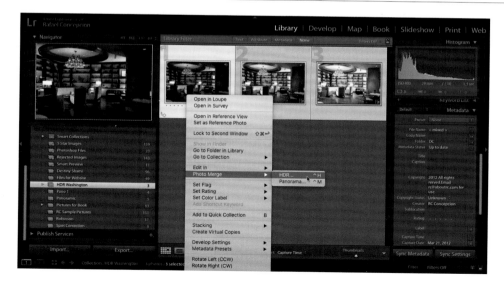

Figure 26.1 Merging images to an HDR file in Lightroom.

A box will appear with a preview of an image that is the result of all three exposures merged together into one (**Figure 26.2**). You'll notice two options here that are pretty important. The first option—Auto Align—allows you to compensate for any movement of the camera between exposures.

The Deghost Amount buttons will help you to compensate for any movement on the subject's part—for example, maybe some trees were blowing in the wind or a person moved from one side of the picture to another. If any part of the scene moves during the bracketed exposure, it will cause ghosting in the picture. The amount of deghosting you choose will depend on how much movement occurred in between frames, and thus how much ghosting there is in the image.

Lightroom is able to merge the files to create an HDR preview pretty quickly because it uses the JPG images that are embedded in the RAW files to do so. In the preview window, you also have an option for Lightroom to Auto Tone the image. This simply adjusts your exposure values so that you can see a pretty good HDR file right out of the gate. Once you select Merge, Lightroom will merge the RAW files to create the finished HDR file, which is an actual RAW file in a DNG format. This means that you have the opportunity to adjust the temperature and tint of the HDR image as if it were an original RAW file.

You'll also notice that you can now adjust the Exposure slider in a range from +10 to -10 (**Figures 26.3** and **26.4**). While this level of exposure is really poor in a picture, the benefit of this is that you can use adjustment brushes to bring in a lot more detail in the highlights and shadows than you could in one of the individual RAW exposures (**Figure 26.5**).

Here's another tip I think is pretty cool: There are times when you would like to bypass the HDR preview window entirely. You know that you want to work with this picture when it's completed, and you don't want to stop in the middle to confirm the choices. Hold down the Shift key while you right-click one of the selected files, and then select *Photo Merge > HDR*. This will merge the files using something called Headless Mode, which skips the preview entirely and produces the HDR file.

In Lightroom, the production of the HDR happens in the background. If you were to try to produce an HDR image in Photoshop, the software would prevent you from doing any other work while it worked on producing the HDR file. In Lightroom, you can continue to work on other pictures until the HDR file is completed.

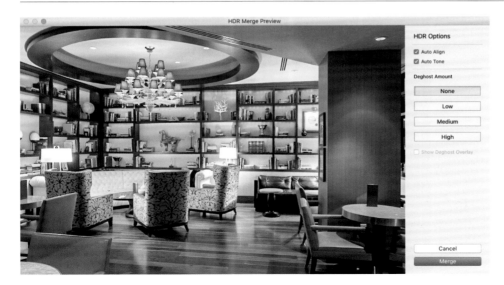

Figure 26.2 The HDR Merge Preview with alignment, toning, and ghosting options.

Figures 26.3-26.4 Take a look at the range you can get out of an HDR file in Lightroom.

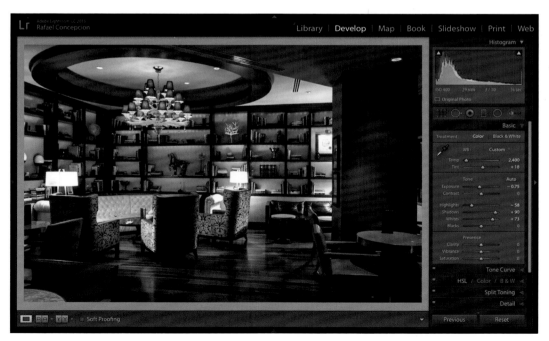

Figure 26.5 The final HDR file with Toning and Adjustment Brush applied.

Figure 26.6 A single-shot, middle exposure.

Figure 26.7 The final HDR image.

27. CREATING PANORAMIC IMAGES

LIGHTROOM MAKES IT easier than ever to create panoramic images using images shot with your DSLR camera. One of the things I like most about this is how fast Lightroom can produce the results, as well as the steps they've taken to make sure you don't lose any data during the process. Let's take a quick look at how to make this happen.

To create a panoramic image in Lightroom you need a minimum of two images with some form of overlap. I've used as many as 12 images to create a single panorama.

I know a lot of people who want to experiment with panoramic images believe there is a set of special tools that you need to use or processes you have to follow in order to create a good panoramic image. I'm here to tell you that you should just go nuts and play with it. You can create a panoramic image with horizontal or vertical pictures. I prefer to use vertical images for my panoramas because it gives me a lot more data to work with if I have to crop the image down.

A lot of times I just mount my camera on a tripod and turn the head slightly after I take each shot. I don't really keep an eye on exactly how much overlap there is, just so long as I have a subject that is not moving. Adobe says you need to have about 20 percent overlap between the pictures to make a panoramic image, so I just make sure there is something in the frame that can repeat across all of the different files. Other than that, it's just a matter of rotating from left to right or right to left—it's up to you.

Once you've shot your images and imported them into Lightroom, select the images you want to use for the panorama by Command-clicking on each image in the filmstrip or in the Grid View mode. Then right-click on one of the selected images and select *Photo Merge* > *Panorama* from the menu (**Figure 27.1**).

One of the things that will surprise you is how fast the Panorama Merge Preview window will appear. What it's doing here is using the JPG files that are embedded in the RAW files to create a preview of the panorama. This significantly decreases the amount of time you have to wait to see this preview. There have been many times when I tried to create a panorama in Photoshop and waited forever for it to render, only to find out that I didn't get the best panoramic image and all of that time was lost because I couldn't do anything else in Photoshop while I waited.

Lightroom merged the four 36-megapixel files shown in Figure 27.1 in about five seconds, which is extremely fast. Now I can make a judgment as to whether or not I want to proceed with this panorama.

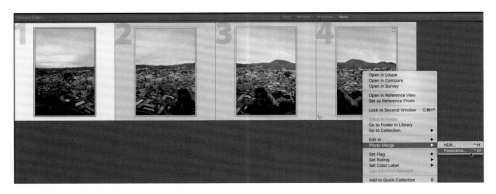

Figure 27.1 Merging images to create a panorama in Lightroom.

In the Panorama Merge Preview window you have a series of different options for extending and finishing the panorama (**Figure 27.2**). Lightroom automatically detects the best option for your image, but you can choose a different one if you wish to.

The Perspective Projection option uses a center image as the foundation for the transformation, and then transforms the images to the left and right by skewing the perspective toward the center. This often results in an image that looks a lot like a bow tie (**Figure 27.3**).

The Cylindrical option uses the same center image as the basis for perspective, but then merges the left and right images together as if you had an unrolled cylinder (**Figure 27.4**). You'll see a little less bow-tie distortion here.

Finally, the Spherical option uses the center image as a base, and then stitches the left and right images together as if the panorama came from the inside of a sphere (**Figure 27.5**). This is really good for 360-degree panoramas, but you don't necessarily see that here. In my opinion, this is the one that creates the least amount of waste in the shot.

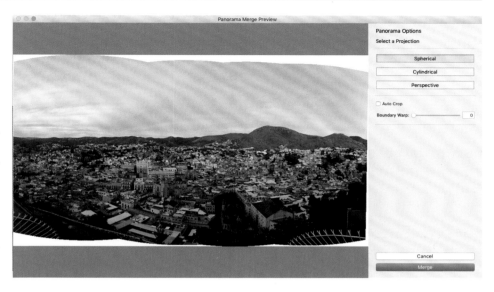

Figure 27.2 You can select a Projection type in the Panorama Merge Preview window.

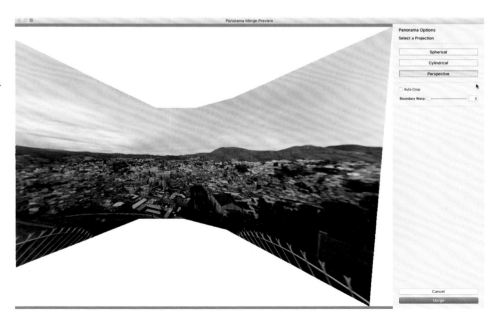

Figure 27.3 The Perspective Projection option often creates an imaged shaped like a bow tie.

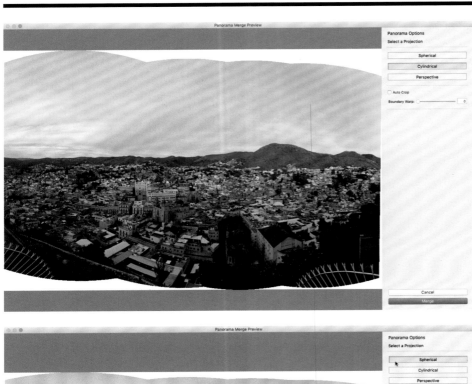

Figure 27.4 The Cylindrical Projection option produces a little less distortion than the Perspective option.

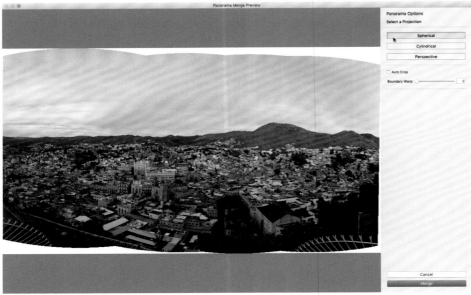

Figure 27.5 The Spherical Projection option produces the least amount of waste when stitching images into a panorama.

The Auto Crop checkbox removes a lot of the white space that you see around the edges of the picture (**Figure 27.6**). You don't need to worry about losing any information here because this isn't destructive. You can always go back and increase or decrease the crop later in the Develop module.

Finally, Boundary Warp will warp the edges of the picture toward the edges of the frame itself (**Figure 27.7**). This creates a little bit of distortion, but you will definitely want to use it because it removes the need to excessively crop the image.

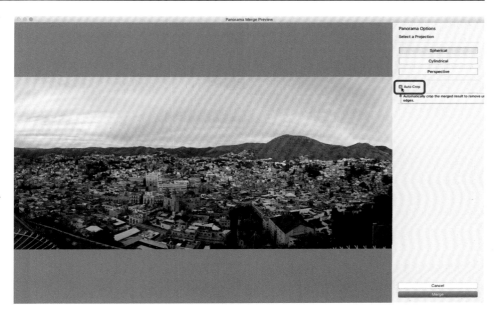

Figure 27.6 Auto Crop removes the white space around the panoramic image.

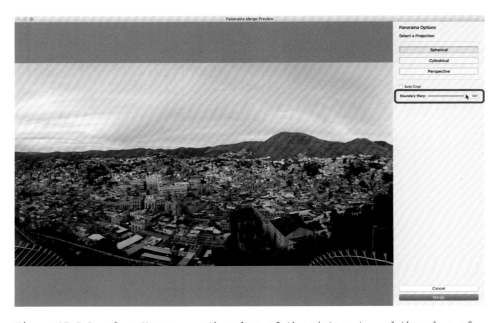

Figure 27.7 Boundary Warp warps the edges of the picture toward the edges of the frame.

After you've selected your transformation options, you can hit Merge, and the final panorama will be generated and placed in your Lightroom catalog. An important thing to note here is that the panorama is now a DNG file, so you can adjust things like exposure and white balance with the latitude that you'd expect out of a RAW file. The DNG file has the extension "-pano" added to it.

Lightroom will take longer to produce the final panorama, but as I mentioned earlier, the image is created in the background, so the process does not tie up your Lightroom resources (**Figure 27.8**). This means you can go back into your catalog and work on different images if you need to. The speed at which your computer renders panoramas largely depends on the speed of its processor, as well as the amount of RAM that you have on it, so your results may vary.

The last thing to point out here is that you can run this process in Headless Mode. When you hold down the Shift key and go to *Photo Merge > Panorama*, your images will be merged using the previous settings, and you will not see the Panorama Merge Preview window. Lightroom simply merges the RAW files in the background as you work on other projects.

Once you have merged your files into a single panoramic image, you can go back into the Develop module and use all of the sliders to get the most out of this large image (**Figure 27.9**).

If you want to see the image in its entirety, hit the letter F to enter full screen mode. This gets rid of all of the Lightroom elements so that you can bask in your newly created pano. Hit the letter F again to exit full screen mode and go back into Lightroom.

Figure 27.8 The panoramic image is processed in the background in Lightroom.

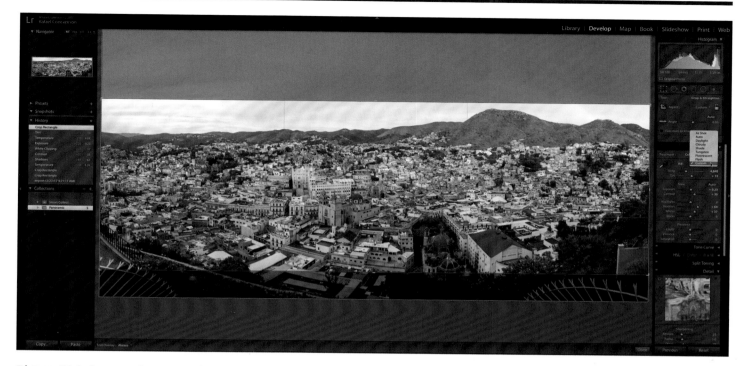

Figure 27.9 Once you've created your panorama, you can make adjustments to the image in the Develop module.

Share Your Best Panoramic Image!

Once you've captured your best panoramic image, share it with the Enthusiast's Guide community! Follow *@EnthusiastsGuides* and post your image to Instagram with the hashtag *#EGPanorama*. Don't forget that you can also search that same hashtag to view all the posts and be inspired by what others are shooting.

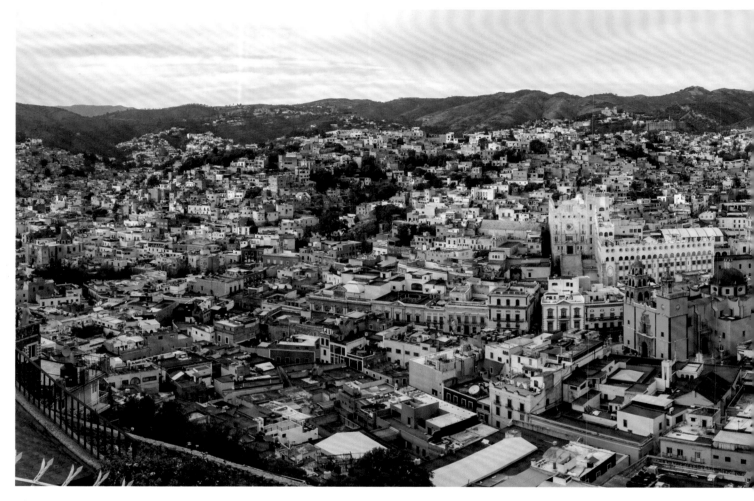

Figure 27.10 The final panoramic image.

28. LENS CORRECTION AND GUIDED TRANSFORMATION

AS YOU START making pictures with your camera, you'll notice that certain lenses cause distortion and vignetting in the images (**Figure 28.1**). This is common across different types of lenses, but thankfully you have the opportunity to change and mitigate some of this distortion in Lightroom.

Open the image you want to fix in the Develop module and scroll down to the Lens Corrections panel on the right side of the screen. In this panel you will see a checkbox that says Enable Profile Corrections. When you click on this checkbox, Lightroom will read the image metadata and make some changes to the image based on the make, model, and profile of the lens you used to shoot the image (**Figure 28.2**).

Adobe is constantly updating these lens profiles so that you can quickly correct distortion and vignetting in your images. If you want to adjust the distortion and vignetting on your own at any point, you can use the sliders down at the bottom of the panel (**Figure 28.3**).

If you notice that your lens suffers from chromatic aberration, you can remove a lot of that by clicking on the Remove Chromatic Aberration checkbox near the top of the Lens Corrections panel.

If you want to take this correction a step further, click on Manual at the top of the panel, and you will find additional options for increasing or decreasing the distortion and vignetting (**Figure 28.4**). The Defringe

sliders enable you to get rid of different pixel colors on the very edges, something that is very common with chromatic aberration.

If your picture is fairly straight and you just want to make these small distortion corrections, the Lens Corrections panel is a great place to start. However, there are times when your camera is off-center or you're shooting from a vantage point that is a little too low, and you need Lightroom to do an additional transformation to get rid of any lines that seem to be bending in an odd direction. This is when you would use the Transform panel in the Develop module (**Figure 28.5**).

Figure 28.1 This image, which I shot in Abu Dhabi, is definitely going to need some distortion correction to straighten it out.

Figure 28.2 Applying corrections based on the lens profile.

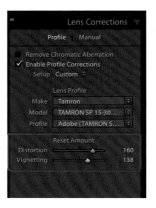

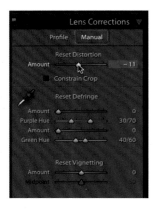

Figures 28.3–28.4
Adjusting the lens
correction after
applying a profile.

By default, the Transform panel is set to Off and all of the sliders are set at 0. If you click on Auto, Lightroom will perform an automatic transformation by looking at the lines instead of the picture, and will attempt to straighten this information for you (**Figure 28.6**). To be honest, I find that Auto works best for me more often than not, but there are a couple of different options here that I think that are important to mention.

The Level option will allow you to work with the horizontal elements to straighten the picture. The Vertical correction allows you to adjust the horizontal elements, but will also try to straighten vertical lines for you. The Full option applies horizontal and vertical perspective corrections. Full is the option I use the least because I find that it usually doesn't work very well.

The newest option in this panel is the Guided transformation (**Figure 28.7**). This allows you to put a series of straight lines in the picture where you believe the straight lines should be. Simply click and drag in an area that you believe should be straight. In **Figure 28.8**, for example, I thought that the main tower should be vertically straight, so I drew a line on top of it. Once I placed that line, I drew a secondary line in another area I believed should be straight (**Figure 28.9**). When I drew the second line on another tower, the image straightened itself out.

Figure 28.5 The Transform panel in the Develop module.

Figure 28.6 The Auto option in the Transform panel will attempt to straighten your image based on the lines in the picture.

Figure 28.7 The Guided transformation option allows you to draw lines on the areas you think should be straight.

Figure 28.8
I think the tower in the center of the image should be vertically straight, so I drew a straight line here with the Guided transformation tool.

Figure 28.9
I drew a secondary line on top of the tower on the far right, which should also be straight.

You're not limited to drawing vertical lines, however. In my example image, I wanted to straighten the wall at the bottom of the image, so I drew a horizontal line across the top of the wall (**Figure 28.10**).

It's important to note that you only get to use four lines, so I drew my fourth line across the top of the square structure on the far-left side of the picture (**Figure 28.11**). This straightened the image horizontally.

Once you've straightened the image, you can use the Crop tool to get rid of some of the white areas on the edges that are a result of the transformation (**Figure 28.12**). In the end, you'll have a smaller picture, but the elements in the picture will be straight.

The one tip I would leave you with is to just try Auto. You'll be surprised by how well it can do.

Figure 28.10
I drew a horizontal line across the top of the wall at the bottom of the image.

Figure 28.11
I drew my fourth and final line along the top of the square structure on the left.

Figure 28.12
After the transformation is complete, use the Crop tool to get rid of the white areas on the edges of the picture.

IN THE BASIC panel, you'll notice that the sliders have a limit to which they can be pulled. That does not mean you need to stop there, however. The technique I'm sharing here is a little bit of a hack, but I tend to use it when I want to get a little extra out of the file, or when I want to create a really cool look (**Figure 29.1**).

For example, let's look at the image of my friend Ilyn (**Figure 29.2**). The picture is pretty cool, but I want to add a little bit of grit to it, so I'm going to grab the Clarity slider and drag it out to 100. This added a little bit of grit, but not as much as I wanted. I'm limited to a Clarity of 100, but I need more cowbell—what do I do?

This is where I would use the Graduated Filter to increase the effect. When you use the Graduated Filter, anything that sits above the top line is going to get whatever effect you select in the Graduated Filter sliders, and that effect will taper down to the bottom line. So what prevents us from grabbing the Graduated Filter and dragging it all the way to the bottom of the picture so that the entire picture gets the effect?

Figure 29.1 Stacking effects in Lightroom lets you go past the basic treatment of a image to make it special. A portrait of my friend Mashael at the Coffee Museum. #Love

Figure 29.2 The original picture of my friend Ilyn.

Figure 29.3 I took the Clarity slider to it's maximum, which added some grit, but I want more.

Click on the vertical rectangle icon below the histogram to select the Graduated Filter. Hold down the Shift key, place your cursor under the picture, and click and drag down just slightly. You'll see a straight line appear beneath the picture (**Figure 29.4**). Anything above that line—in this case, the entire picture—will get the effect. Let's go ahead and grab the Clarity slider and drag it over to the right to +100.

Now hit the New button (**Figure 29.5**) and create another Graduated Filter immediately to the left of the first one. Hold down the Shift key and drag your cursor down ever so slightly, and you'll see a line appear (**Figure 29.6**). Again, everything above it will get the effect you select with the Graduated Filter sliders. At this point, we can grab the

Clarity slider and drag it all the way over to +100 again. Now we have a Clarity of +200.

Now the image is blowing out a little bit (**Figure 29.7**), so I'm going to do the exact same thing to recover some highlights. I'll create two more Graduated Filters here, and I'll pull the Highlights slider to the left to -100 for each one (**Figure 29.8**). This will bring the Highlights to -200.

Figure 29.4 Notice the Graduated Filter handle and line below the picture.

Figure 29.5 Adding a new gradient in Lightroom.

Figure 29.6 Now you can see two Graduated Filter lines below the picture.

I'm doing all of this to create a cool black-and-white effect, so once I've adjusted the highlights, I'm going to click on the B & W option in the Develop module (**Figure 29.9**).

Now I can finish up by adjusting the Contrast and Whites sliders in the Basic panel. I'll also adjust the Post Crop Vignetting Amount slider (in the Effects panel) to burn the edges of the image a little bit from the corners (**Figure 29.10**).

I can even add some realistic photographic grain by grabbing the Grain slider in the Effects panel and dragging it to the right. So now we've bypassed what the Basic panel can do by using Graduated Filters to create an even cooler effect.

Share Your Favorite Unique Effects!

Once you've created a unique image by stacking multiple effects, share it with the Enthusiast's Guide community! Follow *@EnthusiastsGuides* and post your image to Instagram with the hashtag *#EGStackedEffects.* Don't forget that you can also search that same hashtag to view all the posts and be inspired by what others are shooting.

Figure 29.7 Some of the highlights are blown out after stacking the Clarity effect.

Figure 29.8 We can recover some highlights by stacking effects.

Figure 29.9 Click the B & W option to convert the image to black and white.

Figure 29.10 Adding a post-crop vignette and photographic grain.

Figure 29.11 The final image.

30. SYNCHRONIZING YOUR SETTINGS WITH OTHER IMAGES

LIGHTROOM MAKES IT very easy for you to make adjustments to your picture with sliders, and it's pretty straightforward. However, you're not going to be working on just one picture; you're going to work on a ton of pictures, and you don't want to have to go through every single picture to make the same changes.

Fortunately, there's an easy way for you to take advantage of the changes you've made to one picture and copy those changes to all of the other pictures in your shoot by using the sync settings.

I made a bunch of changes to the picture of my friend Destiny shown in **Figure 30.1**, and I've got it exactly where I need it. But this is one of about 100 pictures that I shot, and I would like to apply this effect to all of them. First, I'll hit the letter G to go back into Grid View mode.

In Grid View mode, you can see that the picture is selected and I have flagged it with red so that it's easier to see (**Figure 30.2**).

You can do this by pressing the number 6 on your keyboard. Now that I know this is the source picture, I can Shift-click to select a series of pictures, or Command-click (Mac) or Control-click (PC) to select a noncontiguous group of pictures, to which I want to apply the same changes (**Figure 30.3**).

Once I've selected the group of images, I'll move back into the Develop module. In the Develop module, the primary picture is still selected, but if you look below the image, you will notice that all of the other shots I selected in the Grid View are selected in the filmstrip as well (**Figure 30.4**).

Now I can press the Sync button in the lower-right corner of the Develop module to open the Synchronize Settings dialog (**Figure 30.5**). This allows me to decide which of the sliders in the Develop module I would like to include as part of the sync process. At this point, all I have to do is select the ones that I adjusted.

When you're selecting the sync settings,

keep in mind that Process Version is almost always going to be needed when you want to select a different picture in the series. This has to do with how Adobe processes the RAW file. If you deselect this option, you're going to get a warning. I recommend you always leave that on.

After selecting all of the sliders that I worked with, I'll go ahead and hit the Synchronize button. As Lightroom syncs the selected images, I can hit the letter G to go back into the Grid View mode and watch as all of the images I selected receive the changes I applied to my source picture. This is a huge time saver.

Now I'll select one of the pictures to which I copied the changes and hit the letter N to go into survey mode (**Figure 30.6**). This allows me to see side-by-side that the effects I applied to the source image have been successfully applied to the other image, saving me a ton of time.

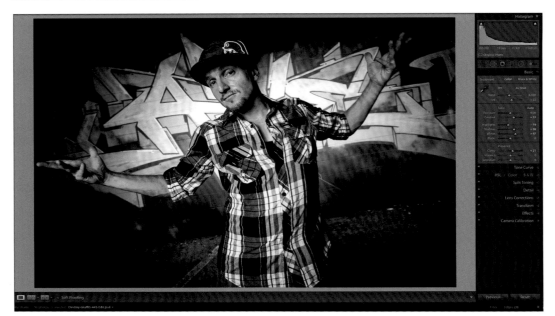

Figure 30.1 The amazing Destiny Shami!

Figure 30.2 I flagged my source picture with red so that it's easy to find in the Grid View mode.

Figure 30.3 I selected multiple images to which I want to apply the changes I made to my source picture.

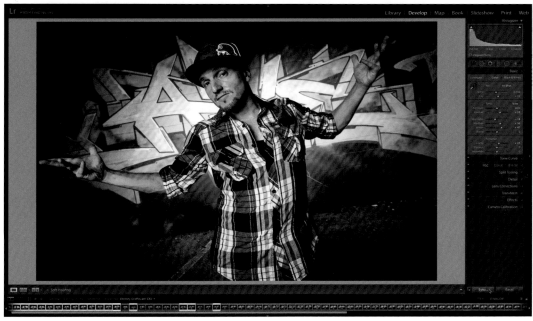

Figure 30.4 The images I selected in the Grid View are still in selected in the filmstrip.

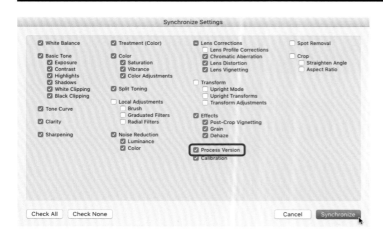

Figure 30.5 The Synchronize Settings dialog. I recommend always leaving Process Version selected.

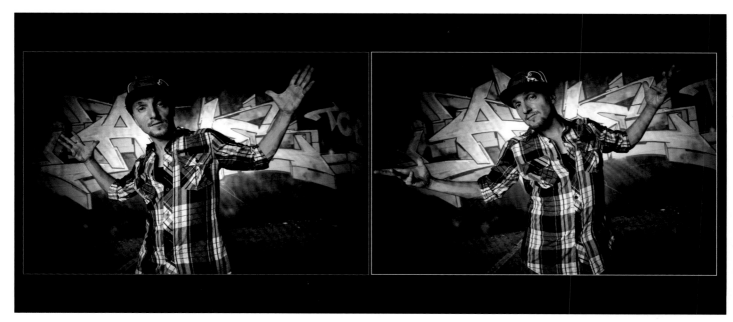

Figure 30.6 I successfully copied the settings from my source image and applied them to the other images I selected.

31. CREATING LIGHTROOM PRESETS

LIGHTROOM IS NOT just about getting the best out of your pictures; it is also about creating special effects and different treatments for your files. That said, when you spend all of your time working on a specific treatment, you'd probably like to be able to use that treatment again on another type of image. This is where Lightroom presets can definitely help you with your images.

At the top of the Presets panel on the left side of the Develop module there is a plus sign that allows you to save the current develop settings as a preset (**Figure 31.1**). Clicking on the plus sign opens the New Develop Preset dialog, where you can give your new preset a name (**Figure 31.2**). I named my preset "RC Selenium 1." Under Settings, you can check all of the changes you made for the development of the current picture. When you click Create, you will see the new preset appear under User Presets in the Presets panel (**Figure 31.3**).

You can now select another image to which you would like to apply your new preset, and simply single-click on the preset in the User Presets area. And just like that, the image is complete.

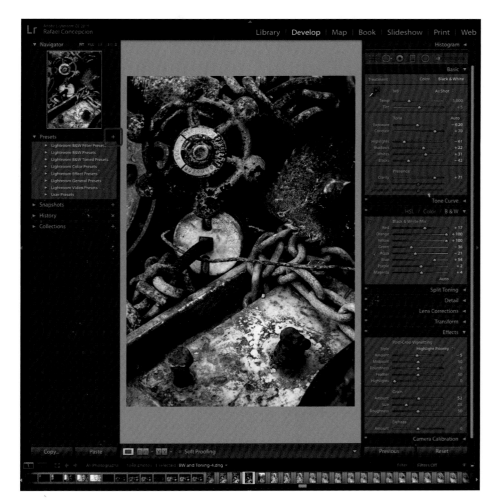

Figure 31.1 I made adjustments to this image in the Basic panel and the B&W panel, and I added some grain and vignetting in the Effects panel. I would like to save all of this information so I can use it again later on, so I'll click on the little plus sign at the top of the Presets panel.

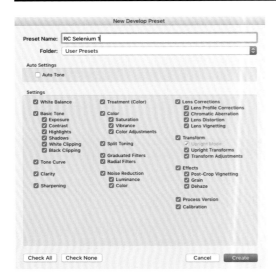

Figure 31.2 I named my new
preset "RC Selenium 1."

Figures 31.3-31.4 Presets give you a one-click treatment that's uniquely yours. You can easily reuse the settings for other pictures.

If you want to share your preset with others, simply right-click on the preset and select Export (**Figure 31.5**). You can save it anywhere on your computer, and then share the file with other individuals (**Figure 31.6**).

If you receive a preset from someone, the import process is just as easy. Right-click in your Presets area and select Import. Select the preset that you want to import and it will appear in the User Presets area.

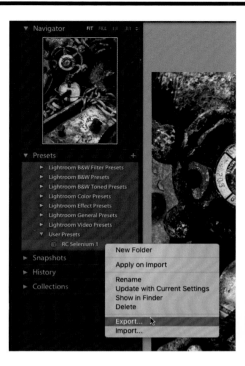

Figure 31.5 Exporting your Presets in Lightroom.

Figure 31.6 A preset file saved to my Desktop.

4

SHARING YOUR IMAGES VIA THE SLIDESHOW MODULE

CHAPTER 4

Now that you've developed all of your images so they're exactly the way you want them, it's time to share your work with the world.

In the past, you may have invited people to your house and had them flip through your photo albums, but these days we can create amazing videos with beautiful soundtracks that we can place on our mobile devices or share with one another online.

Lightroom makes it extremely easy for you to do this, but I have to be frank, the hardest part about making a slideshow is the sequencing of the images. Technically, you can create a slideshow in the better part of two minutes, but it can be tough to decide which picture goes first, which picture goes second, what mood you want to convey with the pictures you're showing, and what music you want to use. These are the things that are going to separate good presentations from great presentations.

Thankfully, my job is easy. I can walk you through the process of creating a slideshow and get you dialed in with what you need to know. The art part behind all of this is the fun part, and that's the part you'll spend a lot more time realizing.

32. ORGANIZE YOUR IMAGES IN A COLLECTION FIRST

WHEN YOU WANT to create a slideshow, the first thing you need to do is organize the images you want to include into a collection, so we'll start out in the Library module (**Figures 32.1** and **32.2**).

The benefit of selecting All Photographs in the Catalog panel is that you can take a look at all of your pictures across all of the different folders you've placed them in. This is the option I like to use when I want to take a look at everything I've done. From here, you can Shift-click or Command-click on a series of pictures to get them ready to add to a collection.

In the Collections panel, click on the plus sign and select Create Collection (**Figure 32.3**). In the dialog, you can create a name for the collection and choose whether to place it inside a collection set. You also have the option to include the currently selected photos in the collection, but I prefer to leave this option unchecked (**Figure 32.4**).

While it might seem like it's easier for you to include the selected photos right from the Create Collection dialog, I usually tell people to wait. When you choose this option and click Create, it will automatically bring you into the collection with the pictures that are selected. That sounds good, but if you want to add more pictures, you'll have to go back to the All Photographs area and scroll up and down to find where you were before you made the collection. To save yourself that step, I recommend leaving Include selected photos turned off.

Now the new collection is part of the Collections panel and you can just drag the selected images onto the collection (**Figure 32.5**). Once the images are in a collection, you can drag them around and place them in the order in which you want them to appear. Simply single-click on one of the images and drag it to its new location.

If you want to see how the images are going to flow from one image to the next, press Shift + Tab to hide the Lightroom interface, and use your left and right arrow keys to go back and forth within the collection (**Figure 32.6**).

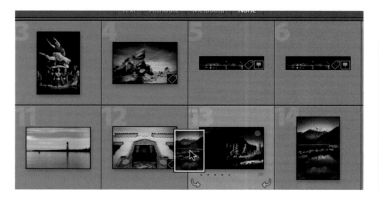

Figures 32.1-32.2 Moving images in the Catalog is a no-go. You're going to need a collection for that.

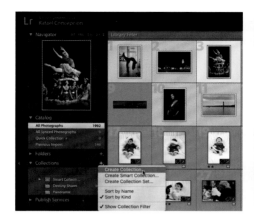

Figure 32.3 Creating a new collection.

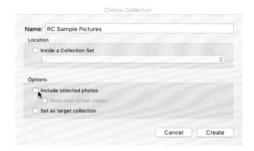

Figure 32.4 I prefer to leave the Include selected photos option unchecked.

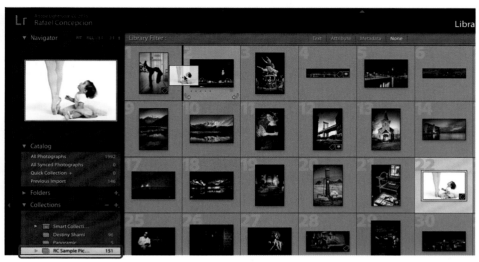

Figure 32.5 Drag the images you want to include in your slideshow onto the new collection in the Collections panel.

Figure 32.6 Press Shift + Tab to hide the Lightroom interface, and then examine the flow of your images without distractions.

You can even start a slideshow from inside the collection by pressing Command + Return (Mac) or Ctrl + Enter (PC). This will load all of the pictures into a temporary slideshow (**Figures 32.7** and **32.8**). You can't change any of the settings, but it will give you an overview of how the images are going to flow from one to the next, and then you can make the changes to the organization of the images accordingly.

Figure 32.7 When you press Command + Return (Mac) or Ctrl + Enter (PC) in the Slideshow module, Lightroom will prepare your images for a slideshow preview.

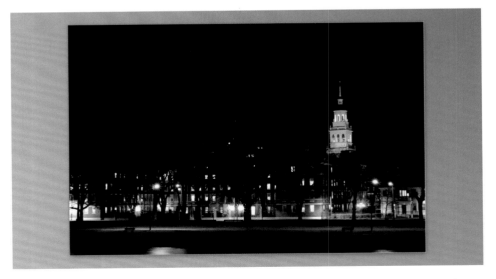

Figure 32.8 Lightroom plays the slideshow preview right from your collection.

AFTER YOU'VE FINISHED putting your images in the appropriate order, make sure the collection you created is selected in the Collections panel and switch to the Slideshow module. The first set of options that you'll see in the Slideshow module deal with the overall look of the slideshow in terms of colors, strokes, drop shadows, and how the images are positioned on the backdrop. These options can be controlled in the Options panel at the top, the Layout panel, and the Backdrop panel. The interface is pretty straightforward—it's one of those "if you like it, select the checkbox; if you don't, turn it off" kind of things. It's probably one of the easiest modules to work with.

The default slideshow includes a silver stroke (border) around each image, and each image has a drop shadow. Both of these features can be controlled in the Options panel. Simply uncheck Stroke Border and Cast Shadow if you do not want to use them. You can change the stroke width as well as the look of the drop shadow by adjusting the corresponding sliders. I prefer to use the circle directly under Angle to change where the drop shadow falls—if I want to use a drop shadow, that is. **Figures 33.1–33.4** show what some of the effects look like (although I've made them a little more pronounced than I normally would so they're easy to see in the book).

One of the spots that you definitely should not overlook is the Layout panel (**Figure 33.5**). The Show Guides option creates boundaries for your images that you can position however you want. This allows you to choose where your images are located on the backdrop. To the left of each slider is a box that allows you to link the corresponding guide to the other selected guides. The linked guides (white boxes) will move together when you adjust one of the sliders. When a box is not selected (gray), the corresponding guide can be moved independently from the others.

However, the most important part of the Layout panel is the Aspect Preview. The slideshow sits on a background of a specific size, which can be changed with the Aspect Preview drop-down menu (**Figure 33.6**). Setting this to 4:3 makes the slideshow much smaller. If you set it to Screen, it will use your default screen resolution, and 16:9 will give you a commonly used HD aspect ratio. These days, most of the monitors you use will use an HD format, so I would stick with the 16:9 Aspect Preview setting.

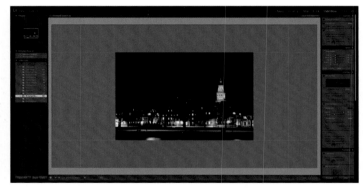

Figures 33.1-33.4 The Slideshow module is pretty straightforward. Don't want something? Just uncheck it.

Figure 33.5 Changing the Layout Guides in the Slideshow module.

Figure 33.6 Changing the aspect ratio in the Slideshow Layout panel.

The background of the slideshow can be controlled with the settings in the Backdrop panel. By default, Lightroom applies a color wash to the background. This means that the background gradually transitions from a specific color to the default background color. Usually Color Wash is set to a dark gray to create a nice fade into the default light gray background color (**Figure 33.7**).

If you do not want to use a background color wash, you can simply click on the Color Wash checkbox and it will be removed. If you want to change the color of the color wash, click on the swatch to the right of Color Wash and select a color from the color panel (**Figure 33.8**).

Figures 33.7-33.8 Changing the background Color Wash in the Backdrop panel.

I'm a big fan of using a black background so that there are no distractions for people viewing my pictures. I also don't like using a very wide stroke; I want a really thin, dark outline around the pictures.

I set my background color to black by clicking on the Background Color swatch in the Backdrop panel and selecting the black preset at the top of the color panel (**Figure 33.9**). In the Options panel, I set the Stroke Border to 1 pixel and input an RGB value of 8 percent across the board to create a dark-gray stroke (**Figure 33.10**).

Figure 33.9 Selecting a black Background Color in the Backdrop panel.

Figure 33.10 I like to use a narrow, dark-gray stroke.

Figure 33.11 This is how I like my slideshows. Pretty simple...black.

ADDING AN OVERLAY can be a good option if you want to make the slideshow a little bit more your own. I tend to not want to do this in the actual slideshow because I think it can take away from the message of the slideshow, but you may feel differently.

In the Overlay panel, you'll see that you have an Identity Plate set up. If you click on the Identity Plate checkbox, your name will appear in the upper-left corner of the slideshow (**Figure 34.1**). You also have the option to move your name around the slideshow frame (**Figure 34.2**), and you can change the color of the text by checking the Override Color option and selecting a new color with the color swatch.

If you want to change the Identity Plate text, click on the down arrow in the lower-right corner of the box and select Edit (**Figure 34.3**). In the Identity Plate Editor dialog, you can type in new text and change the font style and size (**Figure 34.4**).

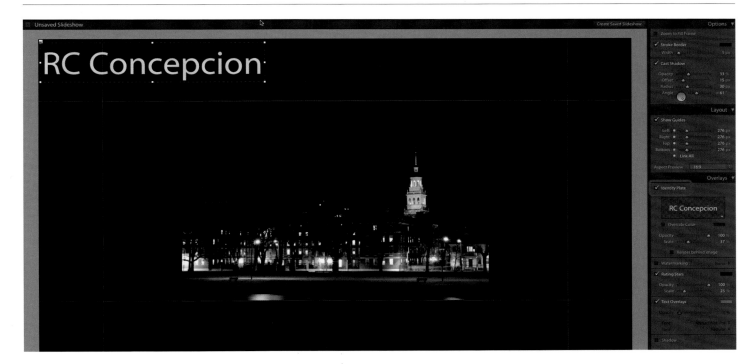

Figure 34.1 The Identity Plate—nice and big in the upper-left corner.

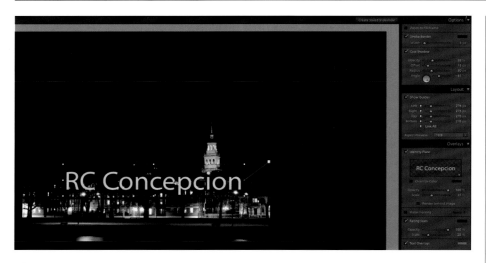

Figure 34.2 You can move the Identity Plate around the slideshow frame.

Figures 34.3-34.4 Changing the text in the Identity Plate.

Here's the thing: I'm not a big fan of using text here because I think it looks a little cheap. Everybody has the same text and everybody has the same style. It doesn't show personality. So, a lot of the time, I like using a graphical identity plate (**Figure 34.5**).

Open Photoshop and create a new document that's about 1200 x 275 pixels. Create a new layer and add some form of a logo (**Figure 34.6**). I use my Wacom tablet to sign my name. You can also do this with a mouse, or you can sign your name on a blank piece of paper and scan it. The point is that you want a logo or something similar on a blank layer.

Now add a couple of text layers to this. You can control the spacing a little bit better here. In **Figure 34.7**, I used an Orator Std font and moved the spacing of the letters a little bit. After you've added your text layers, merge all of the layers into a single flat layer and remove the background layer (**Figures 34.8** and **34.9**). This leaves you with a single transparent layer.

Figure 34.5 You also have the option to use a graphical identity plate.

Figure 34.6 Using the Wacom tablet to make a signature here is pretty easy. If you don't have one, you can always sign a blank piece of paper with a Sharpie and scan it.

Figures 34.7-34.9 I added additional text layers, merged all of the layers into one, and deleted the background layer.

I've created a folder on my hard drive called "Signatures Area," and that's where I save the file (**Figure 34.10**). I save it in a PNG format because that saves the transparency of the file.

All that's left to do is open the Identity Plate Editor, select "Use a graphical identity plate," click on Locate File, and browse to the new file you just created. Now you have something that looks a little bit more customized (**Figure 34.11**).

I'll be honest, though, I don't often use the identity plate in the Overlay panel. But I do use it in the Titles panel. Let me explain a little bit about why titles are important to me. When I create a slideshow, I want to control the experience that people have with my pictures. I don't want to hit play on a slideshow and immediately show my first picture to everybody. I'd like to have a moment to introduce myself and allow people to get ready to watch the slideshow. An intro screen is something that helps with this quite a bit (**Figure 34.12**).

Figure 34.10 I like saving these PNG files in a specific folder because I'm able to find them easily when I need them. It also makes creating Actions in Photoshop a lot easier.

Figure 34.11 The finished identity plate

In the Titles panel, click on the Intro Screen checkbox, and then click on Add Identity Plate. You can now follow the same steps we used previously to insert your custom identity plate, or you can use the text that is already there. This puts your identity plate at the front of your slideshow. You also have the option to set an Ending Screen with the same information.

When you play the slideshow, it will start with the Intro Screen, and then proceed to your images. If you're using your slideshow in a presentation, you can press the space bar to pause it when your Intro Screen appears, give your message, and then hit the spacebar again to continue with the slideshow.

While adding an overlay is not a great option for me, I think that they help in the title section greatly.

Figure 34.12 Using the Identity Plate as an Intro Screen.

35. ADDING MUSIC AND ADJUSTING TRANSITIONS

IF THERE IS one thing you can do to add an amazing mood to your slideshow, it's to include a soundtrack. Music with a slideshow is like peanut butter and jelly, or ham and cheese, or apples and cheddar—you get the idea. It's important to underscore what you're showing with something that people can follow from an aural standpoint. Let's go ahead and start working with a couple of different options that you can keep in mind when you're using music in Lightroom.

It's important to note that you can't just open up iTunes and add whatever music track you want to add. Most of the music in iTunes is copyrighted, and if you post it online, you could be on the receiving end of a takedown notice (best case) or even a lawsuit (worst case). So you need to find sources of royalty-free music that you can use. I'll share a couple of free and paid options, but keep in mind that you get what you pay for.

- **Incompetech.com:** Kevin MacLeod's website Incompetech offers an amazing collection of royalty-free music that you can use, provided you give credit appropriately (**Figure 35.1**). Make sure you take a look at the music FAQ section so that you know how to appropriately credit the music you choose to use.
- **AudioJungle.net:** This is a great place to find quick loops or music ideas and the prices are relatively low (**Figure 35.2**).

- **Pond5.com:** This site provides a great video and audio selection. Their costs are reasonable and their music quality is very good (**Figure 35.3**).
- **TripleScoopMusic.com:** This is probably my favorite site to use because they have an amazing amount of music covering a variety of different emotions and energies (**Figure 35.4**). This is a paid service, but the quality of music is second to none. This is where I go all the time.

Figure 35.1 The Incompetech royalty-free music site by Kevin MacLeod

Figure 35.2 The AudioJungle music site

Figure 35.3 The Pond5 music site

Figure 35.4 The Triple Scoop Music site

Once you've downloaded all of the music that you want to use, you can add it to your slideshow in Lightroom by clicking on the plus sign in the Music panel (**Figure 35.5**). One of my favorite features that has been added to Lightroom is the ability to add more than one .MP3 file to the list. All you have to do is highlight the .MP3 files you want to use and select Choose (**Figure 35.6**), and you'll see the list of all the .MP3 files appear in the Music panel.

You can adjust how the music interacts with your pictures by clicking on the Sync Slides to Music checkbox in the Playback panel (**Figure 35.7**). This will allow you to time the music to the slideshow. Use the Slide Length slider to adjust the amount of time each slide is displayed. The Crossfades slider adjusts the length of the fade transition between slides.

Clicking on Fit to Music will let you automatically set it up. The Audio Balance slider controls how the music will behave if you have a video file included in your slideshow. If you set this slider in the middle, the music and the video audio will play at the same volume. If you move the slider toward Music, the video audio will be played at a lower volume than the music. If you move the slider all the way to the Music end of the slider, you will hear *only* the music, and vice versa.

Lastly, one of the best options Adobe has added in the Playback section is Pan and Zoom. If you're a fan of Ken Burns's work, this is a good option for you. If you click on the Pan and Zoom checkbox, images will zoom in and out throughout your slideshow, creating a little bit more of a dynamic feel.

The key here is to spend some time thinking about the mood you want to evoke with your slideshow. The best sound selection is one that complements your images perfectly, so you don't want to just grab the first thing that you hear. How the slideshow sounds is as important as how it looks.

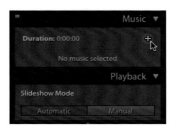

Figure 35.5 The Music panel in the Slideshow module.

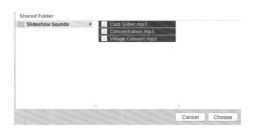

Figure 35.6 You can add multiple .MP3 files to the Music panel.

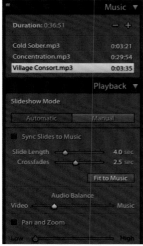

Figure 35.7 The Playback panel.

36. EXPORTING YOUR SLIDESHOW AS A VIDEO OR PDF

NOW THAT YOU have the music and the look of your slideshow taken care of, it's time to export it. You'll notice that there is a Preview button in the lower-right corner of the Slideshow module (**Figure 36.1**). This will create a preview that you can watch in the center workspace in Lightroom. If you want to stop the slideshow, simply click on the center of the show and it will stop.

If you click on the Play button to the right of the Preview button, the slideshow will play in full-screen mode (**Figure 36.2**). The Preview and Play options are great if you're working with a slideshow and you want to

present it from inside Lightroom, but more often than not, you'll want to take this to the web.

The Export Video option in the lower-left corner of the Slideshow module will export your slideshow as a video file (**Figure 36.3**). You can then upload the video to a site like Vimeo or YouTube to share it with everybody. The Export PDF option creates a PDF of the slideshow with one slide per page. This is helpful when you want to send a collection of images to a client via email. Note that music will not be embedded in the PDF. If you want music, you'll need to export a movie.

In the Export Slideshow to Video options (which you'll see when you click on Export Video), you'll need to set a name for your slideshow as well as pick a Video Preset. In the Video Preset drop-down menu you can choose between 1080p and 720p, or select older formats like 640 x 480 or 480 x 270. If you want to be able to email your slideshow, you'll need to choose a relatively small format, such as 480 x 270. If you want to do something a lot bigger, use 1080p. This option is going to be the best for something like YouTube.

Figure 36.1 Previewing the slideshow in Lightroom.

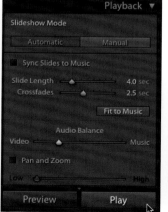

Figure 36.2 The slideshow Play button.

Figure 36.3 The slideshow export options.

5

CREATING A BOOK
IN LIGHTROOM

CHAPTER 5

While sharing your pictures online seems to be de jour, nothing beats physically holding a book of your imagery. I'm a big proponent of organizing your work and sequencing it to a point that you can share a collective body of photography with others, and a book is one of the best mediums for this.

Lightroom has established a partnership with Blurb, a wonderful company that produces amazing-quality books, so it's easy to create a beautiful book right in Lightroom. All you have to do is decide on the size and type of pages you want to use, and then create layouts for the images you want to share. In just a few clicks, you can be the author of your own book.

But you don't have to stop there—creating a book in a PDF format can be a great way to share your portfolio of images or a cool vacation slideshow with others.

Creating a book in Lightroom is pretty straightforward, so let's go ahead and get started.

37. EXPLORING THE BOOK LAYOUT OPTIONS

BEFORE YOU BEGIN to create a book, it's a good idea to place the images you want to work with inside a collection (**Figure 37.1**). This allows you to control the overall look and feel of the book by organizing the images in a manner that is suitable for you.

This is no different than working with a slideshow. When you move to the Book module, Lightroom will place all of the images in the selected collection into an automatic layout, which is based on the settings in the Auto Layout panel.

In the Auto Layout panel, you can see that the pages are aligned according to a specific preset (**Figure 37.2**). If you want to get rid of all of that preset information and start from scratch, just click on the Clear Layout button in the Auto Layout panel, and all of the images will disappear from the book layout.

At this point, you can go ahead and select one of the built-in presets and press the Auto Layout button to get everything organized the way you want it (**Figure 37.3**).

The Lightroom Book module designs books based on the Blurb online publishing service (blurb.com). This a great service that provides quality books in a range of sizes and formats. In the Book Settings panel at the very top of Lightroom's Book module, you can choose the size, cover type, and paper type for your book (**Figure 37.4**).

The Logo Page drop-down menu allows you to select whether or not you want to include the Blurb logo at the back your book. If you remove the Blurb logo by selecting None, the cost of your book will be a little higher, but I think it's worth it when you're producing a book for a client. At the bottom of the Book Settings panel, you will see the Estimated Price for your book based on the selections you've made.

You can also publish your book as a PDF or a series of JPG exports, rather than creating a hard copy through Blurb. Just click on the Book drop-down menu in the Book Settings panel to select one of these options.

All of the images in your book collection are placed in the book layout in the main Lightroom workspace. You will also see all of your images in the filmstrip at the bottom of the window, with a marker above each picture letting you know how many times that picture has been used in your book layout (**Figure 37.5**).

As you look through each page of the book, you'll notice that the images are usually much larger than you want them to be. You may also see an exclamation mark in the upper-right corner of some pages. This tells you that the resolution of the picture does not guarantee a good print at the current size (**Figure 37.6**).

To make the picture smaller, and thereby increase its resolution, single-click on the picture and drag the Zoom slider to the left (**Figure 37.7**). You can also reduce the size of the image by adjusting the Padding slider in the Cell panel (**Figure 37.8**).

Figure 37.1 Organize the images you want to work with into a collection.

Figure 37.2 The Auto Layout option in Lightroom's Book module.

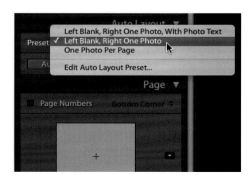

Figure 37.3 Selecting an Auto Layout Preset.

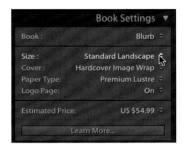

Figure 37.4 Book Settings for publishing a book through Blurb.com.

Figure 37.5 The filmstrip shows how many times each picture has been used in the book.

Figure 37.6 The exclamation mark warns you that the image may not print well at the current size.

Figure 37.7 Single-click on an image and adjust the Zoom slider to make the image smaller.

Figure 37.8 You can also change the size of the image on a page by adjusting the Padding slider on the Cell panel.

38. MANAGING PAGES AND INSERTING PICTURES

AS YOU LAY out your book, it's a good idea for you to see what it looks like overall. I recommend clicking on the Multi-Page View icon in the bottom-left corner of the main workspace [keyboard shortcut: Command + E (Mac) or Ctrl + E (PC)].

It's also helpful to decrease the size of your thumbnails so that you can see all of the pages and examine how they flow from one to another. Use the Thumbnails slider in the bottom-right corner of the main workspace to do so (**Figure 38.1**).

At any point in time, if you want to see what a two-page layout looks like, you can click on the Spread View icon, or use the keyboard shortcut Command + R (Mac) or Ctrl R (PC). This will show you two pages side by side so you can make a judgment as to whether or not you like the layout of the spread (**Figure 38.2**). You can see a single page by clicking on the Single Page View icon or by pressing Command + T (Mac) or Ctrl + T (PC).

Now that you have a good idea of what this book is going to look like, chances are you're going to want to remove some pictures so you can move the layout around. In the multi-page view, single-click on any page with a picture you would like to remove. Then press the delete key and the image will be removed from the page (**Figure 38.3**).

Adding an additional page is pretty easy. Once you've figured out where you want to place the new page in the layout, right-click on the page that comes immediately before that location and select Add Page from the context menu (**Figure 38.4**). The new page will appear right after the selected page.

When the new blank page is selected, you'll see an arrow to the right of the page number. Clicking on the arrow opens a menu of page layout options (**Figure 38.5**). Here, you can modify the page properties and select from a series of layout templates. There are options for one photo, two photos, or multiple photos in various layouts.

For my example, I'm going to use a two-photo, vertical layout. Once you've selected the layout, it's only a matter of going back into the filmstrip and finding pictures that will fit. Drag the pictures you want to use from the filmstrip into the empty cells on the page to add them to the layout (**Figure**

38.6 and 38.7). When you add a picture to the layout, you'll notice that the reference for how many times you've used the picture will change.

Another thing you're going to want to change is how the pictures are viewed on the page layout. You'll notice that in the earlier example, all of the pictures have been enlarged so that they fill each page, which often results in the images being cropped. Command-click (Mac) or Ctrl-click (PC) on the pages you want to modify so that you can make adjustments to multiple pages at once. Then right-click on any highlighted page and select Zoom Photos to Fit Cell from the context menu. This will turn the option off and each selected picture will be shown in its entirety with a little bit of white space around it (**Figure 38.8**).

You can even select multiple pages from your layout and move them around together. Once the pages you want to move are all selected, simply click-and-drag one of them to the new location and all of the selected pages will move with it (**Figure 38.9**).

Figure 38.1 Viewing the entire book layout with really small thumbnails makes it easier to move pages around.

Figure 38.2 A two-page layout in the Book module.

Figure 38.3 Deleting a picture from the Lightroom Book module.

Figure 38.4 Adding an additional page to your book.

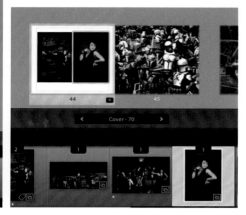

Figure 38.5 The Modify Page Layout menu.

Figures 38.6-38.7 Adding pictures to the layout.

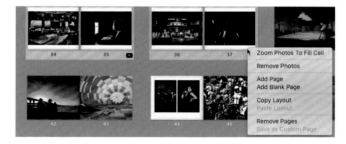

Figure 38.8 Turn off the Zoom Photos to Fit Cell option to show the entire image on a page.

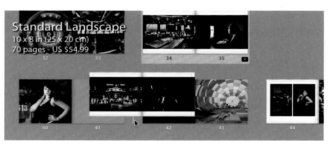

Figure 38.9 Moving multiple pages in a book layout.

39. CREATING TWO-PAGE SPREADS AND MODIFYING BACKGROUNDS

NOW THAT WE'VE made some basic layout changes, let's talk about how to spread one picture across multiple pages. First, you need to add two blank pages to the existing layout (**Figure 39.1**). Select the page on the left and click on the arrow in the bottom-right corner to open the Modify Page options. We've been using the one- and multiple-photo page layouts, but now we can move down to Two-Page Spreads (**Figure 39.2**).

When you click on Two-Page Spreads, you will see that there are various layout options for the spread. I like the spread with a white boundary box around it. Once you've selected the layout, you can go into the filmstrip and drag the picture you want to use onto the two-page layout (**Figure 39.3**). You can control how much of the picture you can see by zooming out (**Figure 39.4**). Single-click on the image to bring up the Zoom slider.

You can also insert graphics or colors onto the backgrounds of your pages. If you want to do this to an individual page or spread, go into the Background panel and uncheck Apply Background Globally. Next, highlight the two-page spread that you just created.

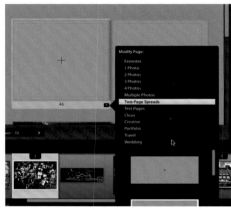

Figures 39.1-39.2 I find it's better to make the two-page layout from blanks rather than change an existing layout in Lightroom.

Figure 39.3 Drag your picture directly onto the new two-page spread.

Figure 39.4 Zoom out on the image to see the full image on the spread.

Now you can grab the exact same picture from the filmstrip and drag it into the Drop Photo area (**Figure 39.5**). This will create a washed-out background for the selected spread. You can further customize the background by changing its opacity with the Opacity slider (**Figure 39.6**).

Figure 39.5 To add a picture as a background, simply drag it from the filmstrip onto the Drop Photo area in the Background panel.

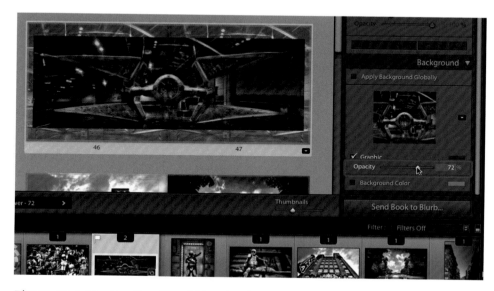

Figure 39.6 Use the Opacity slider in the Background panel to make the background image more or less visible.

You don't have to use existing pictures for the background. In **Figure 39.7**, you can see that I've selected a page with one picture and clicked on the arrow to the right of the Drop Photo area in the Background panel. This opens a menu of thematic graphics that you can use for your backgrounds. It's easiest to review the various backgrounds by applying them to a page in the Single-Page View (**Figure 39.8**).

Let's suppose you want to add elements that are going to run across all of the pages. Start by selecting all of the pages to which you want to apply this background element. I decided to give all of the pages in my example a black background, so I selected everything but the two-page spread that I created previously.

Next, put a checkmark in the Background Color checkbox at the bottom of the Background panel, and then click on the color swatch to open the Background Color picker (**Figure 39.9**). Select the color you want to use by clicking on one of the preset color boxes at the top of the box, or by clicking on the color bar with the eyedropper.

You can also select a light background color and combine it with a graphic.

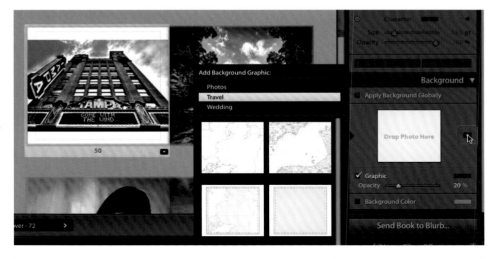

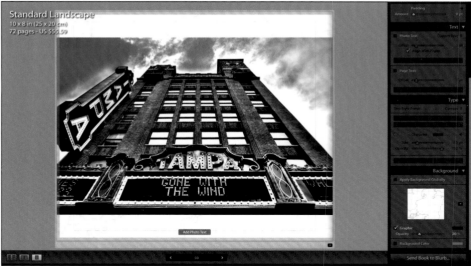

Figures 39.7-39.8 Selecting one of Lightroom's preset background graphics.

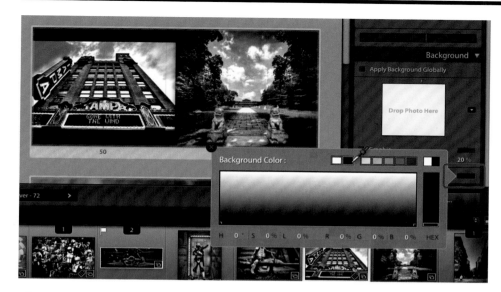

Figure 39.9 I chose a black background to give my book a clean and consistent look.

40. CREATING CUSTOM PAGE TEMPLATES

THE BOOK MODULE in Lightroom gives you the option to create a custom page template that you can apply to other pages in your book. Let's start by going over some of the options you can use to create a custom page.

In **Figure 40.1**, you can see that I've taken one of the pages in my layout and made the cell a lot smaller by adjusting the Padding slider in the Cell panel. I've also made sure that the picture is zoomed all the way out. This allows you to see all of the image on the page clearly.

When you're using Single Page View, you will notice that you have an option to add photo text (**Figure 40.2**). This is a great place for you to add some descriptive text or a title and caption. Click on Add Photo Text at the bottom of the page to open the text box. This also puts a check in the Photo Text checkbox in the Text panel on the right side of your screen (**Figure 40.3**).

You can select the type of text you want to use by clicking on the drop-down arrow in the text box at the bottom of your page, or on the drop-down menu at the top-right of the Text panel (**Figure 40.4**). The Custom Text option allows you to put in whatever text you choose, but this can become a little redundant if you're trying to enter text for multiple pages. I recommend that you use the title and caption information that you added back in the Library module.

When you click on the drop-down, you will notice that there are Title and Caption options available, but what if you want to add both a title and a caption? That's when you would use the Edit option, which opens the Text Template Editor.

In the Text Template Editor, you can add individual fields, whether it be Image Name, Numbering, EXIF data, or IPTC Data (where the Title and Caption options are; **Figure 40.5**). Simply select the information you would like to include and click on the Insert button next to those fields.

You don't want the title and caption to run into one another, so before you click to insert the caption in the Example field, add a colon and a space after the word Title (**Figure 40.6**). This will give you a little bit of extra space between the two.

You have now created a preset that you may want to use later, so it's a good idea to click on the Preset drop-down menu at the top of the Text Template Editor and select Save Current Settings as New Preset (**Figure 40.7**). Enter a name for your new Preset and click Create. Click Done at the bottom of the Text Template Editor, and your text will appear in the text field at the bottom of your page.

Figure 40.1 I gave my image a lot of room on the page by adjusting the Padding slider in the Cell panel and the Zoom slider.

Figures 40.2-40.3 Enabling the Photo Text for a page.

Figure 40.4 Selecting the type of information to include on the page.

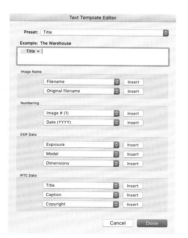

Figure 40.5 The Text Template Editor allows you to select what type of information to include on your page.

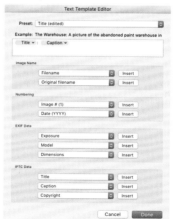

Figure 40.6 Adding a colon and a space between the Title and Caption in the Example field gives you some space between the two types of text on the page.

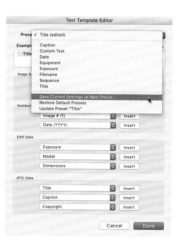

Figure 40.7 Save your Photo Text options as a new Preset.

Once you have that set, you can change the appearance of the text by selecting all of the text in the text field, and then adjusting the font, type, color, size, opacity, or orientation in the Type panel (**Figure 40.8**).

When you make changes in the Type panel, you should save these settings as a preset as well. Click on the Text Style Preset drop-down menu and select Save Current Settings as New Preset (**Figure 40.9**). Give your preset a name and click Create. Now when you save this page as a custom page, the text style information will be included as well.

After doing a lot of work on this cell, you'll want to make sure that you can save this information to use on another page. Right-click on the center of the page and select Save as Custom Page (**Figure 40.10**). When you select another page in your book and click on the drop-down in the lower-right corner of the page, you'll have an option that says Custom Pages (**Figure 40.11**). You can select any of the custom pages that you've created, and the image size and text options from the custom page will be applied to the selected page (**Figure 40.12**).

It's important to note that if you made any changes to the background cell of the image prior to making this style, that information will not be carried over as part of the custom page. You may have to go into the Background panel and change your color manually.

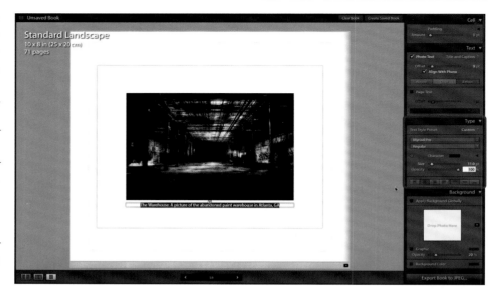

Figure 40.8 Fine-tuning the text with the options in the Type Panel.

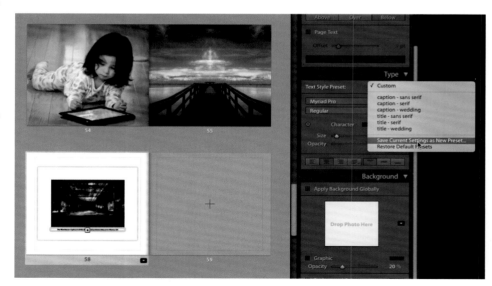

Figure 40.9 Saving the text style as a preset.

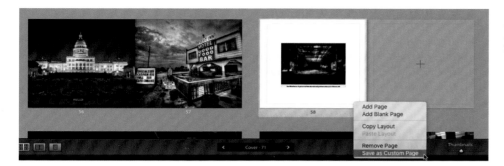

Figure 40.10 Save your page as a custom page so you can copy its settings onto other pages in your book.

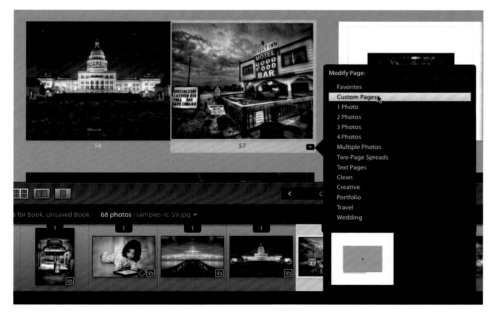

Figure 40.11 Any custom pages that you make will appear as an option when you select Custom Pages in the Modify Page menu.

Figure 40.12 I copied the image size and text options I used for the previous page onto another page in my book.

41. CREATING A CUSTOM AUTO LAYOUT

CREATING A BOOK is really a labor of love, and you spend a lot of time organizing pages in a manner that makes sense to you. However, you can streamline a lot of the process by using the Auto Layout options.

If you know you're going to be adding individual pictures on the left page and multiple pictures on the right page, you can save that layout option as a preset, making it easier to quickly create a layout with the click of a button later on.

In the Auto Layout panel, the Preset drop-down menu has an option called Edit Auto Layout Preset (**Figures 41.1** and **41.2**). Clicking on that will allow you to create a standard automatic layout for the left and right pages in your book. The template options that you see in the Auto Layout Preset Editor are very similar to the template options you would see if you clicked on the arrow in the lower-right corner of a selected page (**Figure 41.3**).

You can specify how you want the images to be positioned on the page and whether or not you want to add photo text. You can also decide whether photos should be zoomed to fill the page—in which case they will likely be cropped—or zoomed to fit the page.

Once you've configured your layout options, click on the Preset drop-down and select Save Current Settings as New Preset (**Figure 41.4**). Give your preset a name and click Create (**Figure 41.5**). Click Save in the Auto Layout Preset Editor, and your new preset will appear in the Preset drop-down menu in the Auto Layout panel.

I don't want you to lose any work that you've done to create a book, so let's talk a little bit about the Create Saved Book option that you see in the top-right corner of the main workspace (**Figure 41.6**). When you select this option, Lightroom saves the layout you have created inside the collection itself. It saves page backgrounds, type, organization, and all of the pages that you've made, so you can always come back to this layout if you want to. It also saves all of the pictures that you've used in this layout.

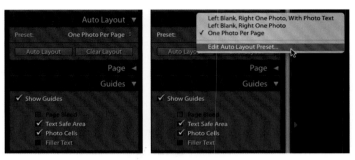

Figures 41.1-41.2 Editing the Auto Layout Preset.

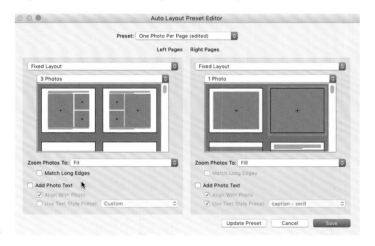

Figure 41.3 Whenever I make a book, I don't like adding any more than three pictures to a page. But how many you add is entirely up to you.

Click on Create Saved Book, give your book a name, and select the collection in which you want the book to be saved (**Figure 41.7**).

The name of your book will appear in the Collections panel under the collection in which it was saved (**Figure 41.8**).

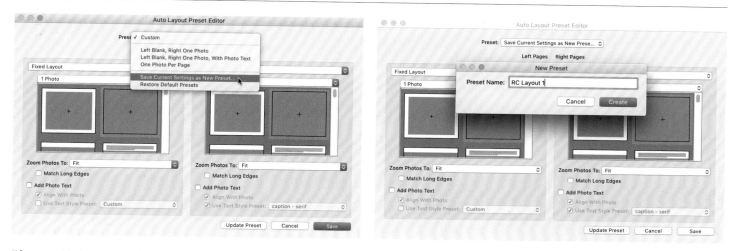

Figures 41.4–41.5 Saving a new Auto Layout Preset in Lightroom.

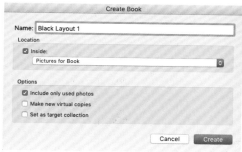

Figures 41.6–41.7 The Create Saved Book option will save your book and all of its settings in one spot so you can go back to it later.

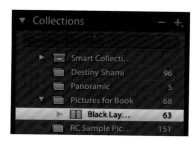

Figure 41.8 Your book will appear in the Collections panel under the collection in which you saved it.

Now you can click back on the collection (it should be directly above the saved book layout in the Collections panel), select Clear Layout in the Auto Layout panel, and then apply your preset to the images in the collection by selecting it from the Preset drop-down and clicking Auto Layout (**Figure 41.9**).

At this point, if you want to move an image around in the layout, you can always click-and-drag the image onto another one to swap the two. Using the Multi-Page View will help you to see how best to organize and arrange your images. You can drag images on top of one another and swap them out until you get the layout that you want.

As soon as you've confirmed all of your layout choices and you're happy with the book you've created, you're ready to send it to Blurb. Click on Send Book to Blurb in the lower-right corner of the Book module, and you will be prompted to sign in to the Blurb website where you can complete your purchase (**Figure 41.10**).

If you've selected the PDF or JPEG option from the Book drop-down menu in the Book Settings panel (see Lesson 37), the button in the lower-right corner will say Export Book to PDF or Export Book to JPEG. When you click on it, you can choose where you want to save the PDF or JPEG file on your computer (**Figure 41.11**).

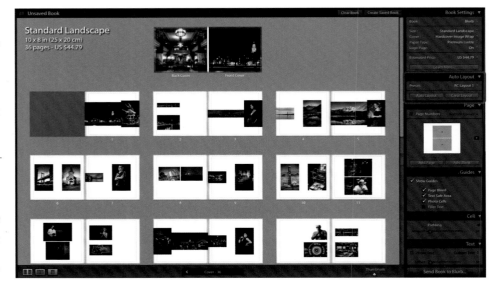

Figure 41.9 Your new layout—in the push of a button.

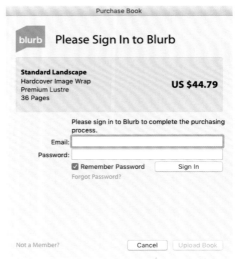

Figure 41.10 Sending the book to Blurb.

Figure 41.11 Saving your book as a PDF or JPEG.

Figure 41.12 The cover image for my book.

6

PRINTING IMAGES

CHAPTER 6

It is amazing to think about how much we spend in terms of both time and resources on our photography. Between cameras and lenses, trips and education (and this book as well), and all of the other special gear, we go all out to fuel our passion and make wonderful pictures.

When we get home, we process these pictures and with a push of a button, all of our work and all of our passion is online for us to share with everybody. We're so quick to post our images on Instagram and Facebook to share the product of thousands of hours and thousands of dollars, and all of that information is gone in the flick of a finger.

I believe that the exclamation point you can put on your photographic vision is to realize that vision in a print. You have a completely different arsenal of options available to you when you start looking at the print as the final note to your song—from the paper you use, to the size of the print, to the sharpness of the image, to whether or not you employ black-and-white techniques.

The problem with making a print is that people are still freaked out about how to make the colors they see on their screen match the colors that come out of the printer. This was a problem for a very long time, but I think it would shock you to see how easy it is to get exactly what you want with just a couple of steps.

42. SETTING PRINT PREFERENCES

WHEN YOU LOOK at the Lightroom Print module, it may seem like there are a lot of things you need to focus on, but it's pretty straightforward, provided you go through it in a specific manner (**Figure 42.1**).

The first thing I usually do in the Print module is adjust the page setup. Think of it this way: the one thing you know right now is the size of the paper you're going to use to make a print, so take care of that first.

Click on the Page Setup button in the lower-left corner of the Print module. This will open the Page Setup dialog where you can select your printer and paper type (**Figure 42.2**). Make sure that your printer driver is set up and that your printer is connected to your computer via a USB cable or a wireless network. If the correct driver is installed, you should see the printer in the Format For drop-down menu. The paper sizes

that your printer is able to support will be listed in the Paper Size drop-down menu in the Page Setup dialog.

Next, select the Orientation for your picture: landscape or portrait. I usually leave the Scale option at 100%—there's no real need to touch it. Click OK to save the page setup.

From here, you have three different options to make a set of prints. Let's cover the basic ones that you see in the Layout Style panel. In a Single Image setup, you're printing just one picture on one sheet of paper. If you select the Picture Package option, you have the option to use the same size sheet of paper, but you can add multiple copies of the same image at different sizes by clicking on the options in the Cells panel (**Figure 42.3**). You can select from commonly used picture dimensions, or click on one of the drop-downs to set a custom size.

The Custom Package option allows you to make even more changes to the page. The benefit of this option is that you can add different pictures to a single page (**Figure 42.4**), whereas the Picture Package option only allows you to add the same image multiple times. If you want to print two different images to a page, Custom Package is the option to use. All you have to do is drag each picture from the film strip onto the page and you're good to go.

For this example, we'll focus on setting up a single picture for print. Highlight the picture you want to print in the filmstrip and select Single Image from the Layout Style panel. You can adjust how the margins of the page are going to affect the picture with the settings in the Layout panel.

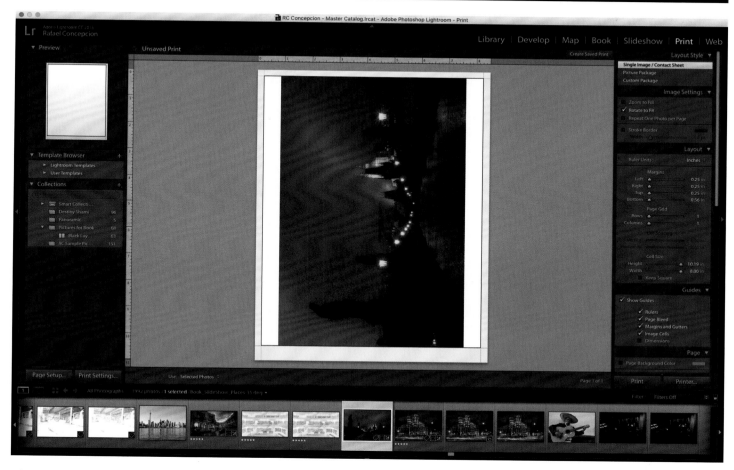

Figure 42.1 Your image is corrected and now you want to print it.

Figure 42.2 Select the printer, paper size, and orientation of your image on the page in the Page Setup dialog.

Figure 42.3 The Picture Package option in Lightroom. Select from common picture dimensions in the Cells panel.

Figure 42.4 The Custom Package option in Lightroom. You can arrange pictures of different types and sizes on a single page.

You can adjust each margin individually by moving the slider, or you can click on the margin measurement to the right of the slider and type in the specific measurement you need, which is what I like to do. Use the tab key on your keyboard to move down from one field to the next.

This adjusts the overall size of the image, but you'll see a guide (black line) that appears around it. This is usually the cell size, and the cell size could be different from the margin size. You can adjust the cell size with the Cell Size Height and Width sliders at the bottom of the Layout panel. To avoid confusion, I recommend adjusting the Height and Width sliders until the cell size matches the boundaries of the picture (**Figure 42.5**).

Figure 42.5 Adjusting the layout guides to match the boundaries of the picture.

Here's a quick tip to keep in mind: when I'm printing a picture, I like to set a light stroke inside the border of the picture (**Figure 42.6**). There are times when I'm printing a high-key image and the white background will blend into the page that the image is printed on, making it difficult to see where the picture ends. A simple one-point stroke helps to define the boundary of the picture itself.

I also find the Dimensions checkbox in the Guides panel to be extremely useful when I'm making a print, so make sure you have that selected (**Figure 42.7**). This shows the dimensions of the image on the screen, so you always know the exact size of the image you're working with.

When you're printing a single image, you can also add a caption and title information. In the Page panel, put a check in the Photo Info checkbox and select Title and Caption from the drop-down menu (**Figure 42.8**). Lightroom will read the EXIF information embedded in the file and add the title and caption to the bottom of your image. You can adjust the font size with the drop-down menu at the bottom of the Page panel.

So there's your simple setup: set the page, adjust your margins, and add any additional information, and now you've got a pretty good layout that you can use for printing.

Figure 42.6 A one-point stroke will make a picture stand out from the paper. This is especially helpful when you're working with a high-key shot.

Figure 42.7 The Dimensions setting makes it easy to see the size of the image you're working with at any time.

Figure 42.8 Adding text information to a picture in Lightroom.

43. CHOOSING A PAPER—LIKE WINE PAIRING FOR PHOTOGRAPHY

PHOTOGRAPHY IS ALL about collecting stuff, whether it be the perfect lens or the perfect camera bag or the perfect filter. You'd be surprised by how much stuff you can accumulate in the process of trying to make great pictures. This translates completely when you start talking about making a print, and opens up new ways for you to express yourself with your work.

Ansel Adams once said, "the negative is the score and the print is the performance," so how you create a print can be very different from picture to picture. The material you print on can also vary greatly—from glossy to matte papers, or canvas to metallic papers.

Deciding on the type of paper to use for the image you're printing is almost like pairing wine with a meal. Yes, there are some general rules regarding when you should serve white wine or red wine, but to be honest with you, I never really know when I'm supposed to drink one or the other, and I kind of just go at it alone after trying a bunch of different things. I'll share a couple of the places I go to when I'm looking for paper.

Before you start any journey to find the best paper for your images, do not discount the paper from your printer manufacturer. This could be a great way for you to experiment with papers getting out of the gate. Canon and Epson are probably the two biggest companies on the print side, and their paper selection has gotten incredibly good over the last couple of years (**Figures 43.1** and **43.2**).

If I'm using my Canon Pro-1000 printer, I often like to use their premium Pro Luster Photo Paper. It's a good, middle-of-the-road photo paper that has a nice feel and the colors look really good.

On the Epson side, I'm a huge fan of their Exhibition Fiber Paper. It's a little bit heavier than a premium luster paper, but it still has the same type of sheen—which is a very soft sheen—and I think it reproduces colors extremely well. While you're there, I would also take a look at their Hot Press Bright paper, which is a beautiful matte paper that has a really nice feel.

Red River Paper is another company to consider (**Figure 43.3**). Some of my favorites produced by them are the 75lb Arctic Polar Luster and the 80lb RR Luster Duo double-sided paper. The Luster Duo is a heavier paper—at 80lbs, it's about 300 GSM, so this is going to be a good bet.

One of the things I love about all of these companies is that they often sell a sampler pack of all of the different types of papers they produce, or they will send you sample images that have been printed on different papers. This allows you to experiment with different papers and decide for yourself which one gives you the results you want for a specific image.

When it comes to photo paper, there is no right or wrong; that's the beautiful part about it.

If you've been looking at Ilford, my favorite paper they've made is the 310 GSM Gold Fibre Silk (**Figure 43.4**). This paper has a really nice tonal range and beautiful colors because of its baryta properties (barium sulfate).

Figure 43.1

Figure 43.2

Figure 43.3

Figure 43.4

Next up are the folks at Canson. They produce a beautiful paper called Infinity Platine Fibre Rag 310 GSM (**Figure 43.5**). You're probably noticing a pattern here: I like heavier papers. When you print on these papers, it gives the print a certain amount of seriousness that you feel when you're holding it. The color reproduction is also beautiful, so a print on this paper is definitely going to make an impression.

The paper company that I keep coming back to time after time has to be Hahnemühle (**Figure 43.6**). They make some of the world's best papers and they have a great range for you to experiment with—from thin, glossy papers to really thick, matte papers; canvas; bamboo; you name it. My favorite is the William Turner 310 GSM paper—just beautiful.

You've probably recognized that I have a specific leaning: I like soft papers, I like heavy papers. That heavy feeling of the paper and the color reproduction tends to make photographs look very artistic, and it leaves an impression with the person when they're holding the paper. That's very important to me, but your results will vary.

Figure 43.5

Figure 43.6

44. PRINT RESOLUTION

IN LESSON 42 I mentioned that the Dimensions checkbox in the Guides panel can provide some helpful information (**Figure 44.1**). This is where it's going to come in handy.

Let's say we have an image ready to print on a 17 × 22-inch sheet of paper, and it looks like the overall cell size is about 20 × 11 inches. But we need to know the resolution of the image that we're working with (**Figure 44.2**).

If you look at it from a general point of view, most images print the sharpest at about 240 pixels per inch, or 240 ppi. In the Print Job panel you will see a Print Resolution checkbox with 240 ppi written next to it. This upsamples any image with a resolution lower than 240 pixels per inch to get it to a target resolution of 240 ppi. However, we need to know the original resolution of the image in order to judge whether this will give us a good print.

Make sure you've selected the Dimensions checkbox in the Guides panel so that you see the image dimensions at the top of the cell. Now when you uncheck the Print Resolution checkbox, you will see the resolution of the image next to the dimensions. In **Figure 44.3**, you can see that our example image is 20 × 11 inches at 368 pixels per inch—this file is huge. There is more information in the file than I need to get a good print of the image. In fact, I could probably print this file much larger and still get a really sharp image because the resolution is so high.

Figure 44.1 Make sure you put a check in the Dimensions checkbox.

Figure 44.2 Checking the print resolution on a file.

Figure 44.3 Uncheck the Print Resolution checkbox to see the original resolution of an image file.

In **Figure 44.4**, I have a low-resolution JPG of Dancing House. Notice that I've unchecked the Print Resolution checkbox, and Lightroom is telling me that if I were to print this image at 19 × 13 inches, my resolution would only be 76 ppi. That's not good at all. But I wouldn't know this information if I had that Print Resolution checkbox checked. The ppi would not be shown next to the dimensions and I'd have to be okay with Lightroom taking the image from 76 pixels per inch all the way up to 240.

This doesn't necessarily mean that the print is going to be bad, but you do need to consider whether or not you want to print with that much of a resolution jump. Any time you let Lightroom upsample your image, the software makes a prediction of what the missing pixels would look like based on the pixels that are there. I'm completely comfortable with making a jump from something like 180 ppi to the 240 ppi range. Lightroom's upsampling technology is pretty good at getting to a final print dimension that doesn't

Figure 44.4 At approximately 19 × 13 inches, the resolution of this image is only 76 ppi.

look to bad. But I begrudgingly make that concession. If I see numbers that are under 100 ppi, I'll always opt for a smaller print. I equate this to jumping from one rock to another across a pond. The closer those rocks are to one another, the more comfortable I am in making the jump.

If you lower the dimensions of the image, you will notice that the resolution will increase. In my example, the maximum resolution I could get for this picture would be in the 250 ppi range, and that would require me to resize my image to about 6 × 4 inches (**Figure 44.5**). So that's about as big as I can go. In this case, I would probably choose a different paper size and print the image with a really big matte.

When you're planning to print an image, you need to know how much information you have to work with so that you can make a decision as to how big your print can actually be. Checking the Dimensions checkbox and unchecking that Print Resolution box will give you the information you need.

Figure 44.5 I would need to resize my image to about 6 × 4 inches to get a high enough resolution for a good print.

45. GET THE BEST COLOR WITH AN ICC PROFILE

IN LESSON 43 I discussed different types of photo papers. This information is going to be very handy as you start working with the print job because it dictates how you send all of the information to the printer from a color standpoint. When you're printing an image, the printer needs to know what type of paper you are using—soft paper versus resin-coated paper, glossy paper versus luster paper, and so on. Just because the printer can spit ink onto the page doesn't necessarily mean that all paper will accept the ink in the same way.

Imagine if I gave you a sheet of loose leaf paper and I told you to put a drop of water on it. The water would dissipate into the paper in a specific way. If I gave you a piece of newspaper and had you do the same thing, the water would behave differently. And if I gave you a piece of toilet paper and had you repeat the process one more time, the water would behave differently once again. How a paper reacts to water—or ink, in this instance—will vary from paper type to paper type.

In the Print Job panel there is a section called Color Management, which is where Lightroom hands off the color and brightness information to the printer (**Figure 45.1**). This is where you need to tell Lightroom, "Listen, I have some specific instructions for what you're supposed to do with these colors." These instructions are known as an ICC profile. The ICC profile is specific to the printer and paper you're working with.

For example, if I'm going to make a print with my Canon Pro-1000 printer, I want to use the Canon Pro Luster Photo Paper. So, I'll click on the Profile drop-down menu in the Print Job panel and select Other from the list. This opens the Choose Profiles dialog with all of the different paper types for the Canon Pro-1000, which were installed as part of the driver (**Figure 45.2**). In this instance, all I have to do is select the paper I want to use (Cannon Pro-1000/500 Photo Paper Pro Luster) and I'll be set.

Figure 45.1
Color management
in Lightroom.

Figure 45.2 The Choose Profiles
dialog includes all of the different
paper types that were installed as
part of the driver for your printer,
as well as any custom ICC profiles
you have installed.

But what happens when you want to use a type of paper that's not listed, such as a William Turner paper from Hahnemühle? In this case, you will to need to go to the paper manufacturer's website to get the ICC profile that is specific to the printer and paper you want to use (**Figures 45.3** and **45.4**). Once you input the appropriate information, you can download the correct ICC profile and instructions for use.

I'm installing this on a Mac, so it's going to go in *Macintosh HD > Library > ColorSync > Profiles* (**Figure 45.5**). If you're using a different computer and you aren't sure where the ICC profile should be stored, make sure you read the instructions that are included with the ICC profile download.

Once you've added the new ICC profile to the appropriate folder on your computer, you should be able to see it listed in the Choose Profiles dialog in Lightroom (which you access by clicking on the Profile drop-down menu in the Print Job panel and selecting Other; **Figure 45.6**). If you installed the profile while Lightroom was running, you may need to restart Lightroom.

Figure 45.3 There's an ICC Profile button right on the hahnemuehle.com homepage.

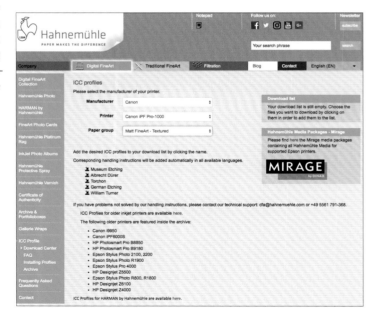

Figure 45.4 Select the printer and paper you want to use, and then download the appropriate ICC profile.

Figure 45.5 Installing the ICC profile on a Mac.

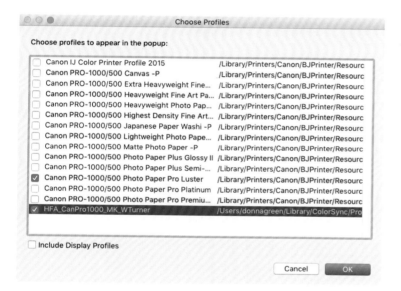

Figure 45.6 The new ICC profile will be available in the Choose Profiles dialog after you restart Lightroom.

Once you have that set, the only thing left is to confirm that the printer has all of the instructions it needs regarding tray-loading and paper type. Click on the Print Settings option in the lower-left corner of the Lightroom interface to open the Print dialog. Make sure the correct printer is selected, and then select Quality & Media from the drop-down menu in the middle of the dialog (**Figure 45.7**). Now you can select the Media Type, Paper Source, and Print Quality. The Media Type and Print Quality information should be included in the instructions that were downloaded with the profile (**Figure 45.8**).

While you're here, I suggest also checking the Color Matching section (**Figure 45.9**). When you have a custom ICC profile selected, the options in this section should be grayed out or turned off. Select Save and you're good to go.

Now that your print settings are taken care of, all you have to do is click on the Print option in the lower-right corner of the Lightroom interface (**Figure 45.10**).

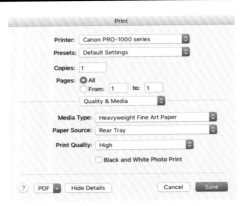

Figure 45.7 In the Print Settings dialog, you can select the Media Type, Paper Source, and Print Quality for your print job.

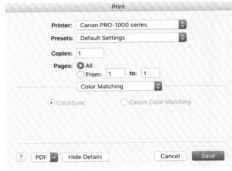

Figure 45.9 The Color Matching options should be grayed out or turned off when you're using a custom profile.

Figure 45.8 When you download an ICC profile from the paper manufacturer's website, instructions for use will be attached to the file.

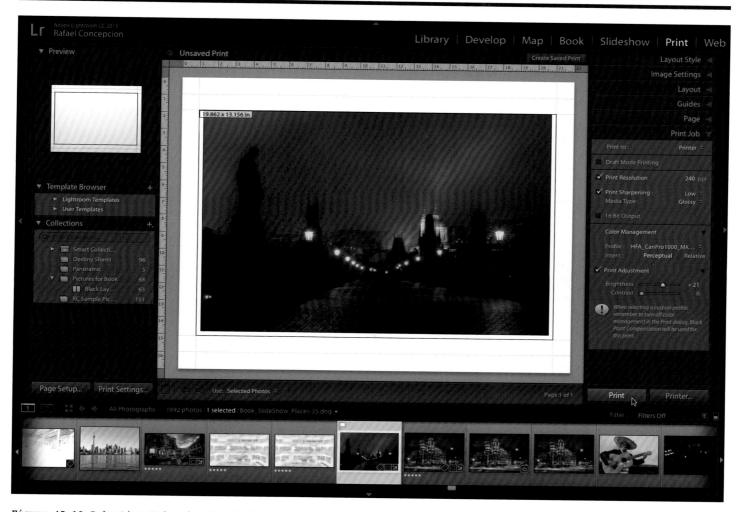

Figure 45.10 Selecting Print is the final step.

46. SOFT PROOFING YOUR IMAGES

ONE OF THE biggest problems that people have when printing their images is getting the prints to match what they see on the screen.

Using an ICC profile will help quite a bit when you're working in Lightroom because it will take care of translating the information between the screen and the final print. That said, there are a couple of other things you can do to help mitigate this process even further.

Soft proofing allows you to review the image and make better adjustments in contrast, color, and tone before you print the image, so you don't end up wasting paper and ink on multiple prints. In the Develop module, select *View > Soft Proofing > Show Proof* from the toolbar at the top of your screen (**Figure 46.2**), or use the keyboard shortcut S. This will bring you to a screen that tries to simulate what the picture will look like when it's printed on a specific paper.

You can change the paper type by clicking on the Profile drop-down menu in the Soft Proofing panel (**Figure 46.3**). This is similar to selecting a profile when making a print (Lesson 45). There is also a Simulate Paper & Ink checkbox, which washes out the picture a little bit (**Figure 46.4**). If you've selected a color profile for a matte paper, you'll be switching from a photo black to a matte black, which could produce very drastic results.

When you make changes in the Soft Proofing panel, you can use the two icons in the upper corners of the histogram to check for any tones that are out of gamut for your monitor or for the print, based on the paper profile that you have selected. If you click on the little monitor icon in the upper-left corner of the histogram, any tones that are out of gamut for your monitor will be highlighted in blue on the image. If you click on the paper icon in the top-right corner, the tones that will be out of gamut for the print are highlighted in red (**Figure 46.5**).

At this point, if you try to make any changes in the Basic panel while in Soft Proofing mode, Lightroom will let you know that you need to make a proof copy of the image (**Figure 46.6**). It's important to note that you originally edited your image based on what you saw on your screen. But that can change when you take a look at different paper types. When you make changes to the image in Soft Proofing mode, you're making changes based on what the Soft Proof looks like (i.e., what the image will look like when printed on a specific type of paper). You don't want to make changes to the original image based on a specific paper type because then you're going to have to readjust the image over and over for different outputs.

In this case, I think making a proof copy is a great idea. This allows you to adjust the proof copy in whatever way you need to for a specific paper type, and also retain the original image the way you edited it to begin with (**Figure 46.7**).

When you're satisfied with your proof, you can use the keyboard shortcut S to exit Soft Proofing mode and go ahead and finish your print.

Let me leave you with two more tips. First, if you're serious about wanting to marry the color on your screen to the final print, I would recommend that you go to spyder.datacolor.com and take a look at their display calibration products, such as the Spider5ELITE or the Spider5PRO. These will allow you to set up a baseline calibration for your monitor so you can ensure that the colors you're viewing are actually correct, and you can pass that information on to the final print product.

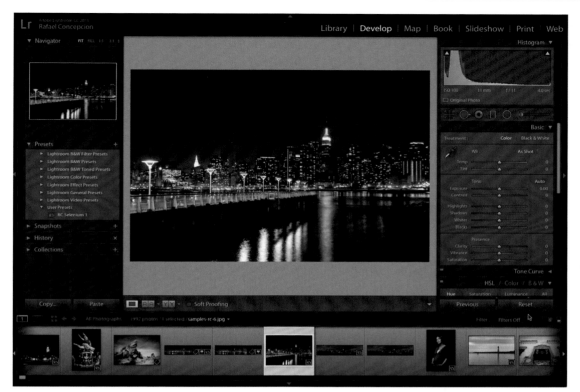

Figure 46.1 **Figure 46.1** This image looks good on screen, but how can I simulate this look on paper? That's where soft proofing comes in.

Figure 46.2 Soft proofing in Lightroom.

Figure 46.3 Selecting a paper type for the soft proof.

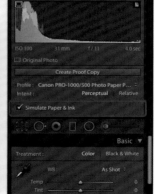

Figure 46.4 The Simulate Paper & Ink setting washes out the image slightly.

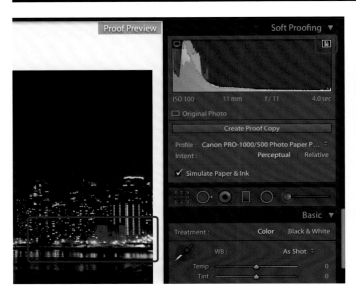

Figure 46.5 When you click on the paper icon in the top-right corner of the histogram, any tones that will be out of gamut for the print are highlighted in red on the image.

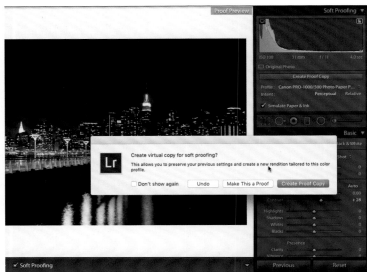

Figure 46.6 If you try to adjust anything in the Basic panel while in Soft Proofing mode, Lightroom will ask if you want to make a proof copy. You don't want to change your settings to fit a print and mess up what you see on screen, and this is where making a proof copy can help.

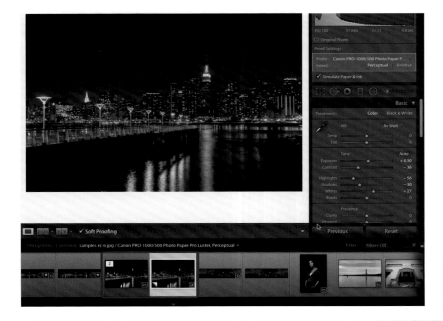

Figure 46.7 Now you can see two versions of the image in my filmstrip: the original image and the proof copy, which has been adjusted for a specific paper type.

The second tip has to do with print brightness. In a color-calibrated scenario, usually one of the first steps you take is to dim the monitor to an unrealistic setting. This works out great when you do a calibration and everything's good, but it presumes that you're going to want to work in this super dim environment all of the time.

I don't know about you, but I like to use my computer to look at Facebook, check my email, and browse the web. There are many other things we need to do with our computers and we cannot always work in this dim environment. So our calibration goes to complete pot because we increase the brightness of our monitors.

Now we have a situation. Most of the calibration we've done has been done on really dim screens, but then we switched our brightness to be super bright. The result: dark prints. This accounts for the largest number of problems that people have with prints.

To account for this issue, Lightroom created the Print Adjustment options (in the Print Job panel of the Print module; **Figure 46.8**)—much to the dismay of a lot of people who follow color management. When you select the Print Adjustment checkbox, you are allowed to add brightness and contrast to the print.

The trick here is that you will not see the change in brightness or contrast reflected on the screen. If you grab the Brightness slider and drag it all the way to 100, the image will still look exactly the same. But don't worry, the brightness will be added to the print when it comes out of the printer.

I find that keeping the Brightness slider between a value of 15 and 25 will do a really good job for the prints I'm trying to make. Normally, I don't really do too much on the Contrast side of things. However, people printing on matte papers for the first time are often not used to the lack of contrast they'll bring. In this case, a bump on the Contrast slider would make sense.

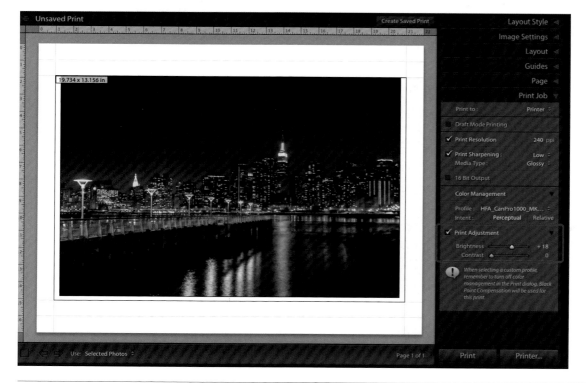

Figure 46.8 Changing the print Brightness here won't affect the view of the image on-screen, but it will add brightness to the print as it goes to the printer.

47. CREATING CUSTOM PRINT TEMPLATES

ONE OF THE things I like about Lightroom in terms of making prints is that it gives you a bunch of options to make really compelling pictures, as well as the option to make your own layouts.

When you select Single Image/Contact Sheet in the Layout Style panel, you have the ability to work with one picture. But in the Template Browser in the left column of the Lightroom interface, there are a series of canned layouts you can use. These are good when you want to print something like a contact sheet (**Figure 47.1**). Perhaps you've done a model shoot and you want to print a series of pictures for your client to review—in this case, a contact sheet is going to be a great idea. I also use contact sheets when I want to see what an image would look like when I print it on a specific type of paper. This way I don't use up an entire sheet of paper on one image.

To set up a contact sheet, select all of the images you want to use in the filmstrip (or you can select All Filmstrip Photos from the Use drop-down menu in the lower-left corner of the center workspace), and then click on one of the contact sheet options in the Template Browser menu. This will populate the page with all of the selected images, according to the page size you have specified.

When you click on other options in the Template Browser, you will notice that there are different layouts that allow you to overlap images (**Figure 47.2**). I think this is a really interesting, artistic way to show your pictures.

You can also create your own custom layouts by selecting Custom Package in the Layout Style panel, and then clicking on Clear Layout in the Cells panel. This allows you to drag-and-drop pictures onto the page and set it up exactly the way you want it, and then you can save that layout for later.

First, let's click on Page Setup in the lower-left corner of the Lightroom interface and make sure we set up the custom layout for a specific sheet size (**Figure 47.3**). For my example, I'm going to use the C paper size, which is 17 x 22 inches.

Once you have that set, you can drag a series of pictures from the filmstrip onto the page. I'll start with my main picture on the left and adjust it to the size that I want. From there, I want to add a series of other pictures to the right side (**Figure 47.4**). These are going to be much smaller. I can immediately make a copy of the small picture by holding down the Option (Mac) or Alt (PC) key while I click on the image and drag over to the right (**Figure 47.5**).

If you want to snap the cells to one another, go to the Grid Snap drop-down menu in the Rulers, Grids & Guides panel and select Cells option (**Figure 47.6**). Once that's done, you just need to align the pictures and you're good to go.

Figure 47.1 The contact sheet settings allow you to print several images on one page, making it easy to review a whole series of images.

Figure 47.2 Some templates allow you to overlap images on the page.

Figure 47.3 Setting up the page size for a custom layout.

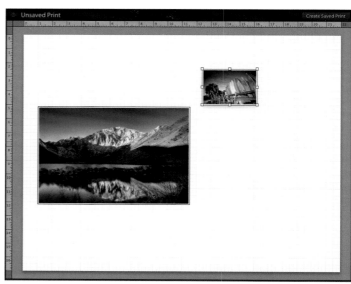

Figure 47.4 Manually adjusting the placement and size of the images on the sheet for a creative look.

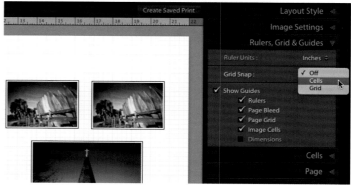

Figures 47.5-47.6 After you duplicate cells, you can align them with a Grid Snap.

Now I want to place a bigger picture so that it fills the entire page, but I want it to be almost like a background element. I'm going to drag a new picture onto the page and resize it to fit the full window. Then I'll right-click on the picture and select Send to Back (**Figure 47.7**). This will set the picture as a background element.

Once you're finished creating your custom template, you'll want to save it, so click on the plus sign next to Template Browser on the left side of your screen. In the New Template dialog, give your template a name and select the folder in which you want to save it (User Templates is the default, or you can create your own folders; **Figure 47.8**). Click Create, and your custom template will now appear in the folder you chose under the Template Browser menu.

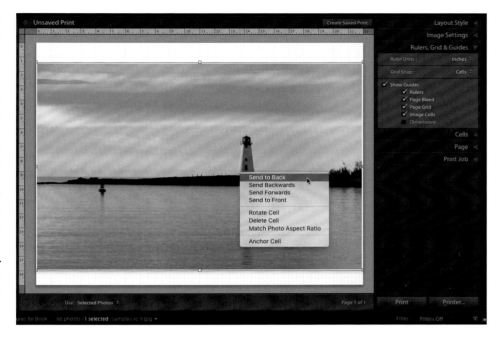

Figure 47.7 Move the big image onto your page and resize it first, and then right-click on it and select Send to Back.

Figure 47.8 Saving a custom template.

Before you use your custom template again, I recommend selecting the Maximize Size option, which will get you back to a single-image layout (**Figure 47.9**). Now when you select your custom template, you'll notice that it shows up as a wire frame (**Figure 47.10**). All you have to do now is drag the pictures into the available frames, and you have your own custom layout right inside Lightroom (**Figure 47.11**).

Figure 47.9 The Maximize Size option takes you back to a single-image layout.

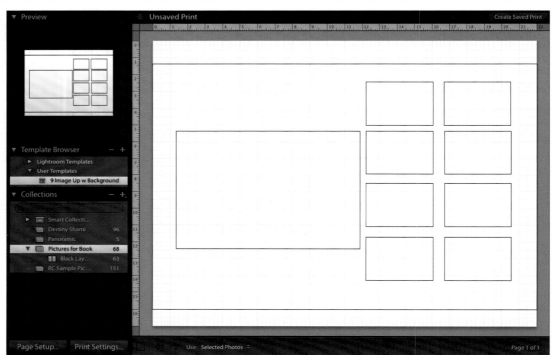

Figure 47.10 A custom print template in Lightroom.

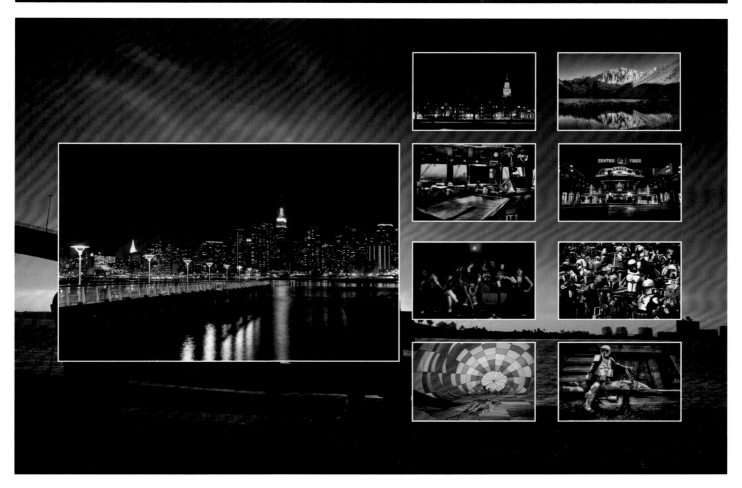

Figure 47.11 This custom layout allows me to showcase nine of my images, with another in the background.

7

FORGOTTEN MODULES AND MAINTENANCE

CHAPTER 7

I titled this chapter "Forgotten Modules and Maintenance," but by no means should you treat it as something that's completely disposable. Yes, there are elements in Lightroom that will not get as much love as other elements. There are also elements that have not been updated in quite some time, and with recent advances in the software, these features seem to be a little outdated. However, they are extremely easy to use, and it's a good idea for you to have a cursory knowledge of how they operate.

I also want to leave you with a little information on how to do some general maintenance in Lightroom, from managing your Lightroom backups to using things like smart collections.

What if, despite your best intentions, you go to Lightroom and try to move a slider in the Develop module and it's unresponsive? A giant "File Not Found" message stares you in the face. You're going to need to know how to overcome this. And it's important to know why you would want to use something like smart previews, or how to be able to take an existing catalog and merge it with another one.

I know that sounds really hard, but everything you've learned in this book so far has been relatively easy, why should we complicate things now? Let's go ahead and get started.

48. USING THE WEB MODULE

THE WEB MODULE allows you to place a series of images on a standalone website. To be honest, it's one of the least-touched modules in Lightroom. Adobe hasn't made that many changes to it over the years, with the exception of updating a series of templates for HTML-5 support. Other than that, it's been the same module from the very beginning.

Start by organizing the images that you want to place on a website into a collection (**Figure 48.1**). Once your collection is complete, you can move to the Web module.

You'll notice that a lot of the text options for the website can be changed directly in the center workspace (**Figure 48.2**). Simply click on the text you want to change—such as Site Title or My Photographs—and a text field will open, allowing you to insert whatever text you want. You can also use the panels on the right to add or change information and modify the appearance of the site.

One field you should pay particular attention to is the Web or Mail Link field at the bottom of the Site Info panel (**Figure 48.3**).

This adds a link with your contact information to the website. Make sure you enter your email address immediately following "mailto:"—do not leave any space between the colon and your email address.

The Color Palette panel allows you to choose the color of various page elements on your website. Click on the color swatch next to the feature you want to change, and select a new color from the color bar.

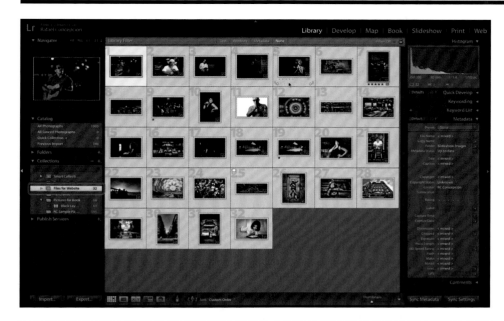

Figure 48.1 When you make a collection of your images it is a lot easier to control how they are viewed on your webpage.

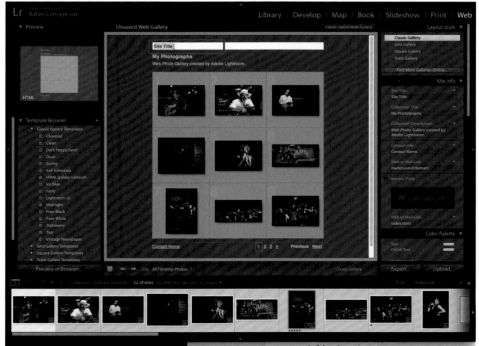

Figure 48.2 You can make changes to the website information with the panels on the right, or directly in the main workspace.

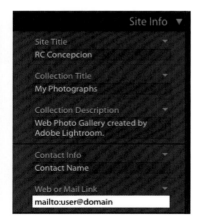

Figure 48.3 When you enter your email address, make sure you don't delete the colon following "mailto."

You even have the option to change the number of rows and columns in your grid by using the Grid Pages option in the Appearance panel (**Figure 48.4**). Play around with the options in the panels until you get the look you want. You can add things like drop shadows and image borders, adjust the size of your images, or even add a watermark to your images.

Once you've adjusted all of the available options and you're pleased with the look of your page, it's just a matter of clicking on Export in the lower-right corner of the module (**Figure 48.5**). This will create a folder with all of the HTML files, content, and resources for you to use on a website (**Figure 48.6**). Give the folder a name, select where you want to store it on your computer, and click Save.

I like the concept of this module and appreciate that it's available, but to be honest, very few people use it. There are a few key issues that prevent people from using it. One of the biggest problems with this module is that it requires you to have some experience using an FTP to upload this folder of information to a website. This also requires you to have a website already set up where you can upload this information—something that sits outside the realm of experience for most users.

Another issue is that if you are uploading information to a website, more often than not, you already have an existing website with a substructure that you want to adhere to (e.g., WordPress, Joomla, etc.). In instances like this, you'll want the album that you create in Lightroom to fit the overall structure of the

website you have already built. Unfortunately, this is not possible. When you use the Web module, you are creating a stand-alone webpage that offers no navigation back to an original website.

Finally, with the inclusion of collections that can be synced online with Lightroom (Lesson 14), you have a mechanism that you can use for adding your images to an already existing website, as well as an online repository where you can place the link for the website directly into social media pages like Facebook and Twitter. So the benefits of the Web module are already built-in with online web collections.

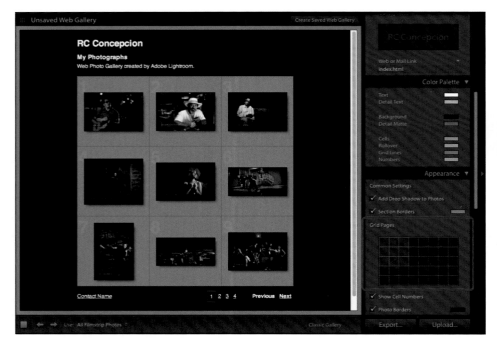

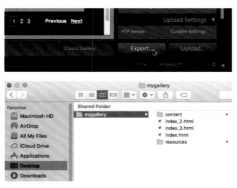

Figure 48.4 Use the Grid Pages option to select how many images you want in each grid.

Figures 48.5–48.6 When you click on Export, Lightroom will create a folder that contains all of the information you need for your webpage.

A MODULE THAT proves to have great promise in Lightroom is the Map module. If you take a picture with a camera that has the ability to capture GPS information, that GPS information is stored in the EXIF file for the picture (**Figure 49.1**).

When you enter the Map module, you will see that all of the images that have GPS information are tagged on a world map (**Figure 49.2**). It's important to note that you have to have an internet connection in order for this map to refresh. The images are attached to pins on the map, and the number on each pin reflects how many images you have from that specific location.

When you click on a pin, all of the images attached to that location will be highlighted in the filmstrip (**Figure 49.3**). If you double-click on a pin, a box will pop up with previews of the pictures from that location (**Figure 49.4**).

If you have images without GPS information, you can add location data manually from within the map. Type in the geographical area in the search field of the Location Filter at the top of the center workspace (**Figure 49.5**). Hit Enter and the map will refresh to the new location. You can zoom in further by using the +/- slider at the bottom of the screen. You can also move the map around by clicking on it and dragging in any direction.

Once you've zoomed in to a level you feel comfortable with, simply select the images you want from the filmstrip and drag them onto that area. The GPS coordinates of that location will now be attached to the pictures.

Whenever I want to make sure I collect GPS information from a shoot so I can add it to a set of pictures that I've taken with my DSLR, I'll take a picture with my iPhone at the location of the shoot. After importing the pictures from my shoot into Lightroom, I import the picture I took with my phone during the same shoot and add it to the collection that contains the other pictures I took with my DSLR.

When I go into the Map module, the iPhone picture will be tagged on the map because it has GPS information. I can now drag all of the pictures from the DSLR onto that location, embedding the GPS coordinates into those pictures in one shot (**Figure 49.6**).

I really like the opportunity to sort pictures according location, but the truth of the matter is that very few cameras to date have the ability to collect GPS data, and even if this feature is available, very few users have turned it on. As GPS capability in cameras becomes more common, the Map module will become much more useful.

If you are using Lightroom to manage and organize your phone workflow, the Map module could be a really big deal for you.

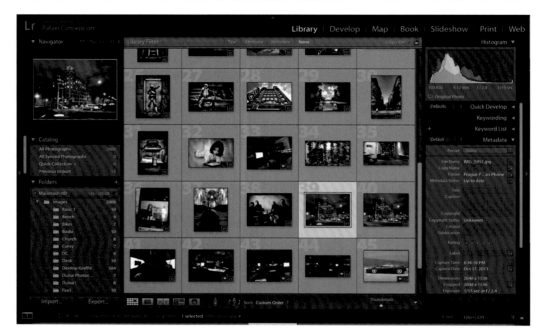

Figure 49.1 Some of these pictures have GPS information and some do not. You'll see which ones do when you enter the Map module.

Figure 49.2 The Map module shows the locations where your images were taken, based on GPS information.

Figure 49.3 Click on a bubble to see which images were taken at that location. These images will be highlighted in the filmstrip.

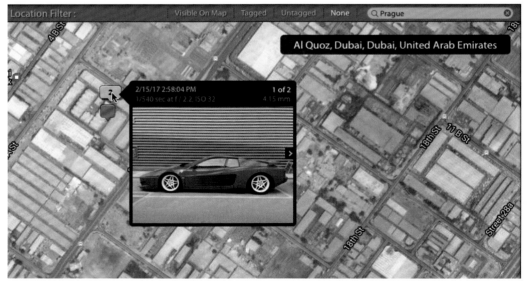

Figure 49.4 You can see a preview of the images taken at a specific location right on the map.

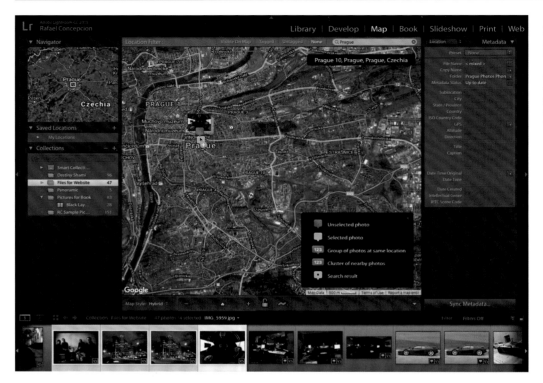

Figure 49.5 Type the location where you want to attach pictures into the Location Filter search field. Use the slider at the bottom of the screen to zoom in to a specific area. Adding images to a location is as easy as dragging them in from the filmstrip.

Figure 49.6 This is a picture I took with my iPhone in Prague. I can drag all of the pictures from my shoot onto this location to quickly add GPS coordinates to every image.

50. ENABLING THE PEOPLE FEATURE IN LIGHTROOM

IN LIGHTROOM YOU have the option to allow the software to search through your entire catalog, an individual folder, or a collection to create a database of faces and names that you can use to find individuals in your pictures. To enable this feature, click on the People button (face icon) in the toolbar at the bottom of the center workspace (**Figure 50.1**).

You will be presented with two options: Start Finding Faces in Entire Catalog, or Only Find Faces As-Needed (**Figure 50.2**). When you choose Only Find Faces As-Needed, this option will only be available when you select the People view feature for the currently selected folder or collection.

All of this will happen in the background mode in Lightroom (**Figure 50.3**). It's not going to slow you down drastically, but there is some processing that will be going on in the background.

Figure 50.1 Enabling the People view in Lightroom.

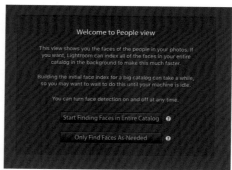

Figure 50.2 Lightroom gives you two options for detecting faces.

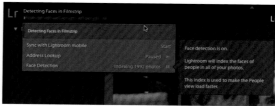

Figure 50.3 Lightroom runs all of the facial detection in the background so you can continue to work on your images.

Lightroom will start going through your pictures and looking for faces to add to the People view. You will see that you have two distinct sections: Named People and Unnamed People. Lightroom will try to group pictures of the same person together. Of course, you will most likely have multiple groups of the same person because they don't always look exactly the same in each picture. You can see how many pictures there are in each group in the upper-left corner of the thumbnail that's on top of the stack (**Figure 50.4**).

At this point the process is pretty simple. All you have to do is select one of the unnamed people and type in a name (**Figure 50.5**). Lightroom will continue to aggregate pictures to that thumbnail when it finds pictures that it believes are a match for that name.

After you've added a name to a thumbnail, that person will go into the Named People section (**Figure 50.6**). If Lightroom continues to process pictures that are similar, you will be prompted with the name for that person. For example, I've created a tag for my daughter Sabine, and in the Unnamed People section in **Figure 50.7**, you can see that I'm starting to get more options asking me, is this person "Sabine?"

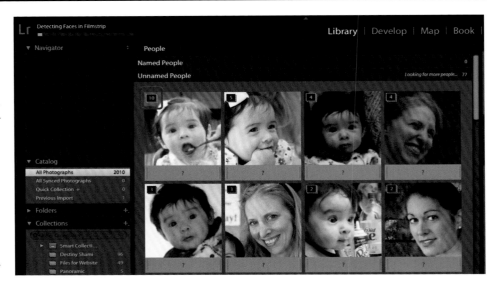

Figure 50.4 Lightroom attempts to group pictures of the same person together. The number in the upper-left corner of each thumbnail tells you how many pictures are in that group.

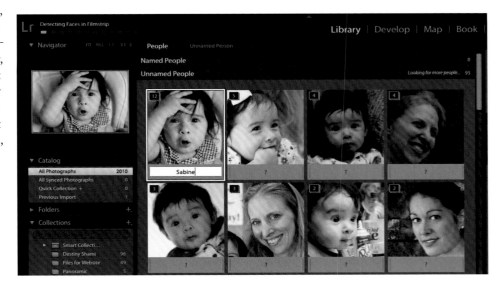

Figure 50.5 Adding my daughter's name, Sabine, to the pictures.

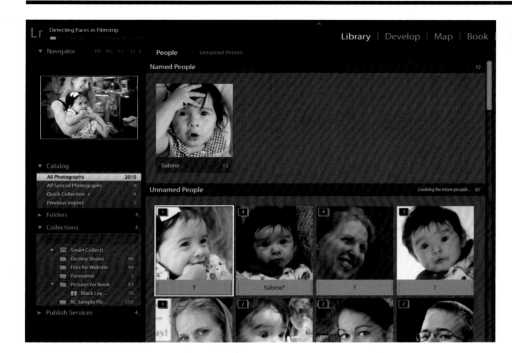

Figure 50.6 There is now a tag for my daughter Sabine in the Named People section.

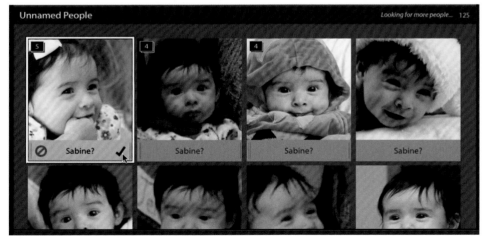

Figure 50.7 As Lightroom gets smarter about finding faces, your job matching them gets a lot easier.

I can single-click on the checkmark in the lower-right corner of a thumbnail, or I can select multiple thumbnails and click on one of the checkmarks, and Lightroom will move those thumbnails to the Named People section. You can also add images to a named person by dragging thumbnails from the Unnamed People section onto a name in the Named People section (**Figure 50.8**).

If you want to eliminate any faces from being sorted by Lightroom, you can always click on the X in the lower-left corner of the thumbnail (**Figure 50.9**).

As you scroll down through the Unnamed People thumbnails and find an image that matches a named person, single-click on the text field and you'll notice that as you start typing, Lightroom will prefill the already existing name (**Figure 50.10**). This is a great time saver.

There will be times when you're not quite sure what Lightroom is looking at because the thumbnail doesn't really show a face (**Figure 50.11**). In this case, you can double-click on the thumbnail and Lightroom will open a full view of the image with a white square around the area that was shown in the thumbnail (**Figure 50.12**). Simply grab the square and drag it over the facial area, and then type in the appropriate name (**Figure 50.13**).

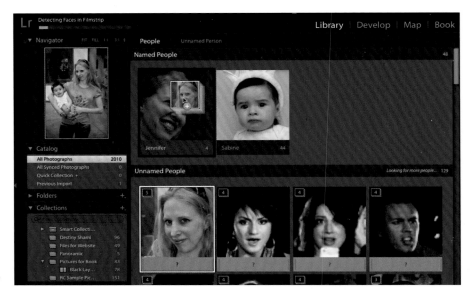

Figure 50.8 You can add multiple thumbnails to a named person by dragging them onto that name in the Named People section.

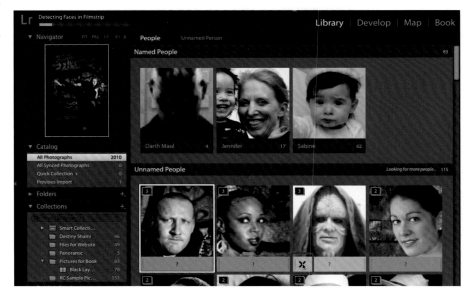

Figure 50.9 I have absolutely no idea who the person in the third image really is. Let's remove him from this list.

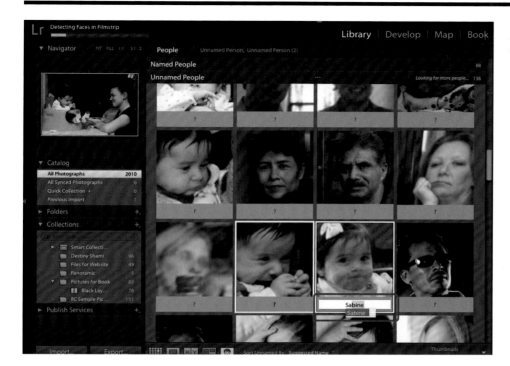

Figure 50.10 Lightroom will prefill an already existing name when you start to type it.

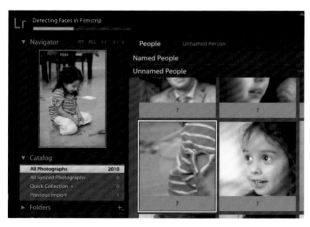

Figure 50.11 I know that's Sabine, but the thumbnail only shows her shirt.

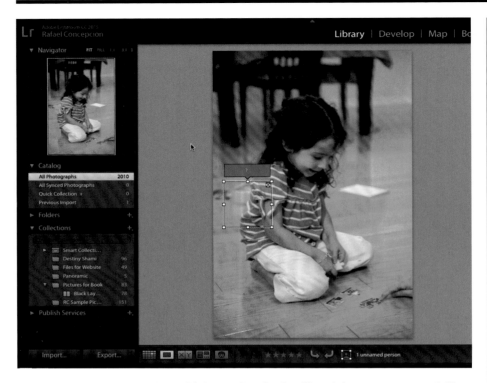

There will also be thumbnails for images that have more than one person in them, but only one person is identified. For example, **Figure 50.14** shows a picture of my wife's grandfather Poppy, and my daughter. However, Lightroom has identified that there is only one face (Poppy). I'd like to tag another face in the image, so I'll drag out a new box for Sabine on the left. Now I can type in both names and both people will be tagged in the image (**Figure 50.15**).

One of my favorite parts about using this feature is that I can scroll through my library and reconnect with some pictures that I haven't seen in awhile, all in the process of working to add names to faces.

Figure 50.12 When I double-click on the thumbnail, Lightroom opens a full view of the image with a square around the area used for the thumbnail.

Figure 50.13 I'll move the square so that it surrounds Sabine's face, and then type her name into the text field.

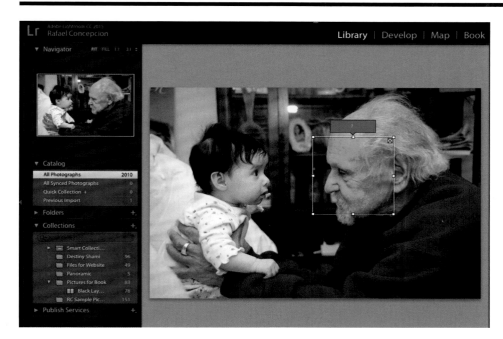

Figure 50.14 One of my favorite pictures of Sabine and her great-grandfather Poppy. May he rest in peace.

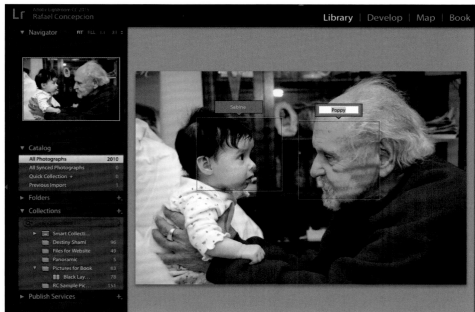

Figure 50.15 Both Sabine and Poppy are tagged in the image.

51. MANAGING LIGHTROOM BACKUPS

REMEMBER THAT LIGHTROOM is your digital notebook. This notebook keeps track of the location of your pictures as well as any changes that you've made to them. The last thing you want to do is lose this notebook. Thankfully, Lightroom gives you the opportunity to back up your catalog so that you can go back to a previously saved version of it if you run into problems.

You can change the frequency of your catalog backups in the Catalog Settings dialog (select *Lightroom > Catalog Settings* from the toolbar at the top of the screen). Click on the General tab, and then select an option from the Back up catalog drop-down menu.(**Figure 51.1**).

The backup information is saved as an LRCAT file (**Figure 51.2**). This LRCAT file is the actual Lightroom notebook. There is also a Previews file that contains the thumbnails for your pictures, but it's not really necessary for that to be backed up. If something happens to your catalog, you can always rebuild those thumbnails from the existing catalog file, so the catalog is the most important part.

In Figure 51.2, you can also see that there is a -journal and .lock file, but don't worry about those. Those files only appear when Lightroom is open, and will disappear once you exit Lightroom.

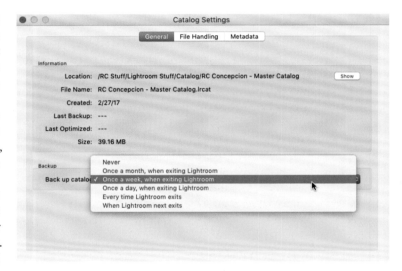

Figure 51.1 Change the frequency of your catalog backups in the Catalog Settings dialog.

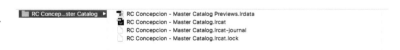

Figure 51.2 Your catalog backup is stored as an LRCAT file.

When you quit out of Lightroom, you will be asked whether you want to back up your catalog files or skip it (**Figure 51.3**). You also have options to optimize the catalog and test the integrity before Lightroom actually backs it up. When you see this window, I recommend that you back up your catalog. You don't want to run into a snag later on and not have a good copy.

Your catalog backups are stored in a Backups subfolder inside the area where your actual catalog is stored, and they will be sorted according to date (**Figure 51.4**).

File Handling is another important section of the Catalog Settings dialog (**Figure 51.5**). In this section you have the option to change the Standard Preview Size that is used during import. If you want to conserve a little bit of space, you can drop to a smaller preview size than what was used previously, but the default setting will always be the resolution you need based on the monitor you have.

You can also change the Preview Quality and the length of time the 1:1 previews are kept. By default, this is set to 30 days, which is more than adequate, in my opinion. It's always a good idea to dump these files when you don't need them. Remember that the 1:1 previews are much larger than standard previews, so if you keep them for longer than you need to, you could clog up your computer with files that you aren't really using. If you need to render new previews at any point in time, you can always zoom into the picture and get the files that you need.

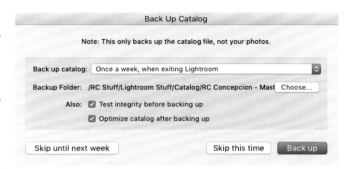

Figure 51.3 I suggest backing up your catalog whenever you see this window.

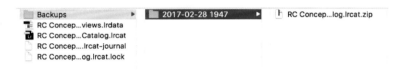

Figure 51.4 Your catalog backups are sorted according to date.

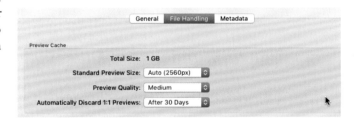

Figure 51.5 In the File Handling tab of the Catalog Settings dialog, you can decide how Lightroom handles previews.

52. USING SMART COLLECTIONS

WE SPENT SOME time earlier in this book discussing collections and collection sets, but there is another type of collection that I think is absolutely helpful, and that is the Smart Collection.

A Smart Collection is a collection that is built inside your Lightroom catalog that agrees to specific rules that you set. So rather than dragging images into this collection, you set the rules by which images are automatically imported into this collection for you to view. This can be very helpful for monitoring images with specific characteristics in your collection.

Click on the plus sign at the top of the Collections panel and select Create Smart Collection (**Figure 52.1**). Now, let's say I wanted to see all of the five-star images I have in my catalog. I'll start by naming my Smart Collection "5 Star Images" (**Figure 52.2**). In the box below "Match all of the following rules," I'll set the Rating to "is greater than or equal to" five stars. When I click Create, all of the five-star images in my catalog appear inside my "5 Star Images" Smart Collection (**Figure 52.3**). Pretty cool, right?

I also like to create a Smart Collection that serves as a monitor of rejected images in my catalog. I'll name this one "Rejected Images," and set the rule drop-down menus to "Pick Flag is rejected" (notice that there are three separate drop-down menus I used to create this rule; **Figure 52.4**).

Again, the moment I hit Create, all of the rejected images in my catalog will be added to the Smart Collection. I use this as a garbage collection. More often than not, as I'm importing more and more shoots, I will reject images, but then forget to delete them. If I see that the number in my "Rejected Images" Smart Collection is getting really high, I know that I probably should go back to my collections and assess how many of those rejected images I need to keep.

Another Smart Collection I find useful is one that displays all of the Photoshop (PSD) files. I will create a Smart Collection called "Photoshop Files," and set the rule drop-down menus to "File Type is Photoshop Document (PSD)" (**Figure 52.5**). If the number in this Smart Collection gets really high, I can go back in and see if I need to compress some images or move some out.

This is also a great way to keep track of how much finished work I have in Lightroom. Chances are, if it's a Photoshop document, I've done work to it and it's probably closer to the final copy of what I need to send out.

The last Smart Collection I suggest creating is one that detects Smart Previews. Name this collection "Smart Preview," set the rule drop-down to "Has Smart Preview," and set the value to "is true." We'll talk about Smart Previews in Lesson 54, but I think this Smart Collection is going to be invaluable to you.

It's important to note that a Smart Collection can have more than one rule. For example, you can create a Smart Collection for five-star images with a blue label, or for Photoshop files that have been marked as rejected. To add additional rules, click on the plus sign to the right of the rule drop-down menus. The combinations are endless, and this is a great way for you to streamline your workflow in Lightroom.

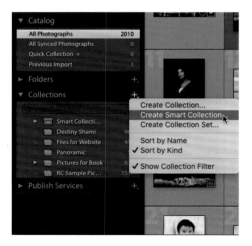

Figure 52.1 Creating a Smart Collection in Lightroom.

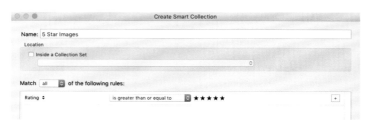

Figure 52.2 Smart Collection: 5 Star Images in my Lightroom Catalog

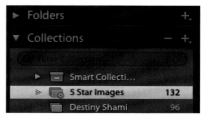

Figure 52.3 All 132 images with a five-star rating have been added to a Smart Collection in my Lightroom catalog.

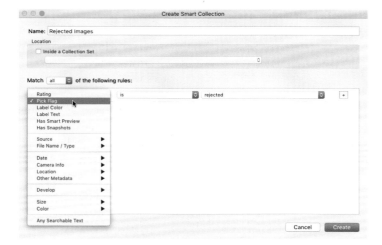

Figure 52.4 Smart Collection: Rejected Images in my Lightroom Catalog

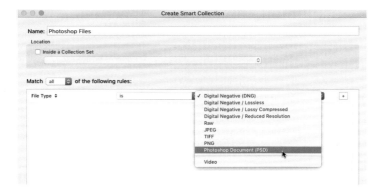

Figure 52.5 Smart Collection: Photoshop Files in my Lightroom Catalog

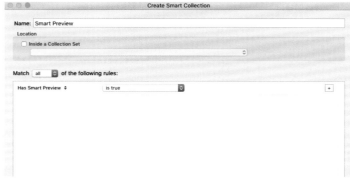

Figure 52.6 Smart Collection: Smart Previews in my Lightroom Catalog

53. FINDING MISSING FILES AND FOLDERS

YOUR LIGHTROOM CATALOG does a great job of managing where you place pictures and what you do with them. However, there will come a time when you move a folder or a set of pictures outside of Lightroom (**Figure 53.1**), and Lightroom is not going to know where it is. Go back to the analogy we used at the beginning of this book: it is as if someone walks into your house and moves a box of pictures, but never writes this down in your notebook.

You'll be able to open up the files in the Library module and Rank, Sort, Pick, add stars, and add colors without a problem, but the moment you move into the Develop module, you'll notice that all of your sliders are grayed out (**Figure 53.2**). This is because the Develop module requires you to have references to the original pictures. Directly under the histogram, there will be a warning message that says the photo is missing.

From here, you have a couple of options. Your first option is to right-click on the picture and select Show in Finder (Mac) or Show in Windows Explorer (PC). Lightroom will provide a dialog box that shows the last location of the picture, just in case you need a little bit of a refresher (**Figure 53.3**). Click Locate, and then browse for the missing picture on your computer or an external drive. Once you find it, Lightroom will match all of the pictures that are in the same directory for you (**Figure 53.4**).

However, I do not recommend using this option. This is a great option for finding a set of images that are inside one folder. But what happens if you've moved a folder that has subfolders inside of it? You can find the individual files in one folder, but then you're going to have to repeat that process over and over again for all of the other subfolders that are inside the main folder.

To avoid this issue, I suggest you take just one extra step. Instead of using the Show in Finder option, right-click on the image and select Go to Folder in Library (**Figure 53.5**). This will take you to the Folders panel in the Library module and you will see that the folder has a question mark next to it. Right-click on the folder and select Find Missing Folder (**Figure 53.6**).

Now you can find the location of the missing folder on your computer (**Figure 53.7**). Once you find it, all of the images inside that folder will be mapped back to Lightroom, and you can work on them in the Develop module again (**Figure 53.8**). If you have subfolders inside the main folder, all of the images in the subfolders will be mapped as well. You can save a ton of time just by taking one extra step.

Figure 53.1 When you move a folder outside of Lightroom, the software no longer knows the location of the images in that folder.

Figure 53.2 When Lightroom cannot reference the original image file, the Develop settings are unavailable. Right-click on the image and select Show in Finder (Mac) or Show in Windows Explorer (PC).

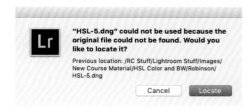

Figure 53.3 Lightroom will show you the previous location of the missing image. Click Locate to browse for the missing image on your computer.

Figure 53.4 Once you've found the missing image, Lightroom will take care of creating new location references for all of the other images in that folder for you.

Figure 53.5 Right-click on the missing image and select Go to Folder in Library.

Figure 53.6 The missing folder will have a question mark next to it in the Folders panel. Right-click on the folder and select Find Missing Folder.

Figure 53.7 When you find the missing folder and select it, all of the images will be mapped back to Lightroom.

Figure 53.8 Now that Lightroom can reference the location of the original image file, all options in the Develop module are available.

54. CREATING SMART PREVIEWS IN LIGHTROOM

SOME PHOTOGRAPHERS LIKE to work with and store their images on removable hard drives, and don't want to have their images connected to the Lightroom catalog all of the time. For that, Lightroom has developed the Smart Preview.

A Smart Preview is a preview that is larger than a 1:1 preview and is meant to serve as a substitute for images when they are not connected to the Lightroom catalog. You can create a Smart Preview during the import process (**Figure 54.1**), and you can also do it inside the main catalog. To create a Smart Preview in the main catalog, go to *Library > Previews > Build Smart Previews* (**Figure 54.2**).

I know what you're thinking—this is a great idea; I can store all of my images on a removable hard drive and then put the hard drive away. This is true, but you do need to remain aware of how much space these previews take up on your computer so you can handle them accordingly.

When your drive is connected to Lightroom, you'll notice that directly under the histogram in the Library module it says Original + Smart Preview (**Figure 54.3**). That means Lightroom has access to the original image, and you can go into the Develop module and make any changes to the image.

The moment your drive is disconnected, you'll notice that under the histogram it says Smart Preview (**Figure 54.4**). Now when you work on the image in the Develop module, any changes you make are applied to the Smart Preview, which is larger than a 1:1 preview, but is definitely not a RAW file. When you reconnect your external drive, Lightroom will sync the Smart Preview with the RAW file settings and show you your image.

Figure 54.1 Building a Smart Preview during the Lightroom import process.

Figure 54.2 Building a Smart Preview inside Lightroom catalog.

Figure 54.3 Underneath the histogram you can see that Lightroom has access to the original image and a Smart Preview.

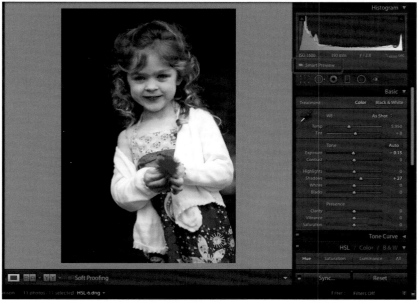

Figure 54.4 Editing a Smart Preview in the Develop module.

This is all well and good, but keep in mind that a Smart Preview is larger than a 1:1 preview. So imagine if every single time you did a shoot, you started converting your images to Smart Previews. Storing a large number of these previews in your catalog can jam up your computer. In the File Handling section of the Catalog Settings, you can choose to discard your 1:1 previews after a specific amount of time because Lightroom knows that having large previews will get you in trouble—you could fill up your hard drive (**Figure 54.5**).

Now you're in a situation where you're creating previews that are larger than your 1:1 previews, but you have no mechanism to control how often they're stored on the computer and when they're discarded. This is where the "Smart Preview" Smart Collection we discussed at the end of Lesson 52 comes in (**Figure 54.6**).

Creating a Smart Collection for your Smart Previews allows you to quickly take a look at whether the number of Smart Previews in your Lightroom catalog is getting really high (**Figure 54.7**). If so, you can go into the Smart Collection and discard the Smart Previews for any images you've already developed, freeing up space on your computer (**Figure 54.8**).

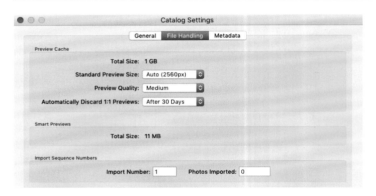

Figure 54.5 Lightroom gives you the option to automatically discard 1:1 previews after a set amount of time to free up space on your computer.

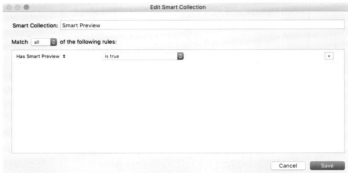

Figure 54.6 Creating a Smart Collection for Smart Previews.

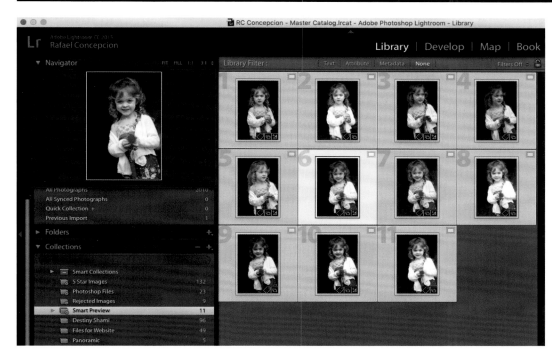

Figure 54.7 Using a Smart Collection for your Smart Previews helps you monitor their numbers so you can free up space on your computer when necessary.

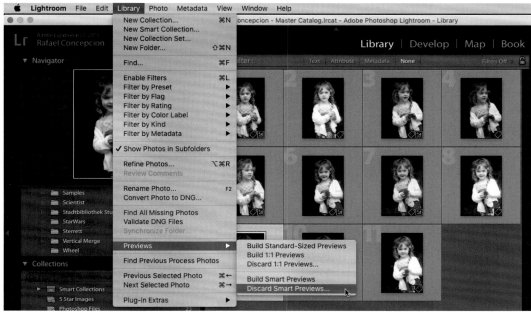

Figure 54.8 Discarding Smart Previews.

55. EXPORTING AND IMPORTING CATALOGS

WHILE LIGHTROOM IS a great program for monitoring your images—where you've placed them and what changes you've made to them—some photographers want to move information from one notebook to another notebook. Lightroom has a pretty straightforward way of doing that.

To export a catalog from Lightroom go to *File > Export as Catalog* (**Figure 55.1**). The Export as Catalog dialog will appear, letting you specify a new location in which to save this catalog file (**Figure 55.2**).

You have a couple of other options here as well. At the bottom of this dialog, you can choose to Export selected photos only, Export negative files, Build/Include Smart Previews, and Include available previews for the catalog. If you're just trying to create a new catalog, but you are not changing the location of your source pictures, it's probably a good idea to leave the Export negative files box unchecked. If you're trying to move all of the files that you have on your computer to a new location and you want to include the catalog, then do select the Export negative files checkbox, but understand that this is going to take quite a while to export.

After you've made your selections, hit Export, and you will see a dialog with the status of your export as it's being completed (**Figure 55.3**). The exported catalog file will be saved in the location you specified, and you can import the contents of that catalog into another catalog on the same computer or on a different computer.

To start the import, open the catalog into which you want to import the contents of the exported catalog (which may be on the same computer or a different one) and select *File > Import from Another Catalog* (**Figure 55.4**). Select the catalog file you want to import—in this case, the catalog you just exported—and click Choose.

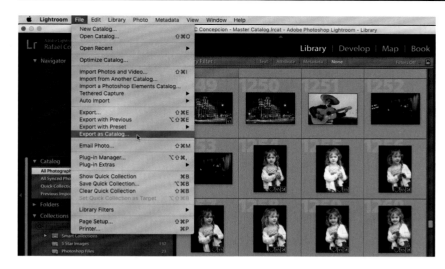

Figure 55.1 Exporting a catalog from Lightroom.

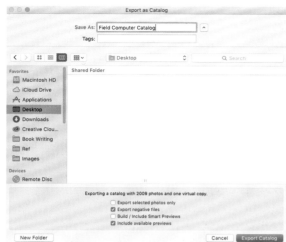

Figure 55.2 The Export as Catalog dialog allows you to choose a new location in which to save your exported catalog file. Select what you want to export with the checkboxes at the bottom of the dialog.

Figure 55.3 The catalog export may take a while if you choose to export the negative files.

Figure 55.4 Importing a catalog in Lightroom.

You will be presented with a dialog that shows the contents of the catalog you are importing and asks you how you want to handle any new images that come into the current catalog (**Figure 55.5**). You can add the photos to the catalog without moving them from their location, copy the photos to a new location and then perform an import, or choose not to import the photos at all. If Lightroom finds any duplicate images in the catalogs, you will also have an option to specify how you want to work with images that have been changed (**Figure 55.6**).

Imagine that I have a home computer on which I store all of my pictures, but I copied a couple of folders onto my laptop and created a catalog so I can work while I'm on the road. The pictures are the same in both locations, so I don't necessarily need to import the pictures from the laptop back onto the computer at home.

However, I did make some changes to the images in the Develop module and created some new collections. I want that information to be brought back into the catalog that I have on my home computer. In this instance, I would export the catalog on my laptop, and when I import it back into the catalog on my home computer, I would select to bring only the metadata and develop settings into the files that I have on my home computer. If I feel like I need to make a structural change to the folder inside the catalog on my home computer, I would select Metadata, develop settings, and negative files.

Keep in mind that if you do this, you will have two separate catalogs of information, and those catalogs may reference two sets of images that live in different places. You're going to have to be careful that you don't duplicate images excessively, or keep tabs on which images are the most recent.

For the average user, this will not really be a problem. You'll spend most of your time working on one computer with one individual catalog. But for people who are trying to work on multiple computers or individuals who have inadvertently created multiple catalogs and are trying to consolidate them, it will require a little bit of work. The process is not hard, but it does require some thought before you execute it.

So there you have it! You now have a good fundamental understanding of how to work with images in Lightroom CC. Keep in mind that Lightroom has many more features than what we've discussed here. The goal of this book is to give you a good, solid foundation on the software so you can start organizing, developing, and sharing your images as quickly as possible. You'll find that these techniques will develop and morph into a workflow that suits your individual needs—and that is totally fine! The most important takeaway is that organizing and processing your images should never get in the way of you getting out there and making great pictures.

I'd love to keep up with how you do on your Lightroom journey. If you'd like to connect with me, please feel free to leave me a message at my personal website—www.aboutrc.com—or check out some of my online training at firstshotschool.com.

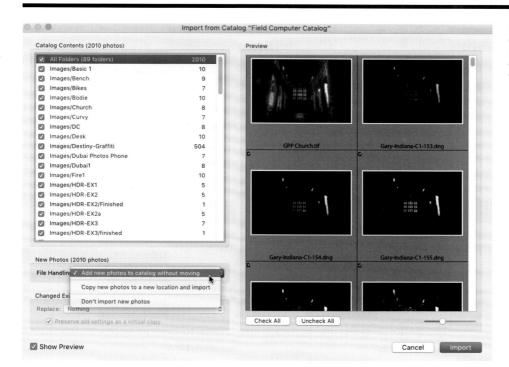

Figure 55.5 When you import the contents of a catalog, you can choose how you want Lightroom to handle any new images that come into the current catalog.

Figure 55.6 You can select how you want Lightroom to handle any duplicate images it finds in the catalog you're importing and the current catalog.

THE ENTHUSIAST'S GUIDE TO LIGHTROOM

THE LEARNING CENTRE
CITY & ISLINGTON COLLEGE
444 CAMDEN ROAD
LONDON N7 0SP
TEL: 020 7700 8642

229

INDEX